ANAÏS NIN:
Naked under the mask

Elisabeth Barillé's novels
have been translated into
English, Spanish and Dutch.
She lives in Paris.

THIS
BOOK
BELONGS TO

Rinella

THIS
BOOK
BELONGS TO

Elisabeth Barillé

ANAÏS NIN
Naked under the mask

Translated by Elfreda Powell

Minerva

A Minerva Paperback
ANAÏS NIN

First published in Great Britain 1992
by Lime Tree
This Minerva edition published 1993
by Mandarin Paperbacks
an imprint of Reed Consumer Books Ltd
Michelin House, 81 Fulham Road, London SW3 6RB
and Auckland, Melbourne, Singapore and Toronto

Originally published in French as
ANAÏS NIN masquée, si nue
Copyright © Editions Robert Laffont, S.A., Paris, 1991
Translation copyright © Elfreda Powell, 1992
The author and translator have asserted their moral rights

A CIP catalogue record for this title
is available from the British Library
ISBN 0 7493 9804 3

Printed and bound in Great Britain
by Cox & Wyman Ltd, Reading, Berks

For Aldo, of course

Author's Note

'I felt again a strong desire to write
the life of Someone. The 'form' itself
appeals to me, the informed, free style,
the telling of character without story . . .'

(Journal of a Wife)

Anaïs Nin's words have inspired this portrait,
albeit a fictionalized one, but woven from the very tissue of
her work and her life.

Contents

PROLOGUE

Cadiz to New York in thirteen days: the *Monserrat* was entering New York Harbour and from her bridge you could just distinguish the confused jungle of concrete and glass, minarets, pyramids, and steel bridges daubed in red-lead paint, when the sky turned inky black.

A squall had blown up, bringing with it the smell of mud, sweeping along the seagulls which zigzagged in the wake of the steamer, churning the waves, fissuring the dark mass of clouds.

Lightning had just struck the prow. Someone was shouting instructions. Sailors hurtled around, people staggered under waves of water. You could hear the grinding of chains.

'Get out of the way! Hang on!'

In the music room, the piano's legs were tied to the radiators. People reeled about, clinging to each other. Gin slopped from their glasses. A female passenger, already grey in the face, mumbled:

'Oh would the Atlantic were all Champagne
Bright billows of Champagne . . .'

In the smoking room, men were crushed together like apples in a ciderpress. Women screamed. Children were sobbing: all of them, that is, except for a little girl who had taken refuge with her mother and two brothers in the Tourist Class reading room: a mouselike face, pointed ears, almond-shaped nostrils, teeth like pearls in a mouth wide with laughter. She was the only one laughing. What a gale – it was beautiful, a wonderful day.

'I want to see New York.'

Her mother held her. 'You can see New York later.'

'I want to see it now.' The child wriggled down and broke free of her mother's grasp, and ran from one porthole to another,

strangely self-assured on her spindly legs, full of a wiry child's energy, staring wide-eyed at the waves.

The black sides of the ship were incrusted with scales, glittering with stars, floating on an upturned sky.

'Oc-e-an!' She was enchanted by the word. Three syllables unfurled in a mute echo, and three syllables answered back: 'Destiny.'

The two words were connected, she was sure. She just knew.

'Destiny.' It was hardly the sort of word a little girl would use to her mother. Could someone who knew what these two words meant still be described as a child? She was haunted by them, like the haunting motif of a sonata.

I ought to write down my ideas in my journal, she was thinking, her nose squashed against the spray-washed glass.

But it was not the right time to be writing. She stamped her foot. 'Where's my journal? What have you done with the basket it was in?' She pulled her brother out of his armchair. 'Where have you hidden it? Give it back to me.' She snatched it back angrily, then ran to find somewhere by herself. From the plaited willow basket she drew her leatherbound notebook.

On the opening page she had written its title, in French: *Mon Journal, 1914*. She could just have well have called it 'My friend, my confidant, my mirror', for in it she would find consolation for a world that made little sense, give free rein to her imagination, pour out her emotions, admire herself.

Had she intended, even at eleven years old, to spend her lifetime writing? Her journal shows her as she was: with all her faults and eccentricities. It neither judges nor condemns her.

My journal loves me as I am. As everybody loves me. Papa, can you hear me?

She tried not to think about her father, the Bohemian father she adored and who now was gone. She tried not to imagine him lest she pockmarked the pages with tears, and her journal must not be spoilt. She'd toyed with the idea of sending it to him, as a

letter, the longest she would ever send him. She knew she mustn't cry, she must write.

She propped her journal on her knees, leafed through it, and paused at the entry for the day before. 'Here I am again with my journal. I'm going to talk to it for a little while . . . Everybody is happy, we have reached New York. I am happy too, but I would rather be back in Barcelona really . . .I am eleven years old, I know, and I am not serious enough. Last night I said to myself: tomorrow I will be good. Good? I wasn't any better than I was the day before. I haven't yet thought out how to be more sensible, how to master my impulses and my temper.'

But she had meditated enough; now she had to write down what her life was like, what she could see. The crazy waltz of the tables, the overhead lights swinging like huge censers, women reaching for their smelling salts and retching . . . And beyond the porthole, those glittering lights in the distance, shining from the very core of the skyscrapers, their tops lost in the clouds. She, a young exile, could see an omen in it. A radiant sketch of the future. She wrote: 'I feel different from any other child . . .My hopes, my dreams, my ambitions are all different. I'm thinking of devoting myself entirely to poetry, to writing, not so that I can be famous, no . . . but just for the satisfaction of writing . . .'

The storm had abated. The *Monserrat* cast anchor. The child closed her journal.

[1] *Rosa*

Of the passengers sheltering from the storm in the Tourist Class reading room, Rosa Nin-Culmell was noticeable for her dignified calm, the kind of serenity you find in allegorical works of art. A sculptor seeing her strong jaw inherited from Nordic ancestors, and her bright eyes, might have used her as a model for Justice. For her eyes held you in their steady gaze, they appraised you, judged you.

Rosa was French on her mother's side, descended from the Angevine squirarchy who had been chased out of France and into the islands by the Revolution. In Havana, where she grew up, she was known as 'the Parisienne', so much did this daughter of the Danish consul possess those titillating looks which Cubans characterize as French. And like the other young ladies who rode in their carriages along the Maleçon – the palm-fringed quayside curving round the bay – she had learnt English and etiquette at the Catholic convent of Brentwood in New York. She was well dressed and she knew what she wanted to do: she was going to be a singer. When she met Joaquin Nin O Castellano, her future had that same clearcut certainty: she was going to be his wife.

At first her father opposed the liaison. This obscure pianist's infatuation for his least attractive daughter seemed suspicious. And since his own wife had preferred a rosy-gummed gigolo to him, and had left him with their seven little girls, whose care had been entrusted to Rosa as the eldest, Consul Culmell had little regard for love.

'If I'd listened to him, I wouldn't be here now, past forty, a deserted mother of three,' Rosa murmured, gazing through the portholes at the sharp silhouettes of the skyscrapers.

'Don't worry, Mama, we're here . . . Look at the towers over there . . .'

Rosa patted the bony nape of her daughter's neck. It was useless withholding her feelings, Anaïs had guessed how bitter she was. Perhaps Anaïs's anguish had sharpened her intuition? Perhaps her anguish was what her mother had mistaken for childishness? Every time her father went on tour there were these outbursts: Anaïs always wanted to go with him. He always refused. 'You would make a cheap family show of your enthusiasm.' Without understanding the insult, Anaïs felt humiliated, rejected. She would sob until she got hiccups, which could only be stopped by her father promising to come back soon. 'It's not true,' she would scream. Joaquin would slam the door and go.

'And what about me, what happiness have I had?' Rosa sighed, remembering the soft pinks, the cool blues, the jade greens of the arcaded façades of Havana bathed in sunshine. Palm trees so tall and gracile, like immense verdant giraffes greeting the Atlantic ocean.

There were black women in wide-brimmed yellow hats, streetsellers with blackened teeth peddling coconut cakes, ribbons, sentimental songs (on which Joaquin had poured his scorn). Joaquin despised any music below the level of the *Moonlight Sonata*. Who else would have played Beethoven in the backroom of a music store in Havana? Joaquin was just launching into the allegro furioso when she had gone into the shop to buy some sheet music. He was as thin as a rake, and dressed like a dandy. Blue eyes. Black eyebrows. It had been passionate love at first sight. At last Rosa discovered what love was all about. He was eight years younger than she. What did it matter? He had no money. She had enough for two. A fortune-hunter? No, Papa, he had ambition. He was burning to go to Paris, to the Schola Cantorum to study fugue and counterpoint. Yes, Papa, to Paris. Like Chopin. The consul, tired of resisting, gave his consent to the marriage. He even gave them a piano as a wedding present. It

was loaded on to the liner which left Cuba in 1902. The newly-weds travelled first class. Joaquin swaggered about in an Alpaca suit, smelling of Guérlain aftershave. Rosa sang in her cabin. Paris, her husband told her, was short of singers.

At the sight of her daughter poring over her log-book, Rosa began to regret having kept no record of their first years of marriage. Neuilly, the prosperous suburb of Paris in which we had rented a vast apartment at 7 rue du Général-Honrion-Bertier. Its windows looked out over a group of ash trees. The impromptu musical soirées. The friends we had at that time: Eugène Ysaye the violinist, Pablo Casals a young cellist who, like Joaquin, had studied in Barcelona, Vincent d'Indy, the teacher and mentor who had helped Joaquin perfect his technique.

We played the old composers. We played to the enlightened who were weary of Romanticism. We were drunk on music. Bach, Rameau, Scarlatti. I knew my Scarlatti to perfection. Joaquin used to accompany me. He made no claims to be a genius, in his silk shirts. In his eyes, I was only a woman. But how could I resist that yearning to be a mother?

He would have liked a son. But it was a daughter I gave birth to on 21 February 1903 in Neuilly. Joaquin hastened to my bedside smelling suspiciously of face powder. I told him the sex of the baby; his expression hardened, froze. He stepped back from the cradle, as though about to leave. In desperation, I asked him to choose a first name for the baby. 'Anaïs,' he said. I shuddered. I didn't care for the name, in fact I grew to hate it. It was the name the Ancient Persians had given to Venus; its ambiguity rang like a perverse incantation in my ears. What sort of future was he imposing on his daughter by giving her the name of a temple prostitute? She was baptized on 21 June, and, to have my own say, I insisted on adding the names of three of her aunts: Juana, Edelmira, Antolina.

Anaïs obeyed the oracles. She was an impulsive child, a will o'

7

the wisp who at the age of two draped herself in my stoles and made off down the street, inviting passers-by to come to tea.

She grew into a laughing, round, pink little girl. Joaquin succumbed.

He bought a camera. He wanted to preserve every moment of her. He bought film upon film. I had to leave them on their own. The photo sessions took place in the bathroom. I could hear Anaïs laughing. 'She'll catch cold.' I ran to the landing. The door was fastened. I hammered on it. Joaquin finally opened up. Anaïs was standing naked in front of the swivel mirror. Her father was looking at her. There was a strange fixedness in his short-sighted gaze.

Then, during a short visit to Cuba, everything changed. It was our first time back since our wedding and it was a disaster. I lost my father. Joaquin was unfaithful to me with one of my sisters. Anaïs caught typhoid. The fever lasted for ten days. We thought we would lose her. Her plump, rosy cheeks grew gaunt, she lost her hair. At the age of three, she returned to Europe almost bald. People felt revolted by her, made fun of her. Sometimes she would lose her temper, more often she cried. The poor little thing, so pathetic, so vulnerable – like a tiny bald fledgling with cartilage showing through its skin.

Being the dandy he was, Joaquin felt soiled by his daughter's appearance, cursed even. Perhaps it spoilt his Don Juan image. Was this God's personal vengeance: this child he had cherished, this flesh he had recognized as his own, this dream of womanhood? He found her loving overtures grotesque.

He avoided being touched by her, avoided her begging looks. Until one day he lost all control . . . I can still hear his rasping voice, driven by that same violence, when he could contain himself no longer: 'Leave me alone! You're so ugly.' I can still recall every detail. The ivory comb which held my daughter's sparse curls in a chignon. The blue ribbon I had tied in her hair. Anaïs smiling in the mirror, then running to the library to see her

father. I heard the door creak. Then that outburst: 'You're so ugly!' Silence. A strangled cry. My daughter running back to me, her mouth twisted. She looked a thousand years old.

'Why didn't you tell me I look horrid? Why did you lie to me? It's all your fault.'

I wanted to hold her close, but she pushed me away and scratched me. I felt hated, terrified. I ran into the bedroom where Thorvald, my youngest child, was sleeping, and pressed the weight of his warm little body against my breast.

I should have gone in to Joaquin. I should have rebuked him. How thoughtless can one be – to vent one's feelings against a child whose need to please is just painfully awakening. A precocious child who drinks in every word. How cruel to criticize one's daughter on a point which will remain sensitive all her life, right into womanhood.

But I said nothing.

Because I was jealous. In spite of her illness my daughter appeared more threatening to me than the most glamorous of his mistresses. That may shock some people. People who think the best of everyone. Bigots, cowards. People in a divided Europe, which war would demolish, a Europe from which I was fleeing to America, where all things were possible: where I could live, work, exist in peace, perhaps even love . . .

'Is Barcelona written with a capital B?'

'Yes, of course it is, all names of towns are. You've already been to quite a few.'

Anaïs counted off eight on her fingers: 'Havana, Paris, Neuilly, Arcachon, Berlin, Brussels, Barcelona, Cadiz . . . and New York, soon.'

So, what sort of childhood have I given her? A rootless existence, moving from one town to the next, from one language to another.

I speak to her in French. Her grandmother in Barcelona only understands Spanish. In Berlin, where we went with Joaquin so

that he could finish his music studies, she learnt German with bad grace. I had just had another son to whom, in a moment of aberration, I had given the name Joaquin, like his unspeakable father. For that's what he was, a double-crosser. His affairs, his lies multiplied, he would humiliate me in front of the children, reproach me for anything that came into his head – how I dressed, my hairstyle, my lack of hygiene. Me, a Dane. He made me disinfect his cutlery. He would eat in silence, bent over his music. A feeling of revolt stifled me. Voices would be raised. My cheeks would burn. He would grow livid, start shouting insults; at times he was violent. What demon drove him to beat a cat to death in front of his children? Anaïs was haunted at night by the memory of it.

At that time we were living in Brussels where he had a professorship at the Ecole Royale. Anaïs had started going to school. She soon revealed herself as a rebel, having no friends but her brothers whom she dominated; she was mistress of all their games. She covered a table with a fringed cloth and made herself a tepee; and with a sheet and two chairs a stage set where she was a princess, or a courtesan. I nicknamed her Sarah Bernhardt.

I thought she was play-acting again one morning when she complained of sharp pains in her right side. But her forehead was burning and that put me on the alert. We quickly called a doctor. He confessed he couldn't find what was wrong. Shortly after he left, a neighbour called to warn us that the doctor had told them our daughter would not last the night. Then I thought my husband would go berserk. We had to do something. He begged the help of a friend in Brussels, a surgeon, who diagnosed peritonitis. They operated, somewhat badly. Afterwards she developed adhesions and was in hospital for three months. I used to go there every day, unable to believe that she could cope with her confinement as well as she did. She was writing: poems, little plays, sketches, portraits. Dozens of sheets of paper scattered over the bed. The best pieces were dedicated to her father. He came to

see her one day with a box of coloured pencils. After that she got the idea that she would be a painter when she grew up. She drew non-stop for two or three days. Then stopped and returned to her writing.

In the spring of 1913 I decided to take her to Arcachon to convalesce. Joaquin was renting a Gothic villa there, appropriately named 'Les Ruines', right opposite the great dune of Pyla. Ivy masked the cracks in the walls. The stonework was crumbling round the windows. But there was a huge drawing room where Joaquin frequently gave parties, spurred on by his neighbour, Gabriele d'Annunzio, whose reputation as a seducer eclipsed his own. One evening the great man honoured us with a visit. Joaquin sat down at the piano. D'Annunzio asked me to sing an aria by Caldara, 'O cessate di piagarmi'. It was wonderful. The poet declared that I was his 'divine diva'. Joaquin kissed my hand. What a farce. Not three paces from me was his mistress. A girl, twenty years his junior, who had been one of his students. Blessed with a fortune, of course. As rich as she was insignificant. Maruça. Even now I still can't pronounce her name without it hurting. Anaïs loathed her as soon as she saw her. I'm sure that beneath her candour she had glimpsed duplicity.

On the evening of 14 May, Joaquin announced that an impromptu concert had been arranged and that he had to leave us.

Anaïs detected the lie. As he put his hand on the doorknob, she began to scream hysterically. She clung to his coat, she begged him. Her cries would have softened the heart of the devil himself.

Joaquin disengaged himself and left.

Then a very strange thing happened. Anaïs became very calm, melancholic, thoughtful. She began to work things out for herself: she was the cause of our unhappiness; Joaquin had left us because of her. Now she understood. She had let her father down. She had betrayed his hopes. She had neither genius nor beauty any longer. She was uniquely to blame.

*

'Mama, do they have *turón* in New York?' Anaïs was very fond of this sweet that her grandmother used to give her — a confection of marzipan and pinenuts that you could buy in all the pâtisseries in Barcelona.

Barcelona . . . was a happy period after the break-up. I knew that Joaquin would never come back, there was nothing to keep me in France. So I went to Spain. Only the friendship of Enrique Granados kept me going, for he had promised me a post as a singing teacher; he was director of a conservatoire there. For convenience, I moved in with my parents-in-law, who were ignorant of the real reason for my being there. When Joaquin discovered where I was, he blackmailed his parents to make me leave. But my teacher's salary was enough for me to rent an apartment near the port. We stayed there for a year. Long enough to restore my belief in happiness.

Can you remember, Anaïs, the ornamental balcony where the smell of jasmine made your head swim? And the heat at night? Your sheets covered in zebra stripes from moonlight filtering through the shutters. Children in black stockings hurtling along the streets. And the nuns who taught you at school, with their cornets like huge arum lilies. And that sky. How did you put it in your journal? 'Blue sky, object of my charm.'

Anaïs didn't hear me. Once she was writing, nothing else existed but her hand, her pen, her words. And she used them as though they were creatures with a secret language only she understood. In Cadiz, I had taken her into the Cathedral. Look, Anaïs. Look at those altars, those ciboriums. I'm looking, Mama. But she wasn't. She was sitting on a prie-dieu, writing.

I couldn't blame her. I had given her the notebook in Cadiz so that she could keep a record of our journey, but wasn't surprised when she turned it to more ambitious use. She manipulated me with it, sometimes telling me that she was writing poetry, sometimes that she was examining her conscience in it; and that

she intended to send it to her father. What did she hope to gain from that? Did she think she would impress him, win him back?

If I had not sent her on deck for some fresh air she would never have left her cabin. She wrote without pause. And after seeing a Remington in the officer's quarters, she dreamed of owning one herself.

'My writing is illegible. You're the only one who can make sense of it.'

'Isn't that enough? Your mother reading it?'

'No. I want the whole world to.'

On 11 August 1914, Anaïs Nin disembarked in New York, accompanied by her brothers, Thorvald and Joaquin, and by her mother, Rosa Nin-Culmell. On the quayside, when she saw her cousins coming to welcome them, the girl grabbed her elder brother's violin and held it in her arms. There was to be no misunderstanding: she was the artist in the family.

ANAÏS

Anaïs Nin. Ana is Nin.

 'Ana' (Russian for 'she'). She is Nin.

 In the Name of the Spanish father.

 Tongues intertwined in a name.

 If 'the unconscious has a structure like language', what is the language of this exile of her own tongue?

 Spanish, English, French. Three vocabularies. Three grammars. Three literatures.

 N/I/N: mirror reflections, play of glass.

 Under a Glass Bell.

N/I/N: The 'I' is established in the reflection.

N/I/N: The 'I' at the heart of the inversion.

Anaïs: enclosed?

 Impossible.

 Anaïs: as much Yin as Yang.

 N.I.N. Always between two men (Miller/Hugo, Rank/Miller, Hugo/Rupert).

 Alone.

[2] *Mother and daughter*

In New York, Rosa met up with her sister Edelmira again. She had married an officer in the American Marines, Gilbert P. Chase, and was now one of the most active members of the Cuban community. Edelmira boosted her morale and gave her financial backing, so that Rosa was able to move into a brownstone house at 158 West 75th Street in midtown Manhattan. The place was large enough to rent out some of the rooms, invariably to Cubans, occasionally to friends. After trying unsuccessfully to earn her living as a singing teacher, she settled down to the American way of life, as a purchasing agent – acting as an intermediary between the stores and private customers. She proved to have quite a flair for business, opened an office downtown, became interested in real estate and bought some shares.

The three children were spoilt. Photos of that period show them tastefully dressed – almost to the point of luxury. Rosa used to take them to the cinema, and from time to time they would have an evening at one of the theatres on Broadway. In summer she rented a bungalow on Long Island.

Anaïs was no longer a 'child of the palace' to quote Lawrence Durrell, but the poor child described in her *Journal*: with scarcely enough to live on, creditors at the door, living on tortillas, the cheapest way to satisfy her two brothers' appetites. Was this perhaps a manipulation of the truth by Anaïs, whose publisher wanted her *Journal* to have mass appeal? Or was it a manifestation of her natural inclination towards the tragic?

'Anaïs loved to dramatize,' her brother Joaquin explained in one of his many letters to me. 'Our mother would ask her to darn a stocking, and she would write that there were two hundred of them. She claimed that all her dresses were hand-me-downs from

her cousins. There were some, occasionally. But most of the time, she had beautiful clothes from the best shops. Our "poverty" was all relative. We always had a maid.'

Around 1916, it was Monsita, a half-caste, cordon bleu cook and a fine psychologist.

Monsita's account

What on earth was Madam thinking of when she rented this house with its seven rooms and three bathrooms? It wears me out. If I didn't happen to like artists, I would have handed in my notice long ago. All Madam's lodgers are musicians. Every evening, they sing, extemporize, play their instruments. All the great composers! Chopin! Schubert! It's thrilling. One of the lodgers has a gramophone. Spanish songs, Catalan songs, Cuban songs, tangos. Till it's coming out of your ears. Yesterday evening little Joaquin gave his first concert; he wants to be a pianist. His brother Thorvald plays the violin. The most gifted of all is Madam — she has a golden voice. Rosa Poncelle can't hold a candle to her. Really heroic of her it was, to give up so much talent for the sake of her career. But Madam has three children to bring up. She enjoys business. Buying at the lowest prices, selling at the highest, getting discounts in the shops, making group orders for private customers. She spends the day in her office on Broadway and comes home at night with her nerves raw. Loses her temper for nothing. Or she's sunk deep in depression; can't get out of bed in the morning. We get the doctor, who prescribes tranquillizers. She won't take them, thinks they'll take away all her energy. She only thinks about work. 'I work to forget,' she says to me. 'Forget what, Madam?' She looks at me as if I were stupid and walks away. I've never yet got her to say her husband's name. In this house that skirt-chasing husband of hers is seen as the archtraitor. Anyone who mentions him had better watch out. Only Anaïs talks about him openly when I ask her. To hear her, you would think he was the most perfect man in the world. 'No,

he hasn't deserted us. But he has his career in Europe. He'll come back to us one day.' She defends her father with such intensity. Well, let her keep her illusions. It's her age. One day she'll see that her father isn't God, but a man like any other — though perhaps more of a seducer than most, judging by the photograph Anaïs has stuck on the first page of her journal. She looks like him: a fine nose, shapely mouth, clear gaze. On the photograph he's written: 'For you, my darling children, Anaïs, Thorvald, Joaquin, with all my thoughts. March 1916.'

He's no monster, just completely self-centred, like all men. From time to time he sends the children parcels. He sends Anaïs French books. She claims he often writes to her. Her lie is very touching. When I was doing her room, I discovered a letter she'd written:

Dear Papa
After having written you several times without an answer, I have gone for two months without writing, as your continued silence seems unexplainable and disheartening.

 Sometimes I am afraid that you have forgotten us a little bit . . . Before finishing this letter, I want to beg you to write to me even if only a few lines. They would give me such great pleasure and would let me stop thinking that you have forgotten your little girl who loves you with all her heart.

(*Early Diary*)

In the drawer of her dressing-table, I found other letters just as heart-rending. I wonder if Madam knows they are there? Probably not. She has forbidden all her children to correspond with the archtraitor; which is why Anaïs does just the opposite.

Her relations with her mother are strange. There's as much tenderness as there is defiance. The girl is devotion itself. She does everything to relieve her mother: washing, cooking, errands, fetching baskets of wood, peeling vegetables, mending. She does it all with good grace. Without her, her brothers would be real tearaways. She makes sure they're properly dressed, takes them

to school. In the evening they have to go over their lessons with her ... Her mother says how tired she is. Anaïs begs her to go and lie down: she'll type her invoices for her; she'll sort the cheques and the receipts. Madam has in her daughter the most attentive of nurses, ready to spend hours at her bedside. And yet ... dare I say it ... I feel that this child is exaggerating her feelings. In a word, her adoration of her mother is forced, because she can't bring herself simply to love her. When she's with Madam, she loses all her spontaneity. She weighs every word, every gesture. She studies herself. She's holding herself in check, you might say. She watches her mother and sometimes I surprise her gazing at her with such coldness. Why is she so eaten up with bitterness? Is she blaming her for taking her away from her father and from France – the only place where she was happy? For leaving her to her own devices while she works overtime? For thinking only of money? For giving up singing? For giving up 'art' – a word Anaïs pronounces with relish? For no longer going to parties and bewitching all the guests? For not being attractive any more?

If you look at the photos taken in Europe, Madam had great charm. She's given it up for austere dresses, dismal hats, lank hair. She could afford the best dressmaker. But no, she reserves that luxury for her daughter. She's transferred all her concern for elegance on to her: soft leather bootees, shoes with Louis XV heels, a coat with a fur collar, black velvet hat and assorted jackets, even an ermine for forty dollars. Nothing is too fine for her. You should've seen her, when there was a ball at the Dancing School, in her tulle dress embroidered with pearls. A flower at her waist, silk stockings, patent leather shoes. A princess.

I can see only one reason for encouraging Anaïs to be so conscious of her appearance: to marry her off with all speed, and put this child at a distance, since her looks, her quick temper and capricious nature remind her of someone else ... Anaïs has become the scapegoat. Madam will put up with all kinds of worries from her sons. But one false move from Anaïs, and she's in trouble: 'Bad blood, her father's daughter,' she shouts at her,

which Anaïs doesn't seem to mind. There's love in the confrontation — and in her self-restraint. Madam can hardly bring herself to cuddle her daughter, except when she's ill. Madam listens to her then, kisses her, hugs her. I would swear that Anaïs only falls ill in order to glean a few crumbs of motherly affection.

But here I am chattering away and dinner isn't prepared. Anaïs, come and help me. Madam has suggested we have Paella Valenciana. What are you doing? You can't still be writing that journal? What can you be writing about that's so engrossing? The state of your soul? You'd do better to apply yourself to your homework. If you keep on lazing around, you'll have to stay down a year at school, which won't be funny. You won't learn anything you don't know already! You conceited little girl. Madam has shown me your dictation. You make more mistakes than I do, and that's saying something. You think you're well read? What good is it reading French novels if you can't write your name in English? You loathe English? That's news to me. That's enough nonsense. Come here. Where are your spectacles? You must wear them. They make you look ugly? But not stupid. You're a pretty little sweetheart, you know that. Enrique Madiguera, our violinist on the first floor, can't praise you enough. Look, she's blushing. Wash that ink off your fingers. Take a basket. Look at her. Always in the clouds. Wake up, Linotte, Miss Featherhead, a good name for you. See if you can find some onions in the cellar, and don't forget the basket. That child reads too much. After a while, reading turns your brain. She has registered at the municipal library. She's made up her mind to read every book in it, systematically, starting with A. A whole lifetime wouldn't be long enough. Anaïs claims that a book makes her day. Her room is full of them. Madam hardly has time to look in there. Anaïs reads everything that falls into her hands. Enormous books, books with no pictures. Too much reading, I say, will make your head explode.

'My head is the most extraordinary object that God could have placed on my two shoulders.'

What a thing to say, I'm lost for words.

[3] *Ardour*

This might well be the title of the *Early Diary*, notebooks in which she confided her most intimate thoughts. The first of these books is written in chaotic French, in such perfect, painstaking handwriting that you can sense the pressure of pen on paper.

It opens with an anthology of thoughts, portraits, poems, photos, sketches – often mocking ones – drawn with sharp, nervous, lively strokes. She saw too much. She lived too intensely, and yet she wanted even more of life.

Anaïs's vocation as a writer is evident in one quality she possessed from an early age, undiminished to the end (though it became more refined): fanaticism.

Excitements, discoveries, enthusiasms, yearnings of the soul, pins and needles in the body.

> 'Ah if only I were strong!
> Ah if only I were tall!'

'I'm shaking, I'm trembling, I'm clenching my fists, as I recognize that I'm not even the size of half a grain of sand. I'm so tiny.' (*Early Diary*)

Her style came from her manner of viewing the world. The way she uses the first person is disturbed, manic, intoxicating. Exclamation marks abound on every page. Writing was her way of holding on to life.

'It is more than a week since I wrote last. And there I was hoping that I could write down what I did every day, hour by hour, minute by minute.' (*Early Diary*)

If you had only ever seen the faded snapshot of her on the cover of the French edition of the *Early Diary*, you might be

forgiven for thinking that Anaïs suffered from melancholy. It is as though she were veiled in crêpe, the sort of photo you find in an enamelled oval frame on gravestones in France. But melancholy was only one part of her nature. She was also 'Linotte', scatterbrain, actress, steel humming-bird, headstrong fusspot. In the labels people gave her at that time beats the heart of a child: one who chose as her idol the French girl, the fiery girl-soldier, the patriot, Joan of Arc.

'Ah Joan, how I love you, how I admire you, oh why did you depart this earth? See the dangers into which the glory of France is falling, save her.' (*Early Diary*)

Joan of Arc was heroine for a child deprived of heroes, an exile's coloured picture.

France was at war, and Anaïs dreamed of returning there to fight; instead, all she could do was knit scarves for the soldiers, or compose poems to the glory of her country. God promised mountains and marvels; she implored him to send her absent father home. She would go to church in the hope that her prayers would be heard, fainting in the scent of lilies, invoking a Father whom she truly took for Papa:

'I took communion this morning, and I have Jesus in my heart. My communion was just for Papa. I said "Papa" over and over again, what a beautiful word.' (October 1914)

'This morning, at communion, I simply murmured: "God—France, Papa."' (April 1915)

She felt uplifted, sublime, beloved.

Every writer has his own brand of mysticism. Anaïs had developed hers very early on, a blend of prose and poetry, the sacred and the profane, dream and reality, pleasure and pain: making a paradise of France, and of her father a God.

This first sequence of chords sets the themes of later journals.

A page from Anaïs Nin's *Early Diary*

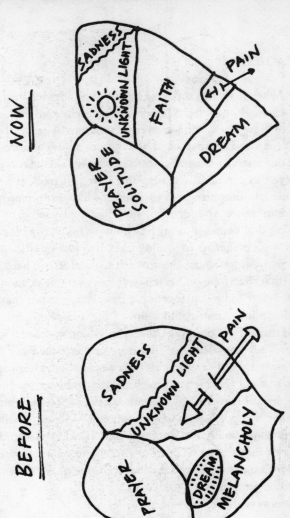

[4] *Cousins*

In 1919, when Rosa was suffering from nervous depression brought on by overwork, they left Manhattan for Richmond Hill, a green suburb of New York, connected to Manhattan by ferry. Rosa had found a redwood clapperboard house, with a bow window which opened out on to a garden. Squirrels gambolled on the roof. 'As far as the eye can see,' Anaïs wrote, 'there are just trees, trees, trees. Here I can philosophize or say whatever I like. I can reason like a poet. I can waste as much ink as I please. I can write. Write everything that comes into my head. I have ink in my blood.' *The Delineator*, a magazine for young girls, had just published one of her poems. Was it because she now felt so confident in her future as a writer that she broke off her studies? Rosa was weak enough – or wise enough – to be convinced: her daughter was not made for a life of discipline. Anaïs could follow a literature course as a non-enrolled student at Columbia University. Alone with her books, she developed her knowledge of literature and enriched her imagination. Anaïs was self-taught: a fact she would always be proud of.

After reading the French novelists, she went on to the moral philosophers: Emerson and Marcus Aurelius, Rousseau and Thoreau; then the poets – mostly Romantic – Keats, Shelley and Lamartine, and finally the diarists. Pen in hand, Anaïs studied the journals of Eugénie de Guérin, of Amiel and Marie Bashkirtseff, against whom she measured the literary value of her own journal. It had to be written as a work of art.

She was seventeen.

'I sometimes wonder if you realize how much we have changed?' she wrote to her father. 'Joaquinito is really tall already . . . Thorvald looks like a man, although he is only fifteen, he's strong and taller than I am. And I am now a young woman.

I wear my hair in a chignon, because I feel so very serious. I was anaemic and shy when I came here. But I am thin no longer. I'm svelte, still a bit shy with strangers and men, but very communicative.'

This is the adolescent whom her cousin Eduardo Sanchez met. Eduardo was two years older, the son of one of Rosa's sisters who had married a rich Cuban cattle-breeder. 'The first boy I fell in love with,' Anaïs would say.

Joaquin Nin-Culmell remembers him at that time as a boy who was 'sensitive, a dreamer, a storyteller – a weak person. Anaïs was the sister of Eduardo's dreams, sensitive, artistic and a storyteller like him, but stronger-willed.'

For this handsome, languid young man who could have stepped straight out of a novel by Maurice Sachs, she decided to give up French, which she spoke badly anyway, and write her journal in English. Later, in 1930, she would meet him again in Paris and, on his advice, she would embark on her psychoanalysis with René Allendy

Eduardo Sanchez proclaimed to all and sundry that his good looks were his downfall, and that he would have been happier if his mother had not lavished on him all the attentions that were due also to her six other children. By too much mollycoddling, she had rendered him helpless. Who could have guessed his distress? He pretended an aloofness, a certain good taste, a subtle form of egoism, a need for luxury and disorder. He read: more good books than bad. He held opinions he hastened to forget. Young women admired his beautiful hands: he did his best to keep them white.

He had no intention of succeeding his father. The idea of having to go to the slaughterhouse every day repelled him. As an excessively delicate young man, he was drawn to others who, like him, were attracted to all that glittered; they were always boys.

Anaïs turned his life upside down.

He would never forget that summer of 1919. His aunt Rosa,

who had just acquired 620 Audley & Curzon Place in Richmond Hill, a house with a veranda and surrounded by pines, had invited him there for the holidays. He was bored in Cuba; he had never met his cousin; he accepted.

His sole knowledge of Anaïs was based on one photograph taken at Richmond Hill, on the porch. She was lying in a hammock, reading. She looked so serious, almost surly. At Kew Gardens Station, he did not recognize the beautiful young woman walking towards him. She had huge eyes, black eyebrows, full lips. His gaze had lingered on that sensitive mouth, those lips that she used to bite to make the blood run into them and deepen their colour, like after a kiss.

In his confusion, he said in bad French, 'Hello, kitchen' (instead of cousin). She had shrieked with laughter. Within a few days they had become inseparable. They shared the same reading, they went to concerts together. They talked about their ambitions. He wanted to be an actor, she a writer. She had no doubts, no uncertainties. For a vacillating creature like him, her determination amazed him. Who had made her like that?

'My father. When he left us he threw me a challenge. It was to win him back. And I have only one weapon: my writing. Without that I'm nothing. An ordinary young woman.'

'What about your looks?' he couldn't help blurting out.

Anaïs shrugged her shoulders. 'My father's surrounded by beautiful women. He doesn't trust them.'

'But you're different. You're his daughter.'

'Do you think so? I feel I'm more like his double: a female incarnation of his shortcomings. I despise the simple-minded, just like him, and I have the same self-centredness. I can't stand stupid people and bad smells. I like to be the centre of attention, to be the first, to be the only one. How can I see him as a father? I don't even know what his voice sounds like. The photos he sends me are taken from concert progammes. There's nothing intimate between us. His letters are artificial. I feel they're an effort, while

I could spend all day writing to him. Telling him about my life and showing him . . .'

'Showing him what?'

'That I'm an artist as well. I have a vocation: literature. I have an obsession: I want to make myself heard, understood, loved . . . Why d'you suppose I keep a journal?'

'So that you can remember things?'

Anaïs laughed at his banality.

'I began it as a letter to my father. Now I want to make it a letter to the whole world. I want one country after another to read it, I want it to pass from hand to hand, and I want it to touch every mind with the same intensity as created it.'

She had taken him into her room to show it to him. Hers was the largest room in the house, the walls in a delicate pastel shade, knick-knacks on the mantelpiece, a canary in a cage. It was just like any other young girl's bedroom, except for the portraits of writers hanging on the pale blue walls. Eduardo recognized George Sand, Alexandre Dumas, Alfred de Musset. A dressing-table with three mirrors stood by the window. Instead of combs and trinkets, it was strewn with books, ink bottles, penholders.

Anaïs used to write sitting in front of her mirrors. Not because she was obsessed with her appearance, but rather because of anxiety. 'I don't admire myself,' she maintained. 'I need to reassure myself that I exist, that the feelings I confide to the page have aroused a real body, brightened a real face, flushed a real skin – mine. Your identity gets lost when you do a lot of writing. You fade.'

But which panel of the mirrored triptych did she look into, wondered Eduardo. The central one reflected an anxious Madonna, the left showed up the little bump on her nose, the 'grave accents' of her profile. In the right the child had given way to a woman conscious of her charms, with sharpened teeth, ready to bite.

Anaïs smiled. She told Eduardo that he was the only one to take her seriously. When she went to Columbia University to put

her name down as a non-enrolled student, for the literature, philosophy and psychology lectures, she was turned down because she was under-age, they said. A child? Only in appearance. She would show them: she would go back wearing lipstick, a silk dress, French shoes and a crocheted hat.

Her journal betrayed those same ambiguities. Eduardo was disconcerted by it: girlish babble followed by maxims. Both profound and trivial, it jumped from one line to the next, from grief to intense excitement, from Chaplin to Bossuet, from carefully constructed classical sentences to lightning images. Eduardo had never read anything so liberated.

Anaïs was not constrained by any model. The writers on her walls did not intimidate her. She listened exclusively to her own voice. She listened a great deal. But she knew how to observe other people and read their innermost thoughts: 'Fine features for a boy; with blond hair and eyes difficult to describe. There are in them a thousand things I cannot name, for the eyes change with his thoughts and feelings. They have their way of enquiring, of dazzling, of hurting.'

When Eduardo read his portrait, he took fright. Anaïs had unmasked him.

Now that for the first time he was not in love with a copy of himself, but with a young girl, almost a woman, he invented a romantic idyll with a débutante in Havana. He distanced himself from her. His family was delighted. In his father, Barnabé Sanchez' eyes, Anaïs was a pretentious girl with enough spirit to make a husband unhappy. Under her influence his son had become even more disturbed.

Anaïs's mother was also satisfied. The attraction that her daughter had shown for her cousin had always irritated her. He was not the man she needed. Hugo Guiler, on the other hand . . . a perfect background . . . excellent education. For this tall, dark-haired young man with his boy-scout smile, the door was always wide open.

28

BEAUTY

At an age when most little girls are playing with dolls, Anaïs was already cultivating the art of seduction: 'My father was always taking photographs of me. All his admiration came through the medium of his camera.'

' "Oh, you're ravishing . . . ravishing," he used to say. It was the only time we spent together.' To exist in the Name of the Father, she had to please.

When he left, Anaïs blamed her ugliness.

As a child she thought she could never be beautiful enough.

Perfect enough – like an icon.

At thirty she had her nose straightened.

'Always treating the flesh as a mask.' (*House of Incest*)

She fashioned her own mask: eyebrows plucked to a thin line; kohl around the eyes; mouth sealed with red lipstick.

At thirty-six she had the gap between her front teeth reduced.

At forty, there were weekly sessions at Elizabeth Arden that made her look thirty, but her doctor saw only ardour.

At fifty-three, she wrote that we never forgive a woman for growing old: 'The sadness [is] that a woman aging is like crushed satin.'

She proceeded to have her first face-lift. The Eastern influence in her name began to take over her face. It became smooth and powdered like a Noh mask.

With the second face-lift her cheekbones were raised, all facial hair and its roots removed, so that her face became like a bare beach under the glare of the photographer's flash. Glazed with the eternal youth of an idol.

[5] *Hugo*

Anaïs who, towards the end of her life, came to extol free love, was only eighteen when her thoughts turned to marriage: 'When I feel weak and discouraged, I feel I would like to rest my head on a husband's shoulder.' But her ambition went further than that.

'I want to marry a genius,' she announced in tones reminiscent of Lou Andreas-Salomé, a character she would later add to her pantheon. Like her, the muse of Nietzsche, Rilke and Freud, she wanted to make the most of herself by finding a man who would satisfy her 'thirst for books and for encounters', her 'immeasurable need to know, to understand.'

As a fatherless girl, she was looking for someone to master her – and to give her freedom. Rosa's bitterness as a betrayed wife, the anxieties she had running a more or less flourishing business, her tempers and her strong character did not make her an easy mother. She exacted a great deal from her eldest child: love, obedience, moral support as well (one might be tempted to say 'more than anything else'). Anaïs was suffocating.

On 12 March 1921, shortly after her eighteenth birthday, she met Hugh Guiler – Hugo – at a ball organized by his parents. His father, Hugh Cheyne Guiler, was from a Boston Irish family, and they had recently moved to Forest Hills, after managing sugarcane plantations in Puerto Rico. Hugo had spent the first seven years of his life there, before being sent away to school in Edinburgh. He was almost European – the sort of boy to attract an inconsolable exile like Anaïs.

Hugo always knew when his mother was going to cry: she would start scrunching her blouse with her hand and he would find

himself disarmed in advance. He put down his coat and sighed, resigned to dining at home. He would spend the time revising for his management course: it was more sensible.

'Why are you smiling?'

'I'm not.'

Mrs Guiler's hand moved up to her blouse again. She was a big woman with anxious eyes. When they had lived in Puerto Rico and she had been someone in society, she had looked quite youthful.

'You most certainly were smiling . . . Hugo, just give me a straight answer . . . What can you see in her?'

He ought to have picked up his coat and slammed out. The same litany, the same tearful blackmail about a name: Anaïs. It wasn't her fault if he loved her. The heart has its reasons which are quite unknown to the head, some philosopher had said. Not that his Protestant mother would understand.

'Believe me, Hugo, she is not the right wife for you.'

'I wasn't intending to marry her.'

Her face crumpled like a little girl's.

'Guettie, why lie to your mother?'

When would she stop calling him this? At twenty-three he wasn't a silly boy any more. He wished he'd had the luck to be born thick-skinned. Then he'd be free to hate. He had a thousand reasons to detest this woman who watched over him so dotingly.

She had massacred his childhood.

Remembering the Eden where he had lived half-naked among the slaves' children, Hugo found it hard to overcome his sense of pain. Puerto Rico, for him, was the most beautiful of all the West Indian islands, a place where the hills merged with the clouds and the wind was as warm as a hand on his brow. At Carnival time when he would celebrate with the natives, he would slip his hand into his father's: '*No tengo miedo . . . pero dame tu mano*,' he would say: I'm not afraid, but hold my hand.'

She had massacred his childhood, tearing him away from the embrace of laughing nannies, who joined in his escapades, to

throw him and his brother into school in Scotland: a prison. Beatings across the back of his knuckles with a ruler had turned him into a timid boy, haunted by a horror of sin. He had gone there for an education: instead, they had inculcated fear.

Sixteen years later she still stuck to him like glue; he finally understood what losing happiness meant.

'Believe me Guettie, she can only be your downfall. Mama is never wrong.'

In 1912, after he had been educated and turned into a young gentleman, he went home to his parents in Forest Hills, near New York. Family life seemed pleasant. He did not allow himself feelings, caught as he was between his mother's desire to reconquer her son and a father who projected on to him all his own failed ambitions.

They had his future mapped out as a businessman or a banker. America had made vast profits out of Europe during the war. It was possible to get rich in no time at all. In 1916 he enrolled at Columbia to study economics.

'Haven't you noticed you've a button missing on your coat? Guettie, I'm talking to you.'

He had a thousand reasons to hate her, yet never felt more than irritated by her. It was the same with other people. His feelings seemed to be colourless, as if his heart were filled with water instead of blood. Aware of his weakness, he had felt crushed ever since he had come to know John Erskine, a successful novelist who taught literature at Columbia: he was the epitome of charm, elegance and authority, and possessed a powerful voice which thrilled the female students and fascinated the male. Hugo had been impressed right from the first lecture. He had waited for the room to clear before approaching the podium. Erskine had liked what he said. They saw each other again. Erskine took pleasure in guiding Hugo's passionate enthusiasm – Hugo was writing poetry between his economics lectures and games of tennis. Hugo thought that Erskine had saved him from the mould into which

his family were trying to force him. Without Erskine, he would have been an 'egghead'. Erskine had his total admiration. His cigars, his hats, his gaiters: magnificent. His novels: masterpieces. His style: faultless. His heroes, sculpted in marble. And their creator was like them. Erskine never had doubts; Hugo was deceived by his self-confidence.

When Hugo looked in the mirror, he wondered how that solid assemblage of muscle could harbour such a vulnerable soul. How long he suffered this illusion we don't know. Everyone considered him to be exactly the type America needed: a strapping young man with broad forehead, big shoulders, big ambition. He had been a tennis champion, and he had come first in his year; now he had just won a competition run by the National City Bank which was recruiting managerial staff for its European agencies. They had considered him worthy of representing his country. His sisters jokingly called him 'the ideal son-in-law', which made him furious. He had no wish whatever to get married. Until he met Anaïs.

He barely knew her when, at his parents' invitation, she came to the ball they had organized in celebration of his new job. All the young ladies of the neighbourhood had hastened to the Guilers', eager to please the young man at the centre of the celebrations.

Anaïs arrived chaperoned by her mother. Hugo had been struck by the contrast between this beauty with China-doll eyes, perfect from her carefully dressed hair to her tiny feet in their tight court shoes which matched her dress of pink tulle, and the woman who accompanied her. Mrs Nin looked every bit her forty years, with a dark dress tailored to make her look slim. It was hard for anyone to believe that she had shared the life of an artist in Paris, or that she had owned furs and jewels, so much did she appear to have renounced everything that in the past had made her desirable.

She adored her daughter. That was obvious. Anaïs couldn't keep still, and as soon as she got up to walk around, pain spread

across her mother's features; she looked ten years older . . . You had to have a nasty mind to listen to the tittle-tattle about her: people said that she was a divorcee. And a feminist. That she left Anaïs to her own devices. And they told even more tales about her daughter: she had left school on a whim; she liked to think she knew a lot about philosophy – Anaïs did not mind people saying that; she lived on raw apples; someone had even seen her not far from Pennsylvania Station, *alone* in a café. It was time a husband tamed her restless spirit. A husband: he could be that very young man. Even before he led her on to the dance floor, he had felt he was meant for her.

He asked her for the opening dance. Pink with embarrassment, she turned to her mother. Mrs Nin smiled at the boy: 'Look after my daughter. But take care: she's an eccentric.' A chatterbox, yes. He thought he had made her dizzy in the one-step, but it was she who had intoxicated him with her chatter. With another girl he might have felt uncomfortable: with her he was walking on air. She had a mind . . . and she knew how to use it. How many young women would discuss Emerson in the middle of a waltz? 'Even the look of a book – a little book bound in soft leather – gives me a shiver of satisfaction,' while he marvelled at her small waist. 'I read the essay on friendship, magnificent in spite of its characters, and the one on love, which is sublime. How suited he is to the subject matter . . . But just because I admire him doesn't mean I follow his philosophy. I completely disagree with him. Don't you?'

What had he replied? Some stupid remark. The 'cream' of Columbia had never felt so uncultured as face to face with this self-taught girl. Not knowing which book to choose at the municipal library, she had proceeded in alphabetical order. 'You don't believe me!' 'Of course I do,' he had protested. 'Prove it to me.' She had tightened her grip and fixed him with a burning look of challenge.

Hugo, in love, put himself to the test. He did not come forward for two months; he contented himself with glimpses of her as she

went with her brothers to their tennis lessons or accompanied her cousin Eduardo who strutted about like a turkey-cock. How could she choose to be with a vain creature like that, a man who sought to impress the world with his gold cufflinks? She seemed susceptible to appearances, and to luxury. She was the most touching of girls and at the same time the most frivolous.

'Anaïs is not like other girls.'

'That's just what's wrong with her. I'm told that she writes.'

'Yes, she does.'

'Good god, what has she got to write about?'

'Her emotions.'

Mrs Guiler shrugged her thin shoulders. Other people's feelings always left her cold.

Anaïs had not yet shown him her journal. 'All the best of me is in it, like a treasure chest belonging to someone who will never grow old; in it are things that will never happen again, and it will preserve them for ever.'

Had she kept the memory of that day in June when I knocked on her door, a book of John Erskine's in my hand, wondered Hugo. We talked on the veranda and walked through the fields behind the house. Then there was an open-air concert at Columbia: our first evening out. Then dinner at the Bossert Hotel; we danced on the terrace; the sky over Brooklyn was so black we looked for the stars on the ground.

His mother drew him out of his reverie. She wanted his overcoat to sew on the missing button.

'Did you know she's broken off her studies?' she asked, bending over her work-box. 'She's got it into her head that she wants to work.'

'Her mother's living from hand to mouth. It's right that Anaïs should be helping her out.'

'By posing as an artist's model?'

35

'I know all about that. She goes to the Women's Art Club once a week.'

Anaïs had been beside herself with joy. 'Can you believe it, I've had the most wonderful luck,' she'd told him. 'It's so happens that the Spanish look is in vogue right now. Some painters even think I look Persian, Byzantine even.' She had suggested that he accompany her, but he had thought it best to leave her alone. She valued her independence.

'Well, she's changed her workplace,' Mrs Guiler replied. 'She's been let loose in town near Washington Square.' Had Anaïs told him she was posing in only light clothing for magazine illustrators?

Hugo did not know what to say. He was suffering. His mother was deep in her mending; she had attained her goal.

He could not bring himself to accuse Anaïs. He envied her. She reminded him of himself as a child in Puerto Rico, hunting crabs on the beach, vying with his brother in daring. Once more he saw himself naked in the sweltering heat of late afternoon. The memory of those stolen moments, of the hour when black people came home from work, made him flush with shame . . .He had been filled with fear. He was impotence itself, while she was desire. In her black velvet dress, he had desired her. He had not touched her. He had forbidden himself such overtures, but had others made them?

Mrs Guiler was singing to herself.

[6] *Model*

'I pose for painters who have studios round Washington
Square, and for others who are on their own further out . . .I
see my face on magazines at kiosks. At an exhibition, there
were two portraits of me, and one had won a prize.'

(*Early Diary*, February 1922)

Of one thing Anaïs was certain: she was beautiful. Recognition
came not just from boys but from artists. It was one more victory
in the war against her father. And by earning her own living, she
was asserting herself against Rosa. She was almost free.

Forty years later she was to say that this period in her life
marked her first real confrontation with the world. It was when
she discovered she was not ugly – 'a very important discovery for
a woman'. Strangely enough, in her late fifties, she claimed she
hardly remembered this time in her life at all, that working as an
artist's model had seemed hazy and unreal. She recalled that she
used to cry about it, that the situation was painful and disgusted
her, but also that it gave her a certain pride. 'However, it was as
though it was happening to someone else.' An expedient attack
of amnesia for a writer deep in her autobiography. The interest
she took in events of that time was that of a writer recognizing
good material, she added.

In 1941 she was commissioned by a collector to write some
erotic stories. They were published only after her death. In one of
these stories, 'Artists and Models', the setting is a studio in
Washington Square. It opens: 'One morning, I was called to a
studio in Greenwich Village, where a sculptor was beginning a
statue . . .' It is one of her rare stories written in the first person.

37

Anaïs is deceiving the reader. But what about? Fantasies? Memories? I have opted for the latter.

A dollar an hour. Today I shall earn four dollars. Four hours of posing seems like forever. At the Women's Club I used to get pins and needles in my legs after twenty minutes. You must not move or smile. My father always told me to keep my mouth closed because my teeth were not good. Those sessions with my father . . . I was three at the time . . . We would be in the bathroom together with the door locked.

My father was short-sighted. His eyes were invisible behind his own thick lenses and the lens of the camera: a double wall of glass. I could not see his eyes looking at me. I was petrified.

He used to make me pose for him naked in the bath. Click, click. I would get goose pimples. I didn't dare put a towel round me in case he stopped photographing me. For these were the only moments when I felt I was real to him . . . At the end of the session he would call the maid in to dress me. He never touched me or held me in the way a normal father would. A father? No, he was just a man I had to please.

In order to please, I had to please everybody. I had to seduce everybody. Could you call it coquetry? It was more like necessity. Through pleasing people I proved that I existed. At the Women's Art Club, they said I was wonderful. Women lie.

The idea of Anaïs becoming a model had come from a friend of Rosa. Rosa had at first opposed the idea, then allowed herself to be persuaded. Her business was shaky: she was not going to complain when her daughter brought home her first dollars. For the ladies of the Women's Art Club, painting was on a par with knitting: just a way of passing the time.

But Anaïs got bored very quickly. She wanted to be with real artists. And so she entered a beauty competition. Her face was made up, bringing out her best features, her hair put in a chignon, and she was decked in a panniered dress and straw boater

trimmed with flowers, copying a painting by Greuze. She won first prize and was given a professional contract as a model.

Her first appointment was in Washington Square, among the cafés and dance-bars. As she ventured alone into Greenwich Village she felt that life was really beginning. She was earning a living: a dollar an hour. She was wearing her black velvet dress. It was rare that studios had any heating. The nearer she came to her destination the more her cheeks began to burn. She was defying a taboo. But she had the feeling that she was acting in closet accord with her own nature, by having a secret life. She wondered what the painter who had asked her to come would look like, whether the model agency had made it clear that she did not pose in the nude. Did the painter know? Several times she was tempted to turn tail.

She had to stand on tiptoe to ring the bell. She felt like Jack meeting the Giant. The man who opened the door to her was hairy, with a thick beard. He was chewing on a fag-end. She began to wish she had not come. He looked her up and down. How tall was she? he asked.

'Five foot one.'

'I'm not a miniaturist.'

His voice was heavy with tobacco and alcohol. She could still have left. But hadn't she written in her journal something about always choosing the most dangerous alternative, for it carries with it the most unforeseen possibilities?

She went inside. In the centre of his studio stood an unmade bed, on whose dubious sheets lay some women's clothing. The painter picked up an Andalucian costume and pointed to a dark corner of the studio.

A fringed curtain concealed a lavatory, a small stove on a table covered with foodstains. Where was she to put her handbag and her hat? On that stool over there. She flicked off the dust, and undressed while the painter busied himself, clanking things about. The noise was reassuring. 'How old are you?' he called out.

'Nineteen,' she said as she adjusted the dress. It was too big.

The least movement revealed her chest. No man had yet seen her breasts. Not even Hugo. What would he say if he could see her here? He could barely tolerate her modelling for women. 'One never knows.' 'Never knows what?' He hadn't answered. She detested unanswered questions.

She found some pins in her bag and fixed the dress. Now she was ready. The painter gave an appreciative whistle. No one had ever been quite so open. Except her father. She felt cramp in her stomach.

'Let's have your feet bare. The *Saturday Evening Post* has asked me to illustrate a 'News in Brief' item. You're the murder victim . . .'

It was easy. When it came to screwing up her face in agony, she was unequalled. She could weep on demand. At home they'd nicknamed her Sarah Bernhardt.

'Oh yes, I do like feet with nicely spaced toes, like the fingers on a hand. Do you have a special friend? You're so pretty.'

Yes, she had a special friend: her journal. She went to it instinctively for the sole pleasure of touching its dog-eared cover. A current flowed between her fingers and its pages, drawing her to the table like a magnet. She was conscious only of the progression of her pen scratching the paper. If someone had tried to kill her then, she would not have noticed.

Men scarcely listened to you. They wanted you for themselves. At the ball Hugo's parents had organized, he had forced her to dance in step with him, even though he could not dance in time himself. She tried to guide him, which had made him tense.

I shouldn't be thinking about him in a place like this – the epitome of everything he loathes: untidiness and Bohemianism. But when your body is forbidden any movement, your mind begins to wander. I can see him now, hailing me from the steps of 620 Audley Street. I was on the porch, reading. I hadn't seen him since the ball. 'My family's away in Europe for a while. I'm living at my uncle's, just on the corner of this street. We're almost

neighbours. I would never have forgiven myself if I hadn't come by to say hello.' His voice was self-assured, virile. I said nothing. Maman saved the situation by asking him to come in. She left us alone. Hugo inspired confidence in her. He was less imaginative than Eduardo, and seemed more mature to her. He came back next day with a bunch of flowers for Maman, and won her heart. Ever since, she has dinned it into me that Hugo is my chance of a lifetime. She must be right.

Maman gave us permission to stay out till midnight. Hugo took me to Greenwich Village to a restaurant where they had dancing, a cramped barely lit night club, with just a few tables where couples sat sipping gin fizz. I dared only have an orange juice. Under the careless gaze of the jazzmen we ate each other with our eyes. He accompanied me home at the prescribed hour. He did not kiss me. He examined my hand, murmuring that he saw infinitely beautiful things in it. I almost cried out: 'Make me forget Eduardo.'

How can I be attracted to two so wildly different men? Eduardo is blond, Hugo dark. One is a sedentary sort of person, the other sporty. One is Cuban, the other almost English. He has that reserve that sometimes almost edges on coldness. Eduardo encourages me; Hugo holds me in check. Eduardo is a playboy; Hugo seems incapable of being unfaithful.

The painter embarked on his third study. She dared not breathe for fear of interrupting the progression of the charcoal across the canvas. Her right sleeve had slipped from her shoulder. With one stroke the charcoal sketched that sleeve.

Hugo has only one defect: he is not creative. Logic always takes precedence over imagination with him. The National City Bank organized a recruitment competition, and he entered for it. He was wild with joy when he was accepted. They have offered him a post in one of their European branches. Possibly Paris. Paris, where her father was living . . . If he chose Paris, she would agree to be his wife. Anaïs Guiler . . . Guiler, Anaïs . . .Impossible.

The surname clashed with her first name, its guttural sound swamping the murmur of the vowels. Anaïs Guiler. Something inside her rebelled: marry Hugo, yield to yearnings aroused by a stranger? Perhaps she should hold herself in check, renounce her ideal, give up, lose the challenge her father had thrown down . . . Anaïs Guiler. A woman just like all the rest. His daughter. She must not think about it any more. Just be a body, a docile doll. An object to be fingered. She let the smell of turpentine intoxicate her as she inhaled it and it wound its way into the innermost recesses of her brain.

He was touching her thighs. The painter was wrapping them with a sheet he had drawn from the bed. He placed his red-haired hands on her body. She turned her head away to avoid his breath, the strong smell of his smock, sweat and tobacco. She had never felt so dirty as now. But she felt no sense of shame. She wondered what she would do if he tried to kiss her. Nothing. She felt free, excited, like a child suddenly understanding that words have meanings.

COSTUME

Her sixteenth birthday: shoulders veiled in tulle.

Barely covered in crimson velvet at nine o'clock on a midwinter's morning: as she models for a painter.

Dressed like a 'Russian princess' for her first session of psychoanalysis.

Donned in red, black and steel grey, a new sort of Amazon to meet Antonin Artaud.

'At Villa Seurat, wearing my red Russian dress': Allendy's couch or Miller's bed – the same dress for the same game: seduction.

Wearing a grey tailored suit – no nail varnish, no earrings: as she listens to André Malraux at a meeting about Spain.

Decked in a black velvet cape, with a red lining, on the café terrace of the Deux Magots: waiting for an admirer.

Swathed in a nunlike dress as she travels from campus to campus preaching her fine words.

Caparisonned in dark wool, at the bedside of a dying woman.

Not only did Anaïs dress up: she donned a disguise.

She dressed both for show, and to protect herself.

'Men always believe in my disguises.'

Hers was the ritual of an actress, of a courtesan, of a prostitute.

Three species of woman: one who lies, one who flatters, one who sells herself. Three temptations for Anaïs.

Pleasure, treachery, fantasy. But also: revenge of a misunderstood writer.

Because no one listened to her, Anaïs chose to express her eloquence through her body.

[7] *A married woman*

Anaïs Nin became Anaïs Guiler on 3 March 1923, in Havana. No photograph of the wedding has ever been published, not even in *Journal of a Wife*, which only at the time of its publication in 1983 – six years after Anaïs's death – revealed the existence of Hugo Guiler. Was it Anaïs's intention to wipe this hidden marriage out of existence? For this marriage *was* spirited away. Neither the Protestant Guilers, with their narrow-minded opposition to their son's marriage to the daughter of a Catholic, the daughter of a woman separated from her husband, nor Anaïs's father were present at it. Stranger still was the absence of Anaïs's mother Rosa: 'My mother was somewhat surprised at the speed with which everything had been arranged,' Joaquin Nin-Culmell explained. 'Somewhat disappointed that it was all done without her. Somewhat jealous of the role her sister played in this marriage.'

In Havana, Anaïs's godmother, Aunt Antolina, dressed in purple satin and played the part of merry widow. People loved her parties. They envied her her lovers. She loved love too much to see it sacrificed. When she learnt that the Guilers had bundled their son off to Europe in the hope that he would forget all about Anaïs, she invited her god-daughter to stay with her. Anaïs arrived in Havana in October 1922. She left as a married woman.

Antolina's account

She was like a convent girl – very well-behaved, in a grey costume and white blouse: that was what Anaïs was like when she disembarked from the boat and threw herself into my arms to show me how grateful she was.

44

'So nothing is fixed. Hugo is biting his nails in Europe. His parents won't hear of marriage. But to read your letters, it seems to me that you are your own worst enemy.'

On the journey to the Finca, she never stopped saying: 'Oh Godmother, Godmother', and gripping my hands tightly. Her own hands were icy cold.

Her last letter had shaken me. She'd said that Hugo had embarked for Europe, that he'd been in a very depressed state and that his efforts to establish her with his family had come to nought.

'An hour before he left, I suffered as never before,' she wrote. 'He telephoned me to hear my voice one last time. My last words to him were: "Be happy." Until that day I believed that I loved Hugo more than myself, and I was ready to sacrifice everything for him . . . I was torn between the desire to say to him: "Leave me. I have a greater duty to perform," and to cry out "I love you". Aunt Antolina, do you think I'm asking too much? Hugo is human. Just human. And it's the human element I reject in others . . . I have no one I can confide in . . . Maman already has enough on her hands with Joaquin and Thorvald. I often think I ought to marry a rich man who would provide for them all.'

I know my niece. She might, out of despair, let herself be led to the altar by a rich fat Cuban. Disgusting. So I cabled my sister, asking her to send me the unfortunate girl as quickly as possible.

The moment she arrived, in the cool of the evening when the balmy air releases a scent of fresh fruit, she seemed to blot her old self out. Here, women know of nothing except how to love. She let herself succumb to their indolence, adopting their silk turbans, their tightly belted cotton dresses, their charming ways, their games with fans, their wildcat sinuations. I took her into the alleys of Havana, places hidden from the burning sun, to streets filled with coquettish black women and pedlars pulling their biscuit carts decked with palm leaves like on Palm Sunday, ice-

cream vendors who sell you mangoes when all you really want is a strawberry sorbet.

I saw Spanish blood pulsing through her, the colour return to her cheeks, her hips flesh out. My cook Carlotta used all her wiles. In just a month that timorous girl became an Amazon.

The energy she generated from her body, which was as small and exquisite as a Tanagra figurine, amazed me. She seemed to take pleasure in proving her strength. She enjoyed her tiredness, challenged it. She never missed any of the parties which filled our idle hours. Her charm became the talk of the gossip columns in the local papers. One had hardly expected such a studied knowledge of seduction from such a reserved young girl. Was she vulnerable? She was seen as a mysterious foreigner with her indefinable accent and openly provocative appearance. My son Charles, whose reputation as a Don Juan was well known, followed her round like a dog, to the great displeasure of a ship owner whose name I forget. But his favoured position got him nowhere: she treated him no better. Anaïs asked him to the Finca to take tea under our English parasols. She served him a cup and then fled, saying she had a headache. The stupid lump said not a word. Anaïs was infected with frivolity. I began to wonder if marriage was a good idea for her. Part of her nature was pushing her towards it, but her craving for life seemed so intense that marriage seemed to me like a threat to the very essence of her being.

At the beginning of December, there was a telegram from Hugo. In it was a clearly spelt-out proposal of marriage. We spent a white night. Anaïs wanted everything to be reconciled: her own happiness, her mother's, Hugo's. She was aware of her own ambition, and she did not want to sacrifice it for his. The idea of marriage disturbed her. Her mother had told her that husbands quickly tire as lovers. I did not disabuse her.

The marriage was decided like a *coup d'état*. Hugo sent an ultimatum to his parents. Anaïs informed her father of the *fait accompli*. Rosa, overcome by the speed of events, decided she

would be wasting her time coming to talk to her. She was furious. I had usurped her throne.

I alone represented the family. We invited just a few friends. The church was almost empty. Anaïs seemed far away. When the priest presented the rings she distinctly hesitated before holding out her hand.

On the morning of the wedding, while I was adjusting her train with the help of our maid, Anaïs asked me if I knew Paris. She began mumbling to herself, somewhat bizarrely: 'Papa lives there, you know. Hugo asked to have his posting there. What greater proof of love can you have, Aunt Antolina?'

[8] Hugo's letters to his brother John and his mother

Paris, 4 January 1925

Dear John

Forgive me for not writing since we arrived, but I have had so many problems to sort out since 24 December. Finding somewhere to live in Paris isn't easy. I won't describe the slums we visited before we gave up the unequal struggle and went to ground here, in a family *pension* at 60 rue d'Assas, not far from my mother-in-law who is living with her two sons in a modest studio on boulevard Raspail. I hope that we will not take root here. The stairwell stinks of leek soup. You feel you've stepped straight into one of Balzac's novels. Anaïs doesn't complain though — You know her well enough to understand how depressed a hideous décor can make her. Do you remember the work she did to our bungalow in Richmond Hill?

I get a lump in my throat remembering our bungalow with its red roof — our first home after we married. The Moorish entrance with its brass lamp decorated with coloured stones, the bedroom with its pale grey walls, and matching old-rose blinds, the drawing room in green and brown, like the curtains she stood behind watching for my return, while Laddie stood guard in the garden. Our big red-haired fox terrier was the finishing touch I had so wanted to add to our happiness . . . I don't know how other people saw us then, John. We probably looked just a bit too quiet for a young couple. We hardly ever went out; instead we used to spend our evenings reading. On Sundays, I liked to do the garden with Laddie, while Anaïs went to see her mother, as she only lived two streets away. It was a modest sort of life, but I loved it.

But Anaïs was obsessed with Paris. I let myself be swayed by my love for her, and by my friendship for her brother. With my

48

help, Joaquin was able to continue his music studies. We found him a bit under the weather when we arrived here. He may have TB of the bone. If it comes to it, I shall pay for his treatment. Don't say, will you, that my generosity will ultimately be my downfall. Like me, you know how a desire for money can ruin you, and counting the cost is not one of the traits I am proud of. Anaïs is helping me to fight it: I would live like a pauper if it made her happy . . .

Now to our crossing. Be sure to tell Mother how greatly touched Anaïs was that she came to see us off. When the order to cast off was announced, she and Anaïs embraced with a very real emotion. Their reconciliation buoyed me up through the irritations of the journey. On the fourth day a storm blew up. We were in the main saloon, I puffing away at my pipe, Anaïs finishing a letter, when the ship gave a great shudder. My little pet's ink bottle shot its contents all over the carpet. Anaïs would gladly have crawled under a sofa to retrieve it. She has some very childish impulses. But she looks like a woman. The way other men look at her as she comes down the stairs to the dining room in her evening gown says it all. She doesn't set out to be provocative though. On several occasions she asked if we could eat in our cabin. I refused: I like to see her being admired. You will soon understand, John, this slightly shaming sentiment with which we men bolster our virility.

But how far can one be complacent? There's a young actor from the Odéon with whom I've had a few drinks at the bar, who's been following my wife around. I'm annoyed that I didn't put him in his place. I have a blind faith in Anaïs. Whatever the family thinks, I didn't marry on sudden impulse. It was a decision which I'd allowed to mature, and twenty months of life together have not made me regret it, not once. I hope that one day you'll meet a woman who cleans your shoes every evening, brings you breakfast in bed, cooks your favourite dishes – at Richmond Hill she even planted three crowns of rhubarb just so that I could have rhubarb pie – the one that Mother makes so beautifully. Anaïs has had a thousand occasions to complain. I've never heard a

single murmur. Sometimes she makes me feel her hands and asks if they've grown rougher with so much washing up . . .Perhaps she does it deliberately so that I can reassure her just how desirable she is. Or perhaps she's hinting just how much she wants a charwoman. It's taking me a long time to earn enough to give her all that a wife can expect from a loving husband . . .Next week, I move into my office at 41 boulevard Haussmann. If they're satisfied with my work, then I'll become manager of the Loans and Credits department before long.

I keep thinking about what Anaïs's father said when he learnt that I wanted to marry his daughter: 'This will be the first time a member of my family marries a businessman.' A strange character. Arrogant, very snobbish, but capable of disconcerting gestures: he insisted on meeting us at Le Havre. When I saw him in his dark cashmere overcoat, it made me think of Baudelaire's 'Don Juan':

> Erect in his armour, a great man of stone
> Stood at the helm and cut through the black waves;
> But the calm hero gazed at the furrowed water
> And deigned to see nothing.

Emotion paralysed him. Anaïs hid hers very well. On the journey from Le Havre to Paris, we exchanged small talk; he about his concerts, I, my career prospects. Anaïs watched us in silence. At St-Lazare he hurriedly left us to avoid my mother-in-law who was meeting us there. We jumped into a frightful taxi. Anaïs could scarcely recognize the city where she was born. 'It's so dirty,' she murmured, her nose pressed to the window. No, John, Paris is old. It seems incredible that in the shadow of these delapidated buildings beats the unmistakable pulse of the world.

We're living in the heart of Montparnasse . . . the artists' quarters, so they say. We haven't seen any yet. We'll have to go to that new brasserie which has just opened, Le Sélect; it has an all-night bar which will be a magnet for all the eccentrics.

It took a long walk through the Tuileries to reconcile Anaïs to her city: 'Paris is mellow this morning,' she murmured when we were watching a bird-charmer. You have to view Paris with a certain amount of indulgence. The concierges are grumpy, the taxi-driver dishonest. Anaïs – who trumpeted her French origins when we lived in America – has no words harsh enough for her compatriots. Her disenchantment is healthy. It's time she judged the world as an adult.

Dusk is falling. You can hear the cats calling to each other. Anaïs is deep in a novel by Anatole France which she bought on the Quai. She's still writing just as much, without any great discipline and without really knowing what she wants to say. Sometimes she's working on a play, sometimes on a second novel. I don't know what's happened to the first one, *Aline's Choice*. What she showed me seemed somewhat confused, and I told her so. She took my criticism as a personal attack. In the end I took her in my arms. It's the gentlest way of making a woman understand that she's in the wrong.

Send your letters to the bank until we've found somewhere more permanent to stay.

<div style="text-align:center">

Your brother
Hugo

</div>

<div style="text-align:right">

Paris, 22 October 1925

</div>

Dear Mother

I believe I can honestly say that you would be very proud of your son's headquarters: a splendid office with mahogany furniture, and a red carpet, overlooking an avenue not far from the Opéra. In my dark suit, striped silk tie and white handkerchief, I already look the part of the financier I'm about to become, if I'm to believe my boss's complimentary remarks. He's delegated to

me the job of creating a new department of loans and investments. We're encouraged by the franc's steady base rate.

We've just moved to somewhere that really suits us: an old artist's studio with vast bay windows which look out on to an ivy-coloured wall. Rue Schoelcher is bordered by the great trees of Montparnasse cemetery; you can almost believe you're in the country. By a stroke of luck the apartment next to us was up for rent. My mother-in-law has moved in there with her son Joaquin, now that they're back from Joaquin's cure at Salies-de-Béarn. Joaquin's preparing for his entrance exam for the Schola Cantorum. But to go back to our home. Hardly had I signed the lease than Anaïs had all the workmen in and was scouring the flea market and the drapers' shops. The result's quite entertaining. All the walls are covered in books (Anaïs wants them classified in order of preference, mixing the journals with works by D'Annunzio and the *Thoughts of Marcus Aurelius*. I had to spend a whole day arguing with her to make her accept a thematic classification); we have leather pouffes, her low table on which I've put all my smoking paraphernalia, and we've had the window frames carved by a local artisan in a 'neo-Gothic' style – the whole place is like being in some eccentric bachelor-pad, except that the curtains, with their geometric patterns, and the kitchen, painted white, reveal a modern young woman, somewhat influenced by the exhibition of Decorative Arts.

We went to see this – a mixture of good and bad taste – spread along the Seine, from the Grand Palais to Les Invalides. Anaïs lingered in the Russian Pavilion, all in wood, glass and steel. One evening we had supper in one of the three riverboats belonging to the couturier Paul Poiret: 'Loves, Delights and Organs' was its theme. In her violet crêpe dress, Anaïs looked like one of the Raoul Dufy creations painted on the ceiling.

My friend Horace has done a lot to help us settle in in Paris. I can have no better guide than the son of Count Guicciardi. A good financier should also mix in society. We go out often. Anaïs has captured people's attention, earning furtive, jealous looks

from other women. How does she manage to look ever more elegant all the time? She looks dressy in almost nothing: it's exquisite. A Spanish shawl over a black dress with a handmade corsage, and people comment as she passes. I couldn't have a more eye-catching ambassadress. The only social convention to which she refuses to submit is to follow my colleagues' wives into the tearooms while we're doing our business. Our American customs are spreading among the French. I belong to several clubs. I still have some scruples about leaving Anaïs on her own, but I'll have to conform to custom soon, otherwise I'm risking my career. I wonder if she realizes my future's at stake? When I come back from the office, I'm tired out and yearning for peace and quiet; she wants me all to herself. I have to listen to her, so that I can give my opinion on what she's written that afternoon, and then she wants me to read a book that she's bought for me. I lose heart. She reproaches me for allowing the bank to take over so much of my life. For stifling the poet in me. What can I say to her? That poetry never made anyone rich? That I like my job? She makes the word 'banker' sound like a swearword . . .

Don't be alarmed. Anaïs is intelligent. It won't be long before she becomes more flexible. Do you know what I find most touching? The way she wants to excel at whatever role she's playing. At Richmond Hill, she was the perfect housewife. In Paris, she's the epitome of elegance. And always the most loving of wives.

Did you receive the postcard we sent you from Touraine? We were advised to hire bicycles, and rode from one château to another along roads festooned with hollyhocks; there were little villages with white stone houses where we stopped for warm *pain au chocolat*. I'd love to show the region to John Erskine, my professor at Columbia, who's honouring us with a visit this coming December. I hope that you'll visit us too. Don't let us languish. Give my father my love. And my love to you too.

Your affectionate
Hugo

JOURNAL

Like Kafka, one can feel isolated in the midst of one's own people; or like Ernst Jünger, be a German officer in occupied France; or like Katherine Mansfield be a sick woman in a world of healthy people, or like Anaïs, be a foreigner in France, a European in America, a writer with no readers. The journal which evolved from the strangeness of exile was like a womb in which the divided self could gather together its thoughts, amuse itself. Ideal, eternal.

I am haunted by a photograph, the one Anaïs dedicated to her readers. She is chastely dressed in a polo-neck sweater, a new vestal virgin, in the vaults of the bank in Brooklyn, where the piles of her journal, like papyrus scrolls hidden in the secrecy of a crypt, await eternity. 'Diary: each day I die.' A momentary vision offered by a snapshot, and death. Fifteen thousand pages typed over half a century. She had to write everything down 'while I'm waiting for a friend, at a café table, in a train, a bus, at a station, in a waiting room, while I'm having my hair washed, at the Sorbonne when I'm bored with the lecture, when I'm travelling, almost while people are talking.'

As if the ink on the page were proof of the existence of blood in the veins.

In her feverish desire to capture and to hold, she had to live with instant phraseology. To voice something meant betrayal. She was tormented by the ethical conflict of the journal: 'How to avoid hurting people. How to reveal in such a subtle way that no explicit statement could be deduced, no facts.'

'All writers have hidden more than they have revealed,' she said, to gloss over its deficiencies, torn as she was between a thirst for truth and a mania for embellishment. She never ceased to

polish her portraits, soften her judgements, remove the sting from her revelations, fix 'the living today' in a sublime eternity, constructing from her 'notebook of sketches' a labyrinthine cathedral dedicated to the cult of herself.

'A monumental confession which, when the world receives it, will take its place beside the confessions of Saint Augustine, Petronius, Abelard, Rousseau.'

In this pronouncement of Henry Miller, the keyword is 'monumental' rather than 'confessions'.

Anaïs Nin. A woman immured in a mausoleum of words.

[9] *I am someone else*

Anaïs gave her notebook a title for the first time: 'Journal of a Wife': it would be a habit she would keep from the Thirties right through her life and it revealed her need for theatricality. But was she using this title to try to convince herself?

The *Journal* opens with conjugal rapture: she talks of her life with Hugo as of a dream from which she would never awaken. But all too soon there are some false notes: Hugo 'smells of the bank', she wrote. He was such a workaholic that he developed ulcers. Anaïs resumed her role as nurse. And as a woman of the world. The Paris in which she socialized bored her. But she was standing at the edge of the Paris she had dreamt of. Wasn't it odd that, living as they did in the heart of Montparnasse, she scarcely mentioned the local inhabitants or the events that took place there? There is no mention of the opening of the Surrealist Gallery (at 16 rue Jacques-Callot) in March 1926, which was widely reported in the newspapers, no mention of André Breton's first *Manifesto*, and yet the journal was describing quite similar forays into Surrealism. She was also an outsider to the cliques of English-speaking artists in Paris, to the Shakespeare Company, to Adrienne Monnier's bookshop in rue de l'Odéon which was one of their haunts. She saw Djuna Barnes on the terrace of the Dôme without knowing who she was, or what she had written. And for someone who would later defend *The Tropic of Cancer*, it is surprising that she admits to being shocked by a novel of Anatole France. She was turned off by the cynicism that abounds in Paris: 'The Parisians are not only immoral themselves, but they also love to drag the English into their own filth'. However, she would keep the erotic engravings she discovered in the studio of a friend of Hugo's.

Anaïs had become a dual personality. She enjoyed it, but it also caused her anguish. It became a source of material for her writing. Her journal was a zone of conflict, but also one of pacification: 'My Journal helps me to reconcile the antagonistic forces within my character.'

'A personality has not one face but millions; it changes shape as much as these pages change.' The theme of future novels was taking shape, a theme which she would compare to the fragmented silhouettes, the multiple exposures, of Marcel Duchamp's 'Nude Descending a Staircase'.

'What am I doing here?' She was seized by a sudden impulse, a brusque movement of consciousness, a somersault, a revolt against the world she had constructed around her with such docility: the décor, the laid table. The gentle banality of a couple entertaining another equally banal couple, perhaps a little richer, a little less happy, much less new: John Erskine, Hugo's professor, his wife and daughter. She could have laughed about it if she could have forgotten about the hours spent polishing their humble studio, consulting cookery books, rushing to the butcher's with its advertisement for 'farm veal' displayed among bunches of parsley. She had better things to do than pace up and down the morning market in boulevard Raspail, in a great sea of housewives: she looked haggard, so different among these women who demanded nothing more of life than an honest husband, studious children and fresh produce to feed them. As she weighed the chicken in her hand, an inner voice said: 'Don't lose sight of what you want.' Even for love. You could grow numb in a husband's arms. Hugo was less self-centred than most men. He had encouraged her to write – provided dinner was ready on time.

When she described the happiness that writing gave her, he scowled, and asked her if it could be as perfect as their moments of intimacy. She heard herself reply: 'No darling. Nothing can equal those moments.' That reassured him. He promised her

presents, dresses, trips, when there was only one thing she really wanted: time to write.

She had begun a novel, a play, short stories, without much application. Only her journal received constant attention. It became an idealized place, where she could order, control, contemplate her life. There she set her goals, then enacted them, but they were goals which existed only on paper. Reference points for a body in motion, for a soul in flight. Ideals of perfection, which could be contained. She preserved them by hiding them in her journal, but talked about them incessantly, and she polished what she wrote about them, over and over, like a madwoman constantly dissatisfied with the shine on her shoes.

When she was a child, she had kept her journal to make herself interesting. Her father's absence had set in motion an irrepressible need to be noticed: she had to capture attention, everybody's attention. There was more than a hint of vanity in this. Her journal made her someone different. An only daughter. The chosen daughter. When her mother entertained, she would come downstairs into the drawing room ostentatiously holding her journal, like a valiant knight bearing his coat-of-arms.

Down through the years, how people viewed her seemed more menacing to her than the all-seeing eye of an improbable God. Their glances could devastate her like a dagger piercing her very soul. If she had been asked to define paradise, she would have replied: a place where people do not look at you.

People looking, people who, while pretending to love her, were actually spying on her. The way her own mother scrutinized her when on the smallest pretence she descended on her at home, and lingered when Anaïs would have preferred to have been alone. Her brother's reproving look when she was getting ready to go out for the evening, applying her lipstick, which matched the silk poppy pinned to her shoulder. Her husband's look: so correct, so unsullied, so precise.

'What are you doing?'

'I'm writing.'

'Where are you going?'

'To write.'

'What are you thinking about?'

'What I've written. Would you like to read it?'

Sometimes she wondered if she was not wasting her talent writing only about herself, if novel-writing was not the only way to recognition. To make a clearer analysis, she made her first attempt at what some described as a 'deplorable habit'. She worked on it intermittently. She cleared a path for herself, for fate. She wanted to put on paper that sensitive flow, that unstable, wavering, illogical stream of 'consciousness'. She wrote a number of passages in such a state of exaltation that she thought she was going mad.

When Hugo gestured to her that it was time to make the coffee, she had made up her mind: she would show them to Erskine.

'Would your wife like something to drink? What about your daughter?'

'I think they would both like some tea ... Anaïs, that was exquisite. Your chicken is worthy of a page in my next novel ...'

'Last time she forgot to remove the gizzard, her mind is so much on other things.'

'From whence her charm, my dear Hugo. Her unworldly demeanour. Her angelic quality.'

'What am I doing here?' she asked herself with a dumb feeling of revolt when the two men rose from the table. Hugo filled his pipe from the tobacco jar which he handed to Erskine. Erskine took the lid off and sniffed. Hugo let bits of tobacco drop on to the tablecloth. He stretched. Erskine stretched, and then continued his monologue, broken only by the sound of laughter. Erskine's daughter, who had not opened her mouth the whole evening, was listening to Joaquin playing a Mozart sonata. Mrs Erskine liked to chat. What would she have talked about with this paragon of virtue, constricted in her violet serge costume?

There was only one thing Anaïs wanted to do: go to her room, take off her clothes and put on a silk kimono which made her feel in the mood for writing, and look at the piece she had written so impulsively. 'I see in the writing of an intimate journal the communion of a soul with itself in the most absolute sincerity and freedom.' Then she would tell herself that it wasn't true . . .

Fear temporarily blocked her power to write: fear of others, fear of people who did not believe in her. She feared them because she knew them to be right. Fear of being unmasked. Fear of discovery. Fear of her own clearsightedness. Fear of the need to wound the man who would discover her, dissect her smallest weaknesses. On the rare occasions when she wrote more caustically, she would change first names, fudge descriptions which were too close to the bone. Fear of Hugo's look when he came home from the bank and surprised her in the act of writing. Her pulse would accelerate as if she were holding, not a pen, but a dagger.

When would she dare to say the unsayable? The forbidden, the inconceivable coming from a young woman like her? 'Mrs Guiler has the face of a Madonna.' 'Mrs Guiler is exquisite.' 'In spite of her youth, Mrs Guiler is an accomplished hostess.' Mrs Guiler . . . It was as though they were talking about someone else. About Hugo's mother. Mrs Guiler of the pale lips and thin hands. Mrs Guiler? You mean Anaïs Nin? The woman who refused to be subjugated. Anaïs, the woman who refuses to live a circumscribed life. Anaïs, the woman who can't be satisfied. The woman who pretends . . .

Her secret. There is no trace of it in her journal. She keeps it muzzled and imprisoned in her body, between her thighs. In that place where Hugo likes to prove he is master. In that place where an unrecognized violence stirs. A rage. Like the laughter of the damned. One day it will be unleashed. Hugo will have to be told . . . So that he can stop deceiving himself about the pleasure which he thinks he is forcing out of her . . .

She remembered the day she went with him to his tailor. While

they were in the waiting room, Hugo's gaze lingered on some photos of chorus girls, their heavy breasts harnessed with straps of pearls and paste jewellery. He made no mention of it. But that evening, he had fucked her brutally; for the first time, he had cried out ... One day she would have to write it down.

She had wanted to write about that last spring, when they had rented a fellow American's studio at 22 rue Pauquet — before moving here — she had discovered a collection of pornographic books ... she had hidden them to read at her leisure during the day. Hugo was working. They were all illustrated, some of them in an eighteenth-century manner, others in a more contemporary style, women with boys' haircuts, wearing garters, black stockings, carefully torn camisoles, leather and steel accessories. For a week, she had read nothing else. It completely changed her outlook. For the first time she noticed women hurrying along the pavement, heavily made up and dressed in gold jewellery in the middle of the afternoon; she noticed curtains drawn in full daylight, the knowing expressions of hairdressers, corseteers ... Her intuition became so acute that when she went to a party, she could guess the couples who were unfaithful. The first time she had taken a look at Mrs Erskine, she had detected a woman for whom a thousand betrayals had destroyed all sexual desire. A bitterness. A thirst for social recognition. A starched blouse of irreproachable whiteness, done up to the last button. A prematurely wrinkled neck.

Mrs Erskine saw everything, but said nothing. Mrs Erskine surprised her husband's hand moving very very close to Mrs Guiler's waist when Mr Guiler was gesturing him towards the table. Mrs Erskine stifled her rage, by crumpling the corner of her napkin which was as white as Mrs Guiler's powdered neck, then she unclenched her fist, unpursed her lips and asked Mrs Guiler where she had bought the material with which the pouffes were upholstered.

'At Bon Marché, if I remember correctly. It's two stops from

here. You just go down boulevard Raspail as far as rue de Sèvres. A half-hour walk, and you're there . . .'

'I'll take a taxi.'

'Don't you like walking?'

Walking was her only pleasure in Paris: aimless, endless walking, without any constraints, with only the nervous clicking of her heels, that languorous laughter behind a half-closed door could suddenly bring to a halt. She would stop, listen. Silence. Then she would start walking again.

Wandering through Paris, she would trace her childhood haunts, pacing beside one of her rare memories: the trees of the beautiful *quartiers*, chestnuts in the Champs-Elysées, plane trees in avenue d'Iéna, avenue Niel, avenue de Wagram, in boulevard Haussmann where she accompanied Hugo before going back up boulevard Malesherbes. In parc Monceau she would catch her breath under the ivy-entwined corinthian colonnade. Then she would get up and, looking straight ahead to discourage men from accosting her, she would resume her walk.

Sometimes she might have given the impression that she was trying to escape, or that she was searching for something, when she walked around Montparnasse cemetery, her peace of mind restored by the delicate shade of the lime trees in rue Froideveaux, intrigued by the special bars for funeral parties where she could see women raising their veils to sip an absinthe . . . As she approached boulevard du Montparnasse, her pace quickened to the rhythm of her pulse. From the terraces came the chatter of girls' voices. She was aware of the blood pulsing through her temples, in her neck. She felt she was alive. She was walking through the territory of artists, of people who had daring.

Where would she find them? At Le Sélect? At La Rotonde? She asked a bookseller in the English quarter at the Vavin crossroads, to whom she had sold some of Hugo's old books. 'La Rotonde? Don't go in there. Their lavatory attendants trade in cocaine when they get too old to sell their charms. Le Sélect? Crammed

with foreigners. The artists are everywhere and nowhere. In cheap rented rooms. In the municipal housing on avenue du Maine, in the bug-ridden hotels in rue Blomet, rue de Château, everywhere where a lady like you would feel ill at ease.'

She wanted to see them, go up to them, beg them not to judge her by her well-groomed appearance, tell them that secretly she was one of them. She wanted to feel the heat of their passion, warm herself on it. Painters, sculptors, musicians, dancers or magicians like that man with a hawklike face and stringy hair, draped in sacking and wearing sandals, whom she'd seen crossing boulevard Raspail. He'd walked in front of her like a blind man. And that strange-looking woman in the black velvet cloak, sitting very erect on the terrace of the Dôme drinking a Scotch. She had red hair and her pale face was very carefully made up. She looked like an eagle and a cat at the same time. She looked arrogant, indifferent. She looked at no one. She looked beyond appearances; the skeleton under the flesh . . .

Anaïs wanted to approach her; burn herself on that cold incandescence. But Hugo's presence paralysed her. Bunched up in her chair, she had drawn her jacket more tightly across her chest, flattening her breasts like a camisole. She had to restrain herself. Hold it all back . . . for how long?

FOOD

Food for Anaïs was mostly of a spiritual kind. Anaïs preferred the library to the dining room. In her stories, smells come from night clubs, from bedrooms, never from kitchens. Her characters never eat. She nibbled at her food.

'A piece of toast, a chicken wing, and she was full,' a friend of the Fifties recalled.

Ever since she was a child, she had fought against anaemia.

A minor form of anorexia?

The anorexic: an idealist who hungers for something else. The anorexic is in revolt, a girl who rejects in her mother everything she does not want to be herself: the wet-nurse, the housewife, the female. 'I always blamed my mother for being a woman first, and only afterwards an artist.'

The anorexic rejoices in her dwindling energy, exhausts herself exercising. Anaïs devoted a lot of energy to becoming a professional Flamenco dancer. 'If you continue to dance the way you do,' a close friend warned, 'you'll become so frail, a gust of wind will blow you away.'

Miller, with his insatiable appetite for enjoyment, restored her figure. A taste for flesh. Sated 'with coitus, with literature' and the paellas she cooked at Louveciennes: 'I enjoy seeing him eat, eating with him.' After their break-up she once more reverted to size 34-inch hips and a diet of yogurt, of which she never tired till the end of her days.

[10] *A beautiful mask*

In Paris, Rosa asked her children, in the name of their love for her, not to contact their father again. It seemed that her wish was respected. Anaïs affected an apparent indifference to Joaquin Nin whom she referred to in her letters to her mother as 'Monsieur N.' In her *Journal of a Wife* she mentions only two meetings. The first, on 24 December 1924, the day they disembarked at Le Havre, the second four days later when she dined with him and his girlfriend Maruça: 'Yet he did not get the best of me in this encounter . . . And the advantages were on my side, even though he is the one who knows so well, so beautifully, what to say and how to say it. But I, being his daughter, can also act when necessary, and I did act . . . the little woman he is going to marry is very sweet.'

Then silence . . . the first lack of truthfulness in the *Journal*. Anaïs was going to 27 rue Henri-Heine, in the sixteenth *arrondissement*. Unbeknownst to her family, in secret, as if she were going to visit her lover.

She knew that he was deceitful and a liar, that he glittered with a brilliance that was false. She knew that he was only an illusion; the hair that glistened with brilliantine was dyed. His gold cigarette-case, his cream-coloured gaiters, his pearl tie-pin — appearance, vanity.

And yet, she so wanted to see him again. She had to see him again, she could not live without seeing him again. She was drawn to him like a magnet, engulfed by him.

Her mother watched her feverish preparations and asked her where she was going in her kid-leather court shoes.

She lied without a trace of a blush. She was like him, his

65

double. Evil. In the mirror he held to her she saw only disorder, distortion.

He had said, 'Don't be late.' She took the first taxi that came along.

'Rue Jasmin.'

'What number?'

'Stop on the corner of rue Henri-Heine. Can you hurry?'

The taxi-driver gave her a lascivious, knowing look. She felt put out, undressed, humiliated. This would be the last time. She had made up her mind not to see him again, this man who had welcomed her with a flirtatious pout: 'I have such an awful headache.' When the taxi reached rue Jasmin, and she could see the strange red-brick building with its Gothic windows on the corner of rue Henri-Heine, she abandoned her resolve.

She gave the driver an enormous tip. The door slammed. On the pavement, she hesitated. She was exactly on time.

Her father lived in the cleanest street in Paris. Manicured lawns, stone lions on the gate posts, chambermaids at the windows. A chauffeur awaiting his employer. She hurried towards No. 27.

Of all the buildings in this quiet street, this was the most imposing. Three storeys. Her father had had the top one added, so that he could dominate his surroundings, as he always did. But its conical roof seemed more like Grand Guignol. His need to dominate was grotesque. Anaïs looked up to the first floor, towards the three windows with their rows of flowerpots, the great salon where he was waiting for her. The curtains were drawn. Maruça opened the door for her. In her childhood she had seen her as an enemy; now she saw her as a victim. She was fragile, almost breakable. How was it that her father had not already crushed this designer-dressed doll? She had tiny hands. Anaïs turned her head away. The sight of them brought back the most painful of memories: Arcachon. The dune of Pyla where she had taken her solitary walks, while her father gave piano lessons to a girl who at that time was called 'Maria Louisa'. . .

'I thought you might like this photo ...' Maruça held out a portrait of Anaïs's father taken at that period. not a wrinkle between his eyes. Nothing hard. Lips half-open, before cynicism had shut them tight.

Her father had had all the walls of the house cork-lined so that no one could hear him practising. She mounted the stairs in silence. Her heart was pounding. What could she do to please him? Would he bring up the subject of divorce? Her father was desperate to get divorced. He already had the papers, but did not know where Rosa was living. She refused to give him the address. The shame of it would kill her mother. She was a Catholic. Divorce signalled failure. Her father had no belief. He only listened to his own desires. At every visit, he insisted. He begged her. Perhaps he only invited her with this in mind: Rosa's address.

He was waiting for her in the Andalucian garden he had designed with its stucco walls and earthenware pots. A fountain stood in the centre of the patio. He was lying languidly on a chaise longue, like a convalescent. The chaise was cluttered with scores. He held out his hands to her. They were soft, manicured. He asked her to stand back from him so that he could look at her.

'I wondered, before I saw you, which side of the family you would take after: the Spanish or the French. You've never looked more Spanish than now. You have become very beautiful. Adorable. That black hair, those green eyes, those red lips. I can see that you have suffered, and yet your face is unlined, serene. Suffering has made you more beautiful ... I feel you are so like me now: proud and indomitable, demanding, an aesthete.'

She let herself slip on to a chaise longue. They talked. What music do you like?' 'Debussy,' she replied, 'Satie.' He approved. He smiled. He caressed the back of her neck. She shivered. Would you like to listen to *La Mer*? No, she would rather listen to him. He was composing. He was writing too. Essays on Spanish music. And two books on art. A writer. A musician. Like her, he lived for beauty, harmony. Suddenly the line between his eyebrows

deepened. His lips closed to a thin line. His face became icy. His grip became like a vice.

'Do you think about me?'

She stiffened, then rose. Impossible. I promised Maman.

Your mother, if only you knew. One day I'll tell you.

No, she didn't want to know. It was late. She had to go.

He asked her again. He begged her. Implored her. Do I have to go on my bended knee? His hand began its caress again. 'Give me the address. Believe me, if your mother grants me a divorce, she will have every advantage. She can begin a new life. Isn't her happiness important to you?'

Like a woman, roused by a desire she would not have thought possible, she capitulated.

She scribbled '11 bis rue Schoelcher, Paris XIVe' on the back of a score.

The following week, her mother received the divorce papers. Her hair turned grey overnight.

LIAR

Anaïs lied. Her childhood was fed on lies. A father who lies is a false God. After that, what is there to believe in but illusion?

Anaïs lied: only the dead cannot lie.

Anaïs lied through over-indulgence in life, in her desire to experience all the emotions, to visit every place, to take on every role: to be here and there, in this bed and that one. In her desire to reconcile everything: 'I want to dope myself with experiences.'

Lying was like champagne. 'I lie when I feel the need to stimulate my life.' It only took a lie to make life exciting.

Whilst she reproached Miller for his frankness, she would lie in order not to hurt. With the dexerity of an artist on the make, retouching her portraits.

Lying was endemic in her. In all women. Women have lying in their blood, in their very essence. Women lie, like artists.

Artifice.

Anaïs never ceased to waver between the reality of an illusion (the novel) and the illusion of reality (the journal).

She was too clear-sighted ever to believe that she could reach the truth, but too much of an idealist to renounce it. Anaïs sought adventure further afield. Beyond the real.

A non-believer in search of a Holy Grail.

[11] *A restive nature*

Hugo could congratulate himself: his salary had increased by seventy-five per cent. Now deputy director of the National City Bank, he managed estates and counted among his clients businessmen, princes and even a maharajah.

Anaïs was given her first fur coat. The dresses made by her mother were replaced by outfits from the couturiers. They went riding. They drove a Citroën. They went to the casino. They had arrived.

'Invitations, too many invitations. We are a handsome couple. Everybody loves us,' Anaïs wrote. She had made friends with Princess Natasha Troubetskoi, a white Russian, quite a good painter, for whom she posed. Her studio was later to serve as a postbox when Anaïs became Henry Miller's mistress.

Rue Schoelcher had become too modest for them. In January 1929, the couple took possession of a vast apartment at 47 boulevard Suchet, not far from the bois de Boulogne, followed once more by Rosa and her son who lodged on the same floor in a neighbouring studio. The two women clashed: 'My mother wanted the impossible, that I remain a little girl, but I have now become an individual.'

She had gained in self-confidence. Life in Paris had taught her how to be casual. She developed a taste for gambling, champagne, sophisticated chatter. A new morality was developing: the more she diverged from normal good behaviour, the more she loved Hugo. Flirting during the day made her more beautiful for him in the evening. She dazzled. She burned. She was on the point of breaking down. Her energy consumed her. It had to consume her: through dance. She chose the Flamenco. A return to her roots, of course, but more than anything else it was a plunge into the

unknown. She took her lessons in Clichy, where, later, along with Miller, her legend would be born. Clichy, full of all the colours of the rainbow, effervescent, suited her feverish state. Clichy was so free. She too was going to be free.

Leaning on the wall mirror which reflected her figure like a bright flame, Mirallés voiced his joy.

'*Eso es, Anita. Eres un fenomeno.*'

She stiffened the curve of her back to breaking point, and with it, her whole body. As she nimbly rose, the black festoon of her skirt rose with her to uncover her slim ankles sheathed in dark lustrous silk stockings ... A stamp of the heel, and her body resumed its posture; straightened; drew itself up to its full height, with a disdainful movement of the chin.

Mirallés held back his applause. Anita made him forget everything: his age, his stiffness, his defences. He ought to stop, return to his sister's in Valencia, or go home to his studio in Pigalle. But this room was the only place he could breathe, this room with its smell of sweat, and the sweetish scent of cheap make-up peddled on boulevard Clichy. As long as Anita came to his classes, he would stay here.

She was his favourite, the one he liked to lead by the waist, when, as he showed her a pose, he forced himself to deny his true feelings, that *flamma* that burned in him, a fire which was also consuming her.

Anita. Anaïs. Nina. My soul and my cross. *Ma gracia*. My little girl ...

The first time that she had stepped on to the uneven parquet of the dancing room, he was on the point of asking her to leave. He could not stand people who were just curious, particularly condescending women in fur coats. This importunate woman wanted a chat with him. He had asked her to step forward. Under the yellowish light bulbs, faces took on an earthy colour. But hers retained the brightness of the pearls around her neck.

In a breathless voice, and in an accent he did not recognize, she

asked if she could become his pupil. He refused. 'You cannot turn down someone from your own country,' she'd argued back. 'I'm almost Spanish. I used to live in Barcelona. My father is a famous pianist. Doesn't his name mean anything to you? He's a friend of La Argentina.' At the mention of the name, Mirallés shook. La Argentina. Antonia Mercé y Luque. The Madonna of *L'Amour sorcier*. His model. Mirallés began to stammer, apologizing for the cramped room with its walls plastered with old posters, his so-called dressing room. He felt humiliated at having nothing to offer her but a broken cane chair.

She did not seem deterred by the poverty of the décor. On the contrary, she examined the place with childlike enthusiasm, seemingly happy to be there with him; addressing him as 'Dear Master'. He accepted her flattery and agreed to her coming to the beginners' class. She said she was no beginner. She had been practising the *Sevillana* and the *farruca* for a whole year, with her brother accompanying her on the piano. She knew how to handle the castanets. Mirallés pocketed her advance payment for three months of lessons. He didn't normally do that. But none of his pupils wore an astrakhan coat.

His new recruit was full of *gracia*. Mirallés did not allow himself the pleasure of being present at her metamorphosis. Anita would arrive, hatted and corseted, and drop her clothes to the ground like a breastplate, then don a black leotard, and a crétonne skirt. She would draw her hair back into a chignon, allowing a few strands to fall across her forehead in a kiss curl. She adored make-up. She used it audaciously. Could it be that the euphoria of disguise took her into a state of trance?

No. She abandoned herself to the genie of the dance. Sweat made her mascara run, stained her armpits; her comb fell, to the accelerated rhythm of the *taconeos*. She cared for nothing but dancing, and dancing better and better.

When he saw her so exhausted, Mirallés could not help wondering if she were trying to expiate something. He had the feeling that she was trying to kill a part of herself. She had settled

on a stage name, even before performing in public for a few favoured friends. Why 'Anita' when Anaïs evoked everything about her: the sinuosity of her body, the singing intonations of her voice, the ambiguity of her appearance, half child, half prostitute? And that ridiculous patronym of 'Aguilera': so close to her married name which she seemed to dislike so much? Hadn't she forbidden him to call her 'Mme Guiler'?

Mirallés wanted to know more. One day, after a lesson, he invited her to Café Au Moncey, in place Clichy. He bought her a bunch of violets from a flowerseller and placed it on the marble table top. She accepted it most graciously. He summoned up his courage. He asked her for money. He wanted to stage two new ballets.

Mirallés knew very well what he was doing: he was demanding money from a rich woman who was ashamed of being so. A coquette who adored having men beg to her. An *aficionada* ready to serve his passion. She agreed to ask her husband. Emboldened, he placed his coarse hands on hers.

'I have another favour to ask.'

She smiled; if that was what he wanted, then yes, she would be his partner. If she could just have more lessons. What about Wednesday . . . Mirallés stopped her.

'A kiss. What I would like is a kiss. Don't refuse me that: you've put me in the mood for it. It's the way you smile at me, as though you've never smiled at another man before. The way you abandon your body to my hands when I guide you, as if you were just waiting for me to hold you tighter . . . *He sonato contigo* . . . I've dreamed about you . . . Anita. You're so provocative. You arouse me . . .'

Slowly, enunciating each word separately, as you would teach the alphabet to a child, she told him that she liked him very much but she did not desire him. His hair was greasy, his chest hollow. She found it difficult to stand his smell.

'Don't be angry with me for being frank. I'm going to be even more so . . . You have often asked me why I wanted a stage name

73

before even going on stage. I haven't given you a straight answer. I've told you I am hiding behind the name of Anita Aguilera to avoid a scene with my father. He's furious at my devoting my energies to an art he considers degenerate. The sweaty smell of the changing rooms, the noise of the class, Lola, Alma Viva, the mules, the kimonos, the Spanish cottons with their huge flowers. I adore everything he disapproves of. When I'm practising side by side with you, I can almost imagine my father appearing, and shouting: 'Have you forgotten who you are? Your class, your family name, your social position?'

She seemed to become very nervous, and started twisting her glove. 'Who am I, Mirallés? I never stop wondering. Don't laugh, or I'll leave. It's not easy to explain myself anyway . . . You ask me why I took another first name. Sometimes, I'd like ten other names . . . I've always been intimidated by the fact that one's personality has so many facets. There are days when I can acknowledge the richness of it, and others when I see it as an illness. Ever since I've been dancing, I've been able to reconcile the two women within me: the pure and the sensual. So I called myself Anita in order to protect Anaïs . . . One day, I'll invite you to my home and then you'll see for yourself why the woman who's sitting drinking a coffee with you in place Clichy, the woman who dresses as a Maja, who poses lasciviously for the sake of the dance, who lingers in the damp changing room, why that woman can't have the same first name as the woman who lives in a luxury apartment in the sixteenth *arrondissement*, with an exemplary mother, a romantic brother and a husband who is charming, but who smells of the bank . . .'

At the invitation of Mr and Mrs Guiler, Mirallés went one evening to a party at 47 boulevard Suchet, a party which, according to the invitation, was intended to bring together a few close friends.

Anaïs opened the door to him in her most beautiful Maja's dress. Mirallés wanted to hold her tightly in his arms. But the

sight of the room behind her paralysed him. He had never seen such luxury. So personal . . . It was disconcerting . . . A mantelpiece in turquoise-and-gold tiles stood out from the sapphire walls. The Moorish furniture was incrusted with mother of pearl and tortoise-shell . . . An Indian lamp, of multi-coloured glass, the deep upholstery, the embroidered cushions, the lamé of the curtains, the rugs thrown over the chairs made it all look so casual, so luxurious.

He felt ill at ease. What dreams haunted the woman who had conceived such a place? He thought that in Anita he had seen the hidden face of Anaïs; now he acknowledged that he knew nothing. In that costume that he so cherished, she had become a stranger.

The other surprise was Hugo Guiler. Mirallés had expected a thin Scotsman. Instead, a handsome man with brown eyes, a rather matt complexion and unostentatiously dressed welcomed him warmly.

Walking sinuously in her dress, Anaïs ticked off her maid with the ease of a *grande dame*.

The Spanish meal was washed down with sherry. Mirallés might have thought that special attention was being paid to him, were it not for the fact that he had compatriots on either side: a pianist and his sister. Among the guests were an American violinist, a friend of Anaïs's brother, a Cuban poet, a relation of her mother, a distant cousin, the Paris correspondent of the *Daily Mail*.

During dinner, famous names were dropped. Manuel de Falla. Albañiz . . . Mirallés said nothing for fear of disappointing his pupil. Was it true that she had never admired him? He felt so now. A knowing look from Anaïs might have reassured him. But she was completely absorbed in her role as hostess.

At the end of the meal, they pushed their chairs back. Hugo disappeared and returned in a gypsy costume. He was carrying a guitar. Mirallés could not believe his eyes.

'Has my wife never told you I can scrape a few notes?' he asked

with a laugh. 'What a secretive woman. I'd like to take Flamenco lessons too so that I can partner her. Would it be possible?'

Mirallés was about to reply when Anaïs interrupted, and announced she was going to dance.

Mirallés found her expression hard, almost hateful, the expression of an 'impostor' suddenly unmasked.

[12] *Lawrence's lady*

Anaïs owed her literary début to the crash of 1929. Hugo was shaken by the catastrophe on Wall Street, his best clients were ruined, he was at a loss how to act. He was forced to leave boulevard Suchet, and withdraw to the west of the capital, to near Saint-Germain-en-Laye. Louveciennes, as she describes it in Volume One of the *Journal*, resembled 'the village where Mme Bovary lived and died. It is old, untouched and unchanged by modern life. It is built on a hill overlooking the Seine. On clear nights one can see Paris . . . behind the windows of the village houses old women sit watching people passing by.'

The dwelling they rented at 2 bis, rue de Montbuisson, had been a refuge during the Revolution for the fleeing favourite of Louis XV, Mme du Barry. Anaïs was moved by its great age: 'It has walls a yard thick, a big garden, a very large green iron gate for cars, flanked by a small green gate for people . . . The bell . . . sounds like a giant cow bell. When it rings, the Spanish maid, Emilia, swings open the large gate and the cars drive up the gravel path, making a crackling sound . . . There are eleven windows showing between the wooden trellis covered with ivy. One shutter was put there for symmetry only, but I often dream about this mysterious room which does not exist behind the closed shutter.'

Rosa and her son came to live with them: 'I lived in a separate wing, at the front, to the right. I had the attic on the third floor, and my mother's room was on the second, together with a bathroom and a kitchen,' Joaquín Nin-Culmell has recalled. 'On the left were Anaïs's and Hugo's apartments; on the ground floor the dining room which Anaïs had painted red, and the small blue salon with its mantelpiece in turquoise mosaic. We lived together yet were independent.'

Anaïs kept a room on the top floor which she painted grey: 'to type'. One cannot imagine a more appropriate refuge for reflection. 'I feel as though I am in a beautiful prison from which I can only escape by writing.'

This took the form of an essay — its subject, a writer who had recently died, misunderstood, and whom she had discovered one evening in December 1929: 'I have just read a strange and marvellous book, *Women in Love* by D. H. Lawrence, entirely devoted to the description of feelings, sensations, consciousness and unconsciousness.'

She was overwhelmed by it. Lawrence's themes were the same ones that haunted her: what part sex should be given in love, what a woman's role was, what a man's emotions were.

She detected, in his style, accents of her own: 'I found the courage to write in the poetic intensity of his prose.'

An avant-garde enthusiasm. At that period Lawrence was considered merely a pornographer with no talent. Anaïs's essay, for the first time, overlooked the scandals and concentrated on his writing.

First she wrote an article. Was it to spare her family that she gave herself the pseudonym of 'Melissandra'? Or was it for the pleasure of wearing a mask?

The article appeared in a Canadian magazine, *Canadian Forum*, at the end of 1930.

Anaïs's writing career had been set in motion. Those printed words had flowed from her own pen, from her blood, from her dreams, from all those hours spent doing nothing but thinking, just thinking, about life, especially her life. Why was she so depressed, yet her sensuality so alive? Now, nothing would stop her.

She went into Paris, to rue Delambre, to the house of Edward Titus, a pillar of the English-speaking intelligentsia, editor of *This Quarter*, a literary magazine for the European market. He had published Djuna Barnes's *Ladies' Almanack*, a satire on the lesbian circle dominated by Nathalie Clifford Barney, and a pirated edition of *Lady Chatterley's Lover*, D. H. Lawrence's master-

piece, with the freedom offered him by his wife's fortune: his wife being Helena Rubinstein. When she arrived at the corner of the Dôme, only a short distance from his house, Anaïs stopped and crossed her fingers to swear an oath: 'Titus is going to be my publisher.' She risked everything, including her talent as a liar — she was going to develop the article into a hundred-page essay — a combination of intuition and flamboyance which women can summon up if they have genius.

'If it matches you in beauty, I'll publish it immediately.' Edward Titus thought he had made a clever remark. He could not stop himself in the presence of a pretty woman. Anaïs realized she ought to be blushing. She's not a lesbian, like all the other barmy literary women, Titus said to himself, as his imagination carried him away. Would he make this frail creature his own? His mistress? He was overcome with impatience. He needed the manuscript immediately.

Anaïs stood up, mumbled a thank you, held out her gloved hand, and withdrew as quickly as possible, escaping from Titus's Medusa-like stare, as he called out to her not to entrust the manuscript to the post as you couldn't be certain of it.

When she returned to Louveciennes, Anaïs shut herself into her study and began to work, surrounded by the photos of Lawrence, John Erskine, Eduardo, her husband and her brother: her pantheon of men.

She wrote from morning till night; she had never before applied herself so exclusively to writing. When Emilia, the maid, called her for supper, she joined Hugo in a daze, as if she had just made love. But she went without that. For two whole weeks her body remained dead. The only thing that stirred her was the hundreds of pages that Edward Titus read at one sitting, intrigued by the audacity of this banker's wife who behaved like a simpering virgin but who dared to state that *Lady Chatterley's Lover* was the most mystical of all Lawrence's novels.

What sort of perceptiveness did she have to conceive this notion? Was it born of sensuality or of an astonishingly free mind?

Anaïs's 'unprofessional study' seems a real marvel to me. She burst through the strait-jacket of gentle womanhood. She uncorseted herself — from her Catholic terrors, from the inflexible position of wifehood, from her female principles. She unshackled herself by defending a demon to whom she was so close that she no longer knew who she was talking about when she said that she believed that Lawrence gave us a choice between life and death, or rather between a fulfilled life, and death. 'Fulfilment' was the pivot of his world, his lighthouse, his centre of gravity. Marriage, for him, was above all else an alliance of two bloods, for blood was the substance of the soul.

These ideas would be read by a man called Henry Miller . . .

[13] *Miller*

First of all, a face.

'Pink emerging from a crumpled mackintosh . . . fleshy lips . . . sea-green eyes, eyes of a sailor used to searching the horizon through the spindrift, that calm look, full of serenity – the naïve attentive look of a dog – taking cover behind large tortoise-shell spectacles, questioning me with curiosity.'

Then a body.

'Slender, gnarled, without an ounce of surplus flesh, this man had the look of an ascetic, a mandarin, a Tibetan guru.'

That was the Hungarian photographer, Brassaï's impression of him. He shared a Bohemian existence with Miller in Montparnasse, in those noisy cafés where ladies of pleasure think they are Muses.

Every evening Miller appeared at the Dôme, hunting down his fellow reveller, the faithful Richard Osborn, a man who thought he was in need of protection. Dick, too, was an American who was fascinated by Miller's loquaciousness, his talent, his freedom. Dick also dreamed of becoming a writer. But he had too great a need of money to give up his post of lawyer at the National City Bank, with his office, furnished in Empire style, on the same floor as his superior, Hugo Guiler . . .

Hugo's account

I'd always refused to take part in Dick's nocturnal jaunts into the shady clubs of Montparnasse, the Jockey, La Cigogne, La Boule Blanche, the Monocle, the Bal Nègre in rue Blomet, lurching from one bistro to another, and returning dishevelled, merry, dazzled by the constellation of geniuses gleaned in a single night. For

some time, he had only one name on his lips: Henry Miller. A fellow American, born in Brooklyn, married to a Broadway taxi-girl, an indefatigable wanderer, always broke, hungry for meat, wine, books, encounters, and women.

Dick told me that he came to Paris as others go to Mecca, with the dual hope of redemption and a miracle, the hope of emerging from his misery through literature, the hope of being recognized and published. Living from day to day, on borrowed money and his wits, changing jobs as often as his bug-ridden furnished rooms, he had decided once and for all to be a writer.

Dick put him up in a pied-à-terre in the Champ-de-Mars which he shared with his Russian mistress Irene. Miller would get up early, pocket any money Dick left lying about and disappear into the jungle of Paris. He knew every street, every bistro, every girl . . .

Dick talked to me so often about him that I had the feeling I knew this happy-go-lucky character, who asked for nothing more than the assurance of two hot meals a day, and who had the nerve to calculate that all he needed were fourteen good souls who would invite him for a meal once a week.

I had put myself forward as a candidate, partly through curiosity, partly through friendship for Dick. For Anaïs too, isolated at Louveciennes. She would like to meet a man who, like herself, made a profession of writing.

That very evening, in our Moroccan salon on the ground floor where we sat reading, I pronounced the name of Dick's protégé. Anaïs exclaimed, 'Miller. Where have I seen that name? In a magazine, I think . . . Oh, I remember . . . He had an article in *The New Review*. A review of *L'Age d'Or*, Luis Buñuel's film. I wanted to show it to you. His style is superb. Savage, vivacious, vibrant. Do you know, darling, what I thought: "Here's a man drunk with life. A free man. Like Lawrence. A man who's afraid of nothing, no one." I'm really pleased you asked Osborn to

bring him here. I'd love to meet him. I hope it'll be soon. Very soon. Could we ask them for tomorrow?'

Most husbands would be alarmed by this feverish enthusiasm. But I knew my wife well – she could get enthused over almost nothing.

Seated opposite me in her long red velvet dress, her 'boyar's wife' dress, her cheeks on fire, she devoured this character with her eyes. What did she see in him? Dick was guffawing about something. He was already drunk. Miller was not. He'd emptied two bottles. And taken a third helping of the roast and potatoes. He drank as he talked, he talked as he ate, he ate as he lived. My wife's hard gaze was fixed on the glistening lips of this jolly, myopic man.

'You must forgive me, I'm just so happy this moment with all the colours around me, the fire in the grate, the dinner, the wine. The whole moment is so wonderful, wonderful . . .'

He held out his glass to me. I poured him another drink. He thanked me with that astonished look of his, a look that showed kindness mingled with a slippery cunning which appeared so momentarily that only someone like me, on the look-out, would notice.

His glass was empty. The monologue began again: 'Paris's atmosphere is not only in the air, but also in its stones, in the ground, in the blood and the glands of the French.' Anaïs was drinking it all in. 'The glands, did you say? How fascinating.'

But Miller had jumped to another subject. Literature. Tolstoy, Gorky, Knut Hamsun, Dostoevsky, Keyserling, Shakespeare, and Balzac. And Zola. He had read them all. At least, he gave the impression he had. Freud? Of course. But you must look at Jung, my young man. The magazine *transition* publishes his writings. My wife exclaimed that she had a subscription, and that she had written to Eugène Jolas for the old numbers.

'You read *transition*? Breton, Duchamp, Dada, you live on it you say. How marvellous.'

He loved meat. The last slice of roast landed on his plate. In three mouthfuls it was gone.

'This beef is divine. A real treat. Incredibly good. And those onions. So delicate, they melt in your mouth . . . like your prose, Mrs Guiler. Dick let me look at your manuscript on Lawrence. I was staggered. I've never read truths put so strongly yet with such delicacy. But why did you choose Lawrence? That sexual virgin. I'll be frank with you: he gets up my nose. He doesn't write, he preaches. When I was reading what you'd written, I was wondering what sort of a person the author was. Dick had said a banker's wife. It seemed unlikely to me. And now here you are sitting right next to me. And I'm looking at you, even more flabbergasted. How could such a beautiful woman, of such distinction, write a book like that? It's incredible. Marvellous. Just like this meal. And those bright flames in the fireplace.'

I sensed it: he was piling on the flattery for her like any old scrounger who wanted to be in his hostess's good books. I held myself in check: Anaïs seemed so happy . . . like a little girl at Christmas . . .

'You can't have read Lawrence properly, Mr Miller. You've only brushed the surface . . . I've spent day after day studying his work. He's . . . awakened me. Yes, that's exactly what he's done. He's confirmed my intuitions, and revealed others to me . . . I felt that writing about him would help me find my way . . . I felt I was setting out in search of a brother, and also a father . . . It was like letting myself go . . . with Hugo's encouragement. Isn't that right, darling?'

I mumbled something. I can't remember what. Anaïs had reverted to her normal, slightly sharp voice to ask me; now she addressed Miller with a soft voice, a throaty voice which I've only ever heard in the dark, when I press her to me and she playfully defends herself from my caresses . . . As if this fellow, suddenly, had surprised us in a deep embrace . . . No, rather I had the

impression of surprising him . . . within her, in the indecency betrayed in that voice . . .

I wanted to cry out. She'd promised me . . . only a month ago. On board the *Lafayette* when we were on our way back from New York from a business trip of mine. The sea was rough as it was for all our Atlantic crossings; I had always refused to see any significance in it.

Except that day . . . I had recognized what I already knew from thousands of little signs gleaned by chance from her conversations on the telephone, inexplicable little wounds, such as when I saw her leaving the hotel, in her best coat, and asked her where she was going and she invented some reason or other, which I was expected to believe. But instead of blinding me, love has made me acutely aware. Anaïs was being unfaithful to me with Erskine.

I waited until the third day of the crossing to take her up to the top deck where there was such a strong wind that it dispersed all our cries, all our sobs. I was ready to forgive her on condition she owned up to it.

At first she defended herself. Nothing had happened between Erskine and herself. 'Don't lie to me, I've had enough lies. Tell me.' I held her arm like a vice and bent her back over the rail. She tried to break free; the wind clamped her hair across her lips. I heard: 'John kissed me. My mouth. My neck. He wanted to see my breasts. He cupped them in his hands. Aroused them. I went mad. I was totally overwhelmed. He could have taken me. He didn't though. He couldn't do it. He felt me all over under my clothes. He whispered obscene things to me . . . Impotent . . . Nothing happened, nothing.' Each word stabbed me. Instead of allowing it to stop there, I pressed her to continue, my nails embedded in her shoulder. My jaw was tense. Jealousy flowed like poison in my veins, cramping all my muscles. I leaned on her. Like Erskine bent over her breasts. She was panting. haggard. Open. I dragged her down to our cabin. I took her, transfixed by the pleasure that those images had aroused, Erskine's body melting with hers . . . then mine.

I was frightened.

I never wanted to feel that kind of pleasure again. It contradicted all my feelings. The nausea at my climax; my self-disgust.

'Hugo, Mr Miller asked you a question.'

'Mr Miller.' My guest chuckled. Anaïs was getting impatient.

Then I observed them, him talking with his mouth full, fingers glistening, she fingering her napkin, tight-lipped; then I was convinced that nothing would happen between them.

Everything separated them. Well, almost everything.

ORGASM

Magnified and made myth in a plethora of metaphors. (Preciosity can be symbolic of impotence. Read and observe the work of Salvador Dali.) But had she ever known one?

Did she pretend? Often 'the contraction of the vulva, the quickening of the breath, of the pulse, of the heartbeats, the sudden languor, the falling away, the half-fainting fog that followed the act: she could simulate everything.' ('Elena', *Delta of Venus*)

'From Henry, I hid that I rarely reached true orgasm.' (*Henry and June*)

A Ninian orgasm. Transfer of mucus. 'Instead of having one sexual core, Elena's body seemed to have a million sexual openings, equally sensitized ... as if each cell of her skin magnified with the sensitivity of a mouth.' ('Elena')

Let us examine those lips of hers: thin, slightly open at the centre, enlarged with a lipstick brush – always painted; then in the Sixties enlarged through cosmetic surgery, Designer-lips of a goddess. Painted lips on a Noh mask.

Noli me tangere. Touch me not.

'I realized a terrible fact – that Hugo was sexually too large for me, so that my pleasure has not been unmixed, always somewhat painful. Has that been the secret of my dissatisfaction?' (*Henry and June*)

[14] *Temptation*

June Miller: a Romanian Jewess: Julietta Edith Smerdt. Did she change 'Smerdt' to 'Smith' to rid herself of a name which in Russian means 'death'?

At the age of fifteen she was a taxi-girl. She allowed men to embrace her for 'ten cents a dance'; and to have full sex for a few dollars more. She read Strindberg. In good times she was an actress with the stage name of 'Mansfield'; Miller made her eternal as Mona/Mara. Muse, mistress and praying mantis, religiously mythomaniac. Resolutely irrational, erring, ruseful, irresistible.

In *Tropic of Capricorn*, Henry Miller recalls their first encounter at the Orpheum Dance Palace, a dance hall off Broadway, in 1923: 'I see a woman perhaps eighteen, perhaps thirty, with blue-black hair and a large white face, a full white face in which the eyes shine brilliantly. She has on a tailored blue suit of duveteen ... What a walk. Tall, stately, full-bodied, self-possessed, she cuts the smoke and jazz and red-light glow like the queen mother of all the slippery Babylonian whores.'

'He loved her,' Alfred Perlès wrote. 'When you love alcohol or opium you don't ask if those drugs are good for you. June was worse than alcohol.'

It was June's black soul deep within her white body that Anaïs became aware of, at her first sight of this bleached blonde in her dark velvet cape who, on 30 December 1931, escorted by her husband, emerged from the darkness of the garden at Louveciennes. 'When she walked ... into the light of the door, I saw for the first time the most beautiful woman on earth. Years ago, I tried to imagine a real beauty; I created in my mind an image of just such a woman. Her beauty drowned me. As I sat before

her I felt I would do anything she asked of me. Henry suddenly faded.'

A meeting of two vain, mutually bewitched women. A game between two players: June played at having fun; Anaïs had fun playing. Two professional liars. A collusion of two bodies: one exhausted by pleasure; the other aspiring only to exhaustion.

In June, Anaïs saw the realization of her fantasy of elusive, multiple woman, the side of her nature she would not admit. June could be sacred priestess or demon, sometimes full of innocence, sometimes malevolent. But, perfumed, dramatic, June was utterly desirable to Anaïs, whose sensuality was aroused by smell and sight.

June liberated her sense of daring, her promiscuity, her feminine and artistic perversity.

June was Anaïs's *fleur du mal*, her flower of evil.

The two women became inseparable. Their husbands were away: Hugo was in Switzerland on business. Miller had taken a job as an English coach at the Lycée Carnot in Dijon for five francs a month, and full board.

Dressed in pink, violet and black, they haunted the dance halls: among them the Monocle on boulevard Edgar Quinet, a place where the female orchestra played for a lesbian clientèle.

June's account

She ordered champagne. What was she trying to prove? That she could pay? – she spent a fortune trying to impress me. That she loved me? – no one loved Juliette Smerdt. Except Anastasia. *Stasia moia*. She changed her name to Jean Kronski, as I had changed mine to June Mansfield. I've always detested my real name. In Russian 'Smerdt' means death. Stasia blew her brains out, which pleased Henry, who loathed her because she would have nothing to do with him. He said she was mad. But in his view all women are. The truth is that he's afraid of them. Except for prostitutes. They keep their legs open and their mouths shut. If only he'd stay in Dijon. Anaïs thinks I love him: 'The only

strength which keeps you afloat is your love for Henry. He hurt you, but he allows you to keep body and soul together.' What does she know about it? I have to be on my guard with her. Perhaps she fancies Henry? Flirting with me might be a way of catching him. Anaesthetizing her rival. She'll do anything to get what she wants.

I guessed that that evening when she entertained us in such great style at her exquisite house in Louveciennes. Henry had gone on and on about how elegant she was, so I got dolled up in my dingy old dress. Did that shock Anaïs? No, she was mesmerized. Her eyes never left me, while Henry scarcely got a look in. He talked. About our years when we were broke, the bootlegging place we had in a Brooklyn cellar before we went bankrupt, our flit to North Carolina, the lingerie business he wanted to start to draw in the suckers, our return to New York – still skint – our daily visits to restaurants ordering food and leaving without paying, the nights I spent at the Catacomb Club and the times he stormed in mad with jealousy, and tore me out of the arms of my clients.

'What a chancer you are. I would give anything to have had your experiences.' She took my hand.

'You're incapable of letting something like that happen,' I said, my eyes sweeping the room.

Henry was green. She murmured that I was probably right.

Perhaps she does love me, or perhaps she's playing at being in love. It beats me. I give her as good as I get. The monologues I know all about. The flattering remarks. The beautiful lies that pour off the production line because there's nothing works better than to tell a middle-class woman who's mad about her figure that she's the most elegant woman ever to walk this earth. 'When you walk, you seem to glide.' She's weakening. You would think no one has ever paid her a compliment in her life, or – more likely – she can never have enough.

What can I whisper to her? That I love her salmon pink dress

with its long-line black strapless top? She would be quite capable of undressing on the spot and giving it to me. Like her turquoise ring. I'd said I thought it was beautiful. 'Take it . . . it was a present from Hugo. It's my favourite stone. You have it.'

She gives me cash. I take what I need to buy silk stockings and some perfume. Never more. There's something that I don't like — she's a woman. I'd rather fleece a man. It's rotten about the cash she steals from her husband. That Guiler is a good guy. A bit of a bore, but serious. If he could hear me, he wouldn't believe his ears. He would think I'm like that girl in the Renoir film who walks the grands boulevards, *La Chienne*, unscrupulous. But I still have more scruples than his wife, who's sleeping with her cousin Eduardo when he's away on business trips. 'I want to dope myself with experiences,' she told me. She wants to see everything, live to the hilt, try every sensation. She wants me to show her what life is all about. And vice as well?

She wanted to go to the Monocle. It's a sinister place. She revelled in it, shivering like a little girl being carried off by white slavers. She stared at the dykes swaggering about in their outfits and their protégées gazing at them amorously, blondes, consumptives. She pointed out one who looked totally lost, she was so drunk, and asked me if I would like to kiss her. I shrugged. I'm not one of them. She seemed disappointed. I think she wishes I was a pernicious pervert. Then she suggested we smoke opium. I almost choked laughing. Opium. Dreams of the Orient. Heavy draperies. Incense burners. Black slaves. Floor cushions scattered among the lilies. A writer's delusions. I've smoked marijuana with Jean. To no effect. I prefer cocaine. Anaïs wants to know all about it. I described the Bengal lights in my brain. The dry lips. The feeling of emptiness in the chest.

'I always find your silences so disturbing, June.'

'I was wondering why you are so good to me.'

'Not good. Protective. Do you remember in that shoe shop when I wanted to buy you some sandals, I got everything you

didn't dare ask for. I laid down the law. I behave like a man when I'm with you.'

'If men were like you, I'd sleep with them more often.'

'Stop being so trivial, June! You're wonderful. Henry is a bad judge of you. You're no demon. It's what life has done to you. I love you, June. We share the same fantasies, the same follies. You're the only woman who lives up to my imagination. You're like me, we're both in search of ecstasy. We're drowning. Let's drown together. It's beautiful, so beautiful. Give me your lips, June.'

She seized my hand, drew my face to hers. I placed my lips on hers. All around us, women were squeezed against us, bracketed together.

Henry would have made a fine scene out of it.

LESBIANISM

Ever since the Belle Epoque, there had been a sympathetic ambience. Paris, from Saint-Germain to Passy, had always shown an openness to deviant behaviour (homosexuality was never an offence in Paris as it was in London).

A literary theme, from Baudelaire to Pierre Louys.

A form of relaxation for a woman of the world, which could claim a distinguished history: from the Marquise de Belbeuf to the Duchesse de Clermont-Tonnerre.

An eccentricity of artistic life: Sarah Bernhardt, Colette.

A brothel speciality.

An ethical code: those pioneers of the Left Bank from 1900 to 1930 who based their modernity on inversion: Nathalie Clifford Barney, Djuna Barnes, Sylvia Beach, Romaine Brooks, Gertrude Stein.

For the thirty-year-old Anaïs: an equation:

Lesbianism = Freedom = Dandyism

She was emancipated by her love for June: 'I have discovered the joy of a masculine direction of my life by my courting of June.'

Perversion of the aesthete: 'Games combining garters and black stockings . . . myrrh between the breasts, incense of their mouths . . .' (*Ladders to Fire*)

Self-love.

Love-making that was mesmerizing because it was sterile.

'There is no life in love between women. Our love would signify death, the love-making of two ghosts.' (*Henry and June*)

That love-making between two women could be another form of narcissism Anaïs had never doubted: 'It was not the desire to possess the other . . . but to become the other . . . Their bodies collided as if each of them had met its own image in a mirror.

93

They had felt the cold wall, they had felt the mirror that never appeared when they were taken by men.' (*Ladders to Fire*) Of pleasure without orgasm: 'They separated. They had not found what they were looking for. It was not the possession they had imagined.'

What was woman looking for, Freud wondered.

Anaïs attempted an answer, though she equivocated.

When she described lesbian love, she defended herself for having indulged in it: 'I experienced a warm friendship towards women, but never a sexual desire . . . I never loved a woman sexually.'

Was she afraid of being drawn into Women's Lib? Of losing Rupert's love?

Had she forgotten Otto Rank's intuitive observation: 'To explain homosexuality as an identification of the man with the mother, and of the woman with the father was not enough. There was a transgression over certain boundaries, which expressed a need for creativity: an imperious energy which has little connection with ordinary sexual activity.'

Should an artist be expected to have only one sex?

[15] *A diabolical contract*

Anaïs was just twenty-nine. The memory of June who had suddenly left for New York, lived on in her body, now awakened by their lesbian idyll. But her mind was elsewhere, swamped in a tide of words, the monologue of a mad *littérateur*, the delirium of a life-junkie exiled to a lycée in Dijon. It was from 'a frightfully cold room, no running water, on the top floor of a dormitory' that he addressed his first letters to Anaïs. Scribbled on the spur of the moment in a seemingly chaotic torrent, on any old paper he could lay his hands on, old envelopes, the back of a menu; often undated, slapdash rough drafts several pages long, bursting from a mind on fire: Miller's letters left her thunderstruck. She said, 'There are two ways to reach me: by way of kisses or by way of the imagination. But there is a hierarchy: the kisses alone don't work.'

D. H. Lawrence's novels had awakened Anaïs. Miller's letters were about to possess her. It was a verbal seduction before it was a physical one.

In the course of one year, 1932, Miller sent her nine hundred letters. And if, on 8 March 1932, she gave herself to Miller the man, in a room at the Hôtel Central, 1 bis, rue du Maine, she had long ago offered herself to Miller the writer.

'What is so strange is that together and alone, we are so human, so softly warmly human (those hours in the kitchen), and in our writing turbulent, turgid, spectral, febrile, monstrous; drenched in homoerotic carnalities. My enameled style and your muscular one, wrestling, drawing sparks from one another.'

They wrote to each other more than they made love. They wrote less because they loved each other than because they loved writing; they were united in literature, more closely joined

95

together 'after' than 'during', when, lying naked in bed, they would return to their 'work in progress'. 'Even afterwards, we talk about work,' Anaïs noted. The flesh which bound them was composed of words. 'What rendered Henry indestructible was the same thing that made me just as indestructible: the fact that at our very centre was a writer and not a human being.'

A writer simultaneously male and female – transgressing the imperatives of his or her sex – profoundly alone, detached, jubilant, requiring for his or her existence nothing more than something to write about.

A writer who looked at himself and herself in the act of love, who listened to his own or her own enjoyment of sex, and who therefore never entirely yielded to love or pleasure. 'Between Henry and me there existed this diabolical contract between two writers.'

These two so very different people would never have been physically united without literature, without the words they produced like a barrage, channelling water into a great torrent, into a violent impatience, a common rage to be published.

The fury of writing is evident in their first impetuous letters, in their jubilation at at last being listened to and read; of being recognized as artists; in their common conviction that there was a failure 'to liberate the element of violence in man without which he ceases to be creative.'

They wrote to each other, nerves raw, at every hour of the day. Letters were composed of the stuff of fiction, 'living, vibrant, white hot'; from manuscripts mutually exchanged, criticized; they were in turn both judge and apprentice. Equals. 'You are not a rival to my work. You are not the sacrificed muse,' was what Miller said to her when he read Anaïs's childhood journals, which he acclaimed as a masterpiece.

They wrote, all their thoughts were about writing; it was what they lived for. Their desire for each other was channelled through their writing: 'what you wrote me is so beautiful it hurts.'

It was not so much a question of the postures of love-making, as the posture of being intellectuals. And a third body was to interpose its sex, its pale skin, dyed hair, black and purple dress: June. A harmful aura. A woman as object twice over, a woman incapable of producing words, only changing, chaotic images from which the two writers drew their fantasies. 'June did not see any difference between fiction and reality,' Anaïs noted. 'We both, so much, loved that in her.'

Before Henry and Anaïs were joined in sex, they had both desired June, they had both plumbed the depths of her black soul, discovering the dark part of their own. She had made Miller suffer. She had taught Anaïs pleasure.

June cemented their passion.

'June felt it too. She said immediately that you were in love with me, or else I with you,' Miller wrote. 'And then June met you and she fell in love with you, and I was a little unhappy, not because of June, but because of you. And when I came and wept in your house, underneath all my sorrow and despair was a deep desire to put my arms around you.'

The day after Anaïs first gave her body to Miller, in a room in the Hôtel Central, she wrote to him: 'Henry – the love for June is still there. I couldn't bear seeing her [photograph] yesterday. She possesses us both.'

When she took Hugo to 'No. 32', a brothel on rue Blondel where Miller was a customer, it was to look at two girls there in lesbian poses: 'I touched the heart of June's being,' she wrote in her journal. She confided the following dream several weeks later: 'I dreamed last night of June. June had suddenly returned. We shut ourselves up in a room . . . I begged her to undress. I begged her to let me see between her legs. She opened them and raised them and there I saw flesh thickly covered with hard black hair, like a man's . . . I just watched her, fascinated and repulsed, and then I threw myself on her and said: "Let me put my tongue there", and she let me do it.'

Without June, there was nothing forbidden. No eroticism.

Miller was no Sade, no Baudelaire. His only vice was life itself. His love-making was that of a virile man who had no doubts. 'Anaïs, I am going to open your very groins. You're food and drink to me — the whole bloody machinery, as it were . . . I am sitting here writing you, with a tremendous erection.'

Healthy pleasures for the unsatisfied wife of a respectable banker. Wholesome pleasures. Too wholesome for this complex woman, whose sensual ambiguity had been awakened. 'I want to dope myself with experiences. I want to know them intimately. I want to bite into life and be torn apart by it. Henry gives me all of that. I have awakened his love. His love can go to the devil,' she wrote at the height of their passion for each other.

She believed she had found someone to master her, but he was just a man whom happiness was to subdue, feminize, soften to the point that he would ask her to marry him. One doesn't marry one's lover, does one?

In August 1932, Anaïs confided in her journal: 'When I read Henry's ardent love letters, I am not stirred. I am not impatient to return to him . . . I feel insincere. I have to force myself to write at all.'

This is a key passage, for there is no correspondence more suspect than that of two writers whose feelings are primed by writing, and whose effusions serve no purpose but style.

CHILDBIRTH

She had no wish to bring children into the world, only dreams and works of art. She wanted to be a mother to artists.

'In order to create you must *not* beget.'

'I could not remember anything. Everything was blood and pain . . . I am too weary to move even towards the light, or to turn my head and look at the clock. Inside of my body there are fires, there are bruises, the flesh is in pain. The child is not a child, it is a demon strangling me.' ('Birth')

Buffeted between the ego of her artist father and the bitterness of a mother who sacrificed herself, the rule was deeply ingrained; it was so strong that at the moment of giving birth in September 1934, she gave birth to death.

'I pushed with anger, with despair, with frenzy, with the feeling that I would die pushing, as one exhales the last breath . . .' It was a little girl, who looked like her. 'Show me the child . . . The doctor holds it up. It looks dark and small like a diminutive man. But it is a little girl. It has long eyelashes on its closed eyes . . .' ('Birth')

The carnal chain is broken. Anatomy abolished. Her destiny is to be creative.

From this death, she brought forth a story, 'Birth'.

From this death, she brought forth words.

The journal: a long pregnancy.

Writing: giving birth to words, nourishing fantasies.

She wanted to be the matrix, to surround like a mother . . . All that happens in a real womb, not in a substitute man-made womb. She wanted to go back into the true womb, to attract men there, struggle to keep them there. Anaïs is Gaia, the first human being.

A mythical mother.

'I am the young mother of the group,' she wrote of the guests at Villa Seurat. 'All of them ... The mother of their dreams. I gave them what their father and mother could not give each of them.'

'Her children! God Almighty,' bellowed Miller. 'She considered her friends — myself included — as her children, as if we were incapable of surviving without her.'

[16] *Detachment?*

From 1934 onwards, after the death of her baby daughter with the long eyelashes ('her father,' Anaïs wrote, 'is an artist who wants all the love, all the warmth for himself') – the letters become bogged down in resentment. Anaïs wanted to serve Miller. Body and soul. Through sex and money. But nothing could fetter this eternal nomad, this mystical pagan who could encapsulate in one burst of enthusiasm the love of a woman and the flavour of a wine: 'The truth is that you are perfectly happy at Clichy on your own,' she reproached him. 'A ray of sunshine and I'm dizzy, a touch of happiness and all too quickly I forget my miseries, you say. I am fundamentally merry, happy, easy-going,' Miller replied. Miller was Adam before the Fall, an Eveless Adam, with no bad conscience, a free but fundamentally innocent man.

Anaïs hoped to topple June's position in Miller's pantheon. She would have liked, like so many mistresses of artists, to be the catalyst for that 'crystallization' Stendhal described, which would have made her the 'eternal idol'. But for Miller – and it was for this that he loved her – Anaïs was an accomplice to whom he could say everything, and even write at the end of a letter: 'Oh well, I have to go and buy a chop now.'

She demanded the ideal. He exalted in the humdrum.

The first attempt to make a break from the relationship happened in November 1934, when Anaïs joined the psychoanalyst Otto Rank in New York, without telling Miller. To make him more jealous, she resorted to sending Miller a letter apparently addressed to Hugo. And Hugo a letter written to Miller, who discovered that it had all been rigged: 'A dull oaf like me' needs time 'to grasp the *real* reason for the mistake, this peculiar

mistake, in which you whitewash yourself so completely. I don't know why I feel hurt but I do, nor why I feel distrustful, but I do ... All women are liars, incorrigible liars the best of them,' he wrote before embarking for New York himself.

Neither their meetings, nor their intense literary collaborations (Miller wrote *Scenario* based on *Alraune* – and early draft of her *House of Incest* – to make it better known; Anaïs went to London to plead Miller's cause with Rebecca West) could reunite them physically.

'When I walk into your place, I see the most expressionless face ... It is not enough just to take a woman to bed, you know,' Anaïs wrote to him in 1937, with the coldness of someone who has just found a new lover.

She would have many others, more handsome, younger, richer, but incapable of the casual devotion of the man who mockingly affirmed: 'You can always use me as a doormat for your art. That should please you a bit, Anaïs Nin (because you are a great artist).'

'Probably, if I had then the sense of humour I have today, and if you had *then* the qualities you have today nothing would have broken,' she recognized in 1953.

Too late.

[17] Bohemian

No. 4, avenue Anatole-France in Clichy. A workman's house, half an hour's walk from Porte de Clichy station, the Metro terminus. 'As beautiful as Park Avenue,' Miller exclaimed when he moved in with Alfred Perlès in the spring of 1932.

'Fred' was an Austrian by birth and a journalist at the Paris office of the *Chicago Tribune*. He had known Henry and June since 1928, from the time of their first European odyssey. As a rejected lover of June, he had transferred his affection to this Brooklyn boy whose insolence he envied – Miller was indebted to him for his position as a night proofreader on the *Chicago Tribune* for forty-five dollars a month.

For someone who had resorted to pocketing tips off saucers in cafés, it was a life of luxury. He could at last have a place of his own, the 'room of one's own' without which Virginia Woolf could not have written.

The apartment had two rooms, separated by a corridor – the two friends could have people in, and go out, in total freedom – a bathroom and a kitchen: 'the most important part of the flat,' Perlès wrote. 'It was where we spent our best, our happiest hours. For one thing there was food in the larder. We no longer had to worry about the next meal, or about the meal after the next . . . But that magical kitchen of Clichy not only catered to our bodies; but our minds as well. It makes the tears come to my eyes when I think back to those long sessions we had there – often till the small hours of the morning when the dawn changed the colour of the air from black to gun-metal blue . . . There wasn't a subject under the sun we failed to discuss in that kitchen. We were gay and insouciant, and permanently inspired.' (*My Friend, Henry Miller*)

It was more than just a place, it was an ideal Bohemian setting for a middle-class woman's secret assignations, which began as soon as her husband went away on business. Anaïs left Louveciennes, the garden, the piano, the Spanish maid and her marquetry furniture, for a view which plunged over the tin rooftops of the *faubourgs*, for an oilcloth stained with Muscadet and ink on which they remade the world; and love.

'How precious the moment in the Clichy kitchen, with Fred, too. They were eating breakfast at two o'clock. Books piled up, the ones they wanted me to read, and the one I brought them. Then in Henry's room alone. He closes the door, and our talk melts into caresses, into deft, acute, core-reaching fucking.'

In a letter to Anaïs, dated 17 June 1932, Miller announced the arrival of a newcomer: 'a Mlle Paulette, *dix-neuf ans, une amie de Fred*. No more housecleaning for us, Paulette will do everything. She makes me very happy to watch her — just like a child.'

From the moment Fred first mentioned Anaïs, with his heart in his mouth, Paulette burned to know the woman he referred to as 'the Goddess', a term which seemed a bit suspect to her. How could someone so divine fall for a man who had holes in his socks, struck matches on the soles of his shoes, drank any kind of rubbishy wine and ate sardines straight from the tin.

Paulette was told that Anaïs was rich, that she had fitted out the apartment at her expense, and that she led a grand life in a vast house to the west of Paris . . .

When Paulette cleaned Henry's room, her perfume made him gag. The scent of *Chypre* and narcissus clung to the curtains. Sometimes when Paulette changed the sheets, a garter would slide out like an exquisite little snake. In the drawer of the commode where Miller shoved his papers was a pile of silk underwear . . .

Fred was wont to say: 'Anaïs. Talk about casting pearls before swine . . .'

Paulette left the room then. She felt ill. One morning, someone knocked when Paulette was still lazing in bed. 'Who is it?' she

called out, drawing the covers up to her chin. 'It's me,' a fluid monotone voice replied. Paulette guessed it must be the goddess. She dressed hurriedly and opened the door to a tiny woman, out of breath from running. So, what was exceptional about her apart from her turquoise earrings? Her eyes: the muted shine of jade. She carried an enormous leather suitcase and cast anxious looks around the room.

'Where's Henry?'

'At the paper, with Fred.'

'Are you his new friend?'

Paulette nodded, but there was something in her tone she didn't like.

'Is the room ready?'

Paulette almost shouted at her: 'Who do you think you are, playing the goddess with me?' but the sight of the suitcase shut her up. She followed Anaïs into Miller's room, wondering what marvels the suitcase might contain.

Anaïs made a minute inspection of the room, opening the wardrobe, the drawer of the bedside table, examining a letter which lay on the chest of drawers. She even went so far as to feel inside the pockets of a pair of trousers hanging over a chair. She found nothing. She seemed piqued. She decided to undo her case. Paulette craned closer, her hands behind her back. Her temptation was always to touch. The lid sprang up. Paulette let out a cry. Inside lay the trappings of a goddess: a satin petticoat, a bodice in Calais lace, crêpe-de-chine pyjamas, silk stockings, *Mitsouko* by Guérlain, powder by Caron: 'Love only me'. Two or three books and a huge notebook which she carefully laid on the bed.

'Don't touch it – it's my journal. Henry has to read it this evening.'

Her journal. It was so thick that Fred had nicknamed it the Whale. Henry had brought it in to read to Fred. Paulette remembered their angry outbursts. 'She'd do better to wall it up somewhere where it could never be opened again. She should be living instead of petrifying her life,' one said. 'It's sensitive,

shattering,' the other one countered. 'It's gobbledy-gook. She should write less and sweat a bit more. Her sentences are too dramatic, too throbbing – she writes like an hysterical woman.' 'She must publish her journals. They are eating her away.' They had argued half the night.

You had to be a crackpot to get excited on paper.

Anaïs was certainly that, and more.

In the end the two women got used to each other: Anaïs lost her air of superiority. She took to Paulette, who was not much more than a child, and who kept her company when she came to stay at Clichy without warning, suitcase in hand, on the point of tears when she did not find Miller in. Paulette would make her coffee and they would sit in the kitchen, with Anaïs peeling the vegetables to calm her nerves, but all the time plying Paulette with questions. What time did Henry get back? Which bar did he go to? Who with? Paulette would lie. It would have hurt Anaïs to know that he had stayed out all night.

Anaïs would kiss her on the cheek, reassured.

She improves on acquaintance, Paulette would say to those who thought her pretentious. She could make tortillas like no one else. You ate them piping hot with a glass of red wine. Anaïs never got drunk, just merry enough to laugh at the men's jokes.

Then each couple would retire to their room. Sometimes you could hear her calling out: 'Heinrich!'

Did she love him? At first appearances, yes. Nothing was too beautiful for him. God knows how many shirts she had given him, and the typewriter clattering away till dawn, and the gramophone, and the records, not to mention money.

Anaïs gave him masses of that.

She could also be cruel at times and scathingly point at his clumsiness: a stain on his shirt or a speck of sauce at the corner of his mouth. Miller would blush like a little boy taken to task. She took her revenge. And quite rightly so. Miller was not always what you might call 'chic'. The money she gave him went on girls, Anaïs knew that. Paulette wondered if there wasn't some-

thing a bit perverse in the way she handed him money. In her patience too: what woman would put up with listening to panegyrics about her rival? Anaïs did.

Miller was obsessed by June: June's voice, June's pallor, June's splendour, June's figure. What a woman! The insults rained. Anaïs would calm him down. 'You're being unfair to her, Henry. Listen to me. Only I understand her. She's foundering without you. She confided in me. One day I'll write my version of June.'

Who was she losing her head over?

One day when Paulette was walking through the Gare St-Lazare with Fred, she had seen Anaïs wandering about like a lost soul, her eyes full of tears. Fred went up to her and she collapsed on his shoulder.

'I'm at the end of my tether. You know that he regularly sends me what he's in the process of writing? His book on June . . . A package came yesterday evening. Thirty typed pages of passion for another woman. I read them over and over all night. It tortures me to read those descriptions, even if I like reading them. He uses words that stab me to the quick, sentences that poison my dreams, little remarks on the way she is, her habits.'

'Calm down, Anaïs. When a man starts writing about a woman, it's because he looks upon her as dead. And don't take everything he says literally. Miller always fantasizes to some degree.'

'Is that all you can find to say to me? That he's invented it all? What are you trying to do to me? You're saying he loves either a real woman, or the fantasy image of a woman, but either way it's not me.'

There were happy days. At Louveciennes. Paulette, Fred and Henry would ride over on their bicycles. Henry carried his manuscripts in a large pouch. He never wrote a line without submitting it to Anaïs. He considered her a better judge than Fred.

Paulette was dazzled by Louveciennes. Its copper, precious glassware, the Moorish pedestal table on which sticks of incense were burnt. And the bedrooms. Her own on the first floor was in

faded pink with wall hangings. Anaïs had placed a bowl of fresh fruit and illustrated magazines on the bedside table, a vase of wild flowers on the windowsill. There was even a negligée.

How could a woman of such delicate sensibilities allow her lover into her own marriage bed, wondered Paulette, astonished to take sides with the unknown man in tennis clothes in the framed photograph on a table in the drawing room. Hugo Guiler had boyish looks. He had glamour, and a certain frailty too. He didn't deserve to be deceived. For Fred, it was not so simple.

'Guiler knows all about it.'

'Then why doesn't he say something about it?'

'He's had as much as he can take. Anaïs exhausts him . . . he can wait.'

'Wait for what?'

'For their passions to cool. One day, Anaïs will tire of entertaining Henry . . . Where do you think she gets her money from?'

'She sells dresses.'

'She may claim that. What really happens is that she doctors the bills. Guiler always gives her cash to pay; she pockets the difference and hands it over to Henry who goes straight to the brothel.'

'God, you're sordid.'

'It's true. Anaïs is buying herself a genius who gives her a lot of pleasure. And Miller has a *grande dame* who's mad about literature. Neither one nor the other should have anything to complain about. They know very well what they're doing, why they're doing it, and how long it will last.'

'And what if Henry asks her to marry him?'

'He already has. She's turned him down. She would never leave her husband. Do you know what she said to me one day? "Henry is mostly a physical person and that's why June is so essential to him. Me too. I love him in a sensual way, but in the long run it can't last. He is condemned to lose me."'

Anaïs could be clear-headed when it suited her.

TRANSITION

There were many things that Anaïs was to owe to *transition*: the courage to venture beyond her Journal, to use her imagination like 'a drug', her dreams as revelations, to draw on her trilingualism to create her own language, to use her neurotic temperament as a subject for literature.

A review. *The* review for English-speaking writers in Paris between 1927 and 1938, writers who, in the footsteps of James Joyce and Gertrude Stein, fomented the revolution of the word, and who, like Eugène Jolas, its founder, felt the need for a new language crossbred from all languages, all myths, all forms of art. Anaïs, exiled in Louveciennes, recognized a territory beyond magazine covers by Miró, Mondrian, and Duchamp, a territory resonant with the dissonances of 'Dada', the dazzling prose of the Surrealists, like Breton, Kafka, and Michaux whose first translations she had read, and the sonorous poems of Hugo Ball, as well as the writings of schizophrenics. Her brother Joaquin recalls that she was 'more interested in Jolas's theories about hallucinations than in extracts from James Joyce whom, however, she defended with verve against his detractors.'

'*transition* released my imagination,' she wrote in April 1932, when she was making preliminary sketches for *The House of Incest*, the kind of prose poems which would have been right for *transition*.

Spring 1932: No. 21 of the review had just published a manifesto, which stated:

'The revolution of the English language is an accomplished fact.

'The creator of literature has the right to destroy primary matter: words which are imposed on him through manuals and dictionaries.

'He has the right to resort to words which he himself has fashioned and to ignore laws of grammar and existing syntax.

'Time is a tyranny which must be abolished.

'The ordinary reader can go to the devil.'

For an untried writer, what better drug than these *diktats*?

Anaïs would learn how to abuse them.

[18] *Allendy*

When Anaïs walked into the mansion of 67 rue de l'Assomption, she recalled what her cousin Eduardo had said: 'The moment had come for me to be psychoanalyzed. Only Dr Allendy could be a guide.' A maid showed her across a shadowy hallway, then into a drawing room with dark velvet armchairs. Opposite stood a door hidden by a curtain in Chinese gold brocade. It was Dr Allendy's office.

Allendy was a man of paradoxes. He stood midway between the establishment and the fringe. With Marie Bonaparte he had founded the French Society of Psychoanalysis; he was passionate about allopathy, occultism and alchemy. And modern art. With his wife Yvonne, he supported Antonin Artaud who dined with him every Sunday, and recognized his genius by inviting him to the Sorbonne where he was directing a series of lectures on the organization of philosophical and scientific studies in order to examine new trends. Anaïs had attended them before meeting him. She had remembered a sentence of his: 'Psychoanalysis can outwit fate.'

This new development in her life had nothing daring about it. As Elisabeth Roudinesco shows in her book, *L'Histoire de la psychoanalyse en France* (Seuil, 1986): 'In France, after 1920–22, the intelligentsia as a whole were interested in Freud's theories, if only in order to reject them. They were curious; they wanted to know more about this revolutionary concept . . . There was a "fashion" for Freudian theory in the salons . . . Psychoanalysis became an integral part of medical treatment since a number of intellectuals decided to undergo analysis. This was the case with [Georges] Bataille, [Michel] Leiris, [René] Crevel and even [André] Gide . . . Generally, they viewed analysis as a therapy, and not as an intellectual adventure.'

Anaïs's attitude was more ambiguous. Her guilt about her deceitful life weighed her down, she was haunted by her father, and by her memory of June. She invested in analysis a banal hope of being delivered from them. However, she was mistrustful. The jargon repelled her. The practical aspects disturbed her. If she revealed so much of herself, what would she have left to put into her journal?

However, she was prepared for it. She was curious. She wanted to refine what she had learnt from the Surrealists, to draw her own 'surreality' from the experience.

Allendy also intrigued her with his 'air of a *moujik*'. He looked more suited to reading horoscopes or dabbling in alchemy or reading a crystal ball: he looked more like a magician than a doctor. Ultimately he would let her down. He did not take her seriously. He nicknamed her his '*petite fille littéraire*' — his little literary girl. He reduced everything to incest. She was hoping for a magus, a priest, a god. She rejected him as a man, by seducing him.

Otto Rank would have the same fate.

People have interpreted her behaviour as flirtatiousness, nymphomania, sometimes hysteria . . . I myself view it more simply as a means of freeing herself. Seducing your analyst is a way of finishing with the analysis without abandoning the unconscious.

The black curtain fell. Allendy lay down and brought his hand to his nose. He smelt only the smell of her flesh. Hadn't he embraced her strongly enough? In the course of the session Anaïs had complained about her small breasts: 'It's perhaps a sign of certain masculine traits I have.' He thought it wouldn't hurt to ask her: 'They haven't developed then?' It was a practical question. He'd expected a short answer. She had sighed. She had smiled. With her, her gestures betrayed her words; her intonations contradicted her looks; above a straight skirt, she might wear a blouse with a plunging neckline; beneath a dark coat buttoned to the neck might be glimpsed a dazzling red dress.

She had smiled, and showed him her pale pointed breasts, like the breasts of a virgin.

Anaïs, Anaïtis. Goddess. Vestal. Fatal. Emblematic. Sister. Whore. One of his patients, Eduardo Sanchez, had sung her praises at each of his sessions. Anaïs was his cousin. She had been his mistress. Once, twice perhaps – as a favour, he said. To reassure myself. To prove to myself that I was a man. No, she was not perverse. She was candid, even when she was bad.

For their first session, she dressed like a female warrior. But the helmet of auburn hair, barbarian bracelets, and bold dress did not deceive Allendy. The *femme savante* hid a vulnerable woman.

'I've read everything of yours. I even took notes on your *Problème de la destinée intérieure*. I was interested by its theme. You know that I write?'

'Eduardo often mentioned your intimate journal.'

'He's frightened by it. They're all frightened by it. Him, Hugo, my father, even Henry – who claims it's a form of regression. They would destroy it if they could. How can you possess a woman who writes with her nerves and her blood? When I was working on D. H. Lawrence, my body remained completely dead for a fortnight. Hugo couldn't understand me. He thought it was his fault. He was so crestfallen. I had to reassure him, console him, mother him. It's not strong women who make men weak, it's weak men who make women too strong.'

Her forehead was burning, but her hands were trembling. 'Stop lying,' he could not help saying.

She burst into tears.

They were to see each other every Thursday.

Her vivacity, her sensitivity, her astonishing visual recall, the agility with which she ridiculed her dreams made her an extraordinary patient; but her case was not.

Allendy recognized with a hint of bitterness that it was a question of a banal Oedipus complex. The feeling of guilt associated with the father's departure channelled his patient's behaviour into two patterns: a violent desire to win her lost father in every man she

met; and an equally violent fear of being dominated by him, fear that she exorcised by playing at being a female Don Juan. As for her neurosis, it was similar to what he had dealt with in his last lecture: a morbid form of idealism.

Ever since she was a child she had felt guilty. She was haunted by images, deformed images, as though seen through a screen of water: black suitcases on a wagon, a figure of Christ in a Spanish cape standing in front of the white pages of a notebook, a narrow tunnel with the menacing flexibility of a snake. Allendy deciphered each one with ease. He reduced everything, simplified it, refined it until he was back to the fundamental patterns. Self-assured in his knowledge, he moved through Anaïs's unconscious with a machete.

She was at first attentive, industrious, enthusiastic when he gave her several pieces of research to do which he did not have time for himself. She made notes for him on books on medicine and astrology, translated his articles for an American magazine. She never missed one of his lectures. She would dress with care, sit in one of the front rows and wave to him, discreetly. He was proud of it. Stupidly so. He loved to make fashionable women confess.

Anaïs's brother gave a piano recital. Allendy was invited and took his wife with him to the Chopin concert hall. Yvonne was wearing a dress with a dropped waistline which made her look large. She did not know how to dress. Ordinarily her gaucheness aroused in him a feeling of tenderness towards her. That evening he detested her for being so lacklustre compared to Anaïs, whom he perceived in the gallery in the interval, glittering in lamé and furs. They waved to each other. She did not come down to see him. A bewitched circle of admirers held her as in a cloud. She felt like a queen up there. Eduardo was giving her smouldering looks. Hugo leant towards her, drinking in her words. He recognized Miller, a great beanpole with a balding head, in conversation with Eduardo. Hugo's shoulders shook imperceptibly. All these men

around her. They were young, proud, luminous. He felt he was undesirable, encumbered by his body, as though tainted with his wife's gracelessness.

The analysis wavered.

His rule was to say nothing, screened behind the armchair. On the following Thursday, when she was talking about her father who had also been at the concert, he mumbled:

'And me, what did you think of me?'

'You looked sad. You looked more human, almost unhappy.'

Why was she smiling? Why did she leave her chair? Why did the cigarette she had just been smoking seem threatening? He tried to defend himself.

'As soon as you're dependent on someone, you work it so that the process is reversed: you wish that I needed you. You feel this need to conquer, because you've been conquered . . .'

She smoked, slowly. Her rounded lips around the cigarette seemed heavier. Fuller. He panicked.

'I noticed Henry Miller at your brother's concert. Do you know what I think? I think he's a monster. It's your neurosis that attracted you to June, to Henry, to their friends, an extraordinary woman like you . . . like a flower on a dungheap!'

She burst into a throaty laugh, such a deep, indecent laugh. Her lips opened, carnivorous above a string of little pointed teeth.

'You're jealous. That's really too funny for words. Come on then. Torment yourself no further. Ask me questions. I'll tell you everything: the nights spent with Henry, love-making in a taxi with June. What dark looks you're giving me. Is the word lesbian burning on your lips? Is that what I am, *cher maître*? You know *nothing* about it. You think you know.'

'Love between women is an escape . . .'

'It's more than that. It's a regression. A desire for death. It's that that we enjoyed. I've written a book about it. I'm still looking for a title. *Alraune* perhaps. I've put everything of myself in it, nightmares, silences, shipwrecks. How I would like to melt into June. "Your beauty inflames me. I'm dissolving as I've never

dissolved with a man. I am different from all the men, and I am myself, but I see in you that part of me which resembles you. I feel you in me." Would you call that transference?'

He detested intelligent women. However, he confessed he was beaten. He was tired of being untouchable. He became naked. He confided his bitterness to her. He and his wife slept in separate rooms.

'Would you analyze Hugo?'

'No, that wouldn't be possible.'

'Do it for me.'

And so he took on Hugo Guiler and listened to him behind the screen of his armchair.

'When I put my arms around Anaïs, she behaves like a corpse. She jumps if my skin brushes against her. She avoids my caresses. Or else she leads me on, so that she can escape all the more quickly. She stays out all night. I find messages left on my pillow. "Will be back later. Love you more than all the world." I slide down between the sheets, stunned by her words. When I wake up, her side of the bed is still empty.

'Her coldness excites me.

'Did you know she has a false journal in which she exorcises her fantasies? She talks of Miller in it. She describes their nights together. I discovered it in her room. I demanded an explanation: "Darling, it's all only an invention. I'm a writer. I have a monstrous imagination. You know me, I'm as pure as pure. Would I be acting as calmly as this if you'd discovered my real journal? I'd be in despair. Look at me, I'm smiling . . . I'm like a child."

'It was no child who forced me to go into that brothel in rue Blondel.

'The Madame seemed to know her. Anaïs asked for two women. She wanted to choose them. One of them looked like her, the other . . . had a raucous voice . . . like June. One wanted to be the man. Anaïs stopped them. She wanted them to stay as

women. You could hear their moans. Anaïs looked very tense. She pushed me towards the two girls . . .

'Has she spoken to you about our agreement? We had been married for two or three years. She demanded her freedom. "Once a week." No recriminations. No questions that day. One day a week to keep to herself for the rest of her life. She made it all sound very reasonable. But living it fifty-two times a year for ten years is more than a man can stand.'

[19] *Antonin Artaud: a composite portrait*

Anaïs–Artaud, from March to June 1933: three months of acid, sophisticated banter, from the Coupole to the Louvre. There is too little of it to understand Artaud, but enough to extract an intense, but untrue portrait.

March 1933. Anaïs could ill conceal her excitement when Allendy at last agreed to introduce her to his protégé; that evening she was to entertain Antonin Artaud, author of *Art and Death*, an actor with a mystical face, a theoretician of creative violence, a Surrealist disowned by the Surrealists, a bachelor, a man of inspiration – at last he was going to be seated opposite her at dinner.

She had been plaguing Allendy for such a long time.

'Do let me meet him. I've read everything he's written. The articles published in the *Nouvelle Revue française*: "Heloïse and Abelard", "Position of the Flesh", "Manifesto in Clear Language", his magazine interviews. His book of course. *Art and Death*. Every word had meaning for me; his "great thinking fervour", his "inaccessible virtuality". He is my brother in writing.'

'Don't play games with him.'

'I find his genius attractive, that's all.'

'Then don't flirt with him. Behave like a friend.'

'I tend to be rather masculine in the way I behave towards people anyway.'

'But that is hardly true of your body.'

Allendy was becoming distraught with jealousy. She no longer admired him. She complained about him. He was weak. He yielded too readily. At each visit Anaïs reformulated her request.

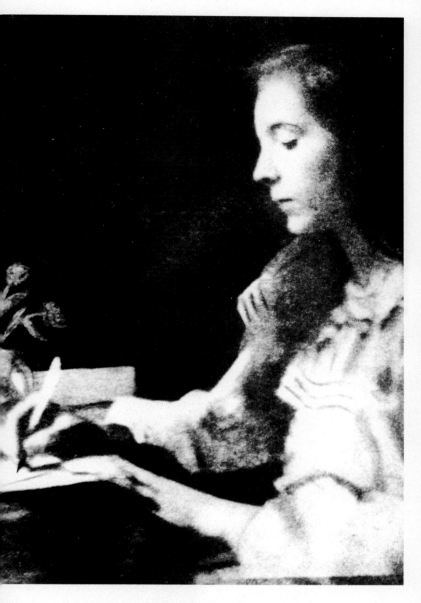

Anaïs Nin at the age of eleven, when she began her diary.

Anaïs-Astarté in Kenneth Anger's
film. Prisoner of her myth?
(*Photo Cinémathèque francaise*)

Antonin Artaud:
'His serpent's eyes,
as though shining from
the depths of a cave'
(*Photo Arch. E.R.L.*)

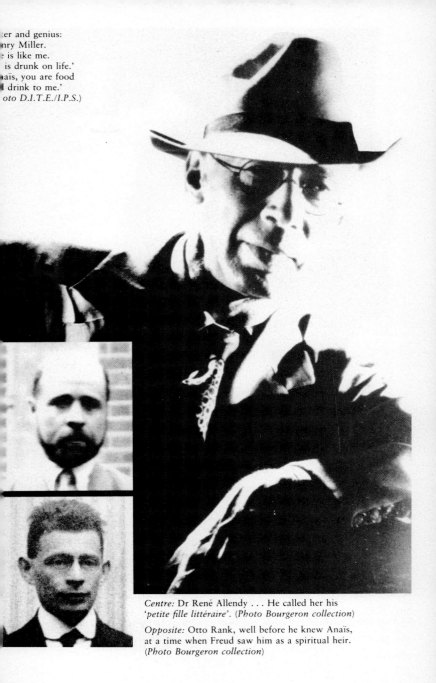

...er and genius:
...nry Miller.
... is like me.
... is drunk on life.'
...aïs, you are food
... drink to me.'
oto D.I.T.E./I.P.S.)

Centre: Dr René Allendy . . . He called her his
'petite fille littéraire'. (*Photo Bourgeron collection*)

Opposite: Otto Rank, well before he knew Anaïs,
at a time when Freud saw him as a spiritual heir.
(*Photo Bourgeron collection*)

Anaïs Nin, 1960s. (*Photo: Christian du Bois Larson. Copyright © 1966, 1976 by Anaïs Nin. Copyright © 1992 by the Anaïs Nin Trust. All rights reserved.*)

Anaïs Nin, 1960s. (*Photo: Christian du Bois Larson. Copyright © 1966, 1976 by Anaïs Nin. Copyright © 1992 by the Anaïs Nin Trust. All rights reserved.*)

The fame for which Anaïs had
waited fifty years. She bowed
to all its constraints:
interviews, lectures, residential
courses. American youth
identified with her. Dazzling,
somewhat fanatical, almost
Messianic. The journal became
'her letter to the whole world'.
(*Photo: Jill Kremnitz, above
left, and Louis Monier*)

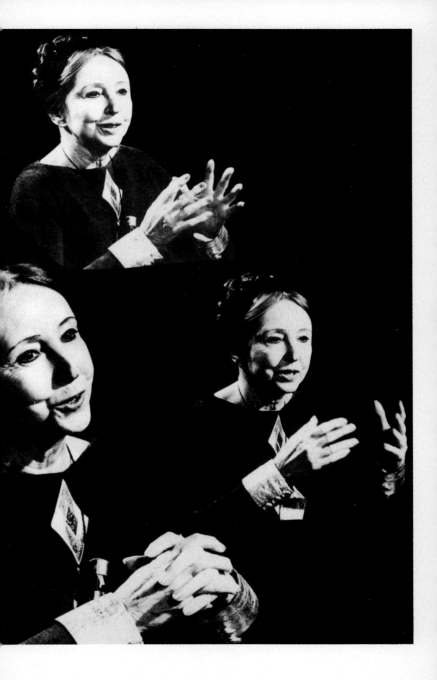

In the Brooklyn vault where she kept her journal: dozens of
notebooks covered in feverish handwriting.
(*Photo: Keystone*)

Allendy would hear nothing of it, until the day Anaïs proposed dinner at Louveciennes. Hugo would be there.

'He's interested in Artaud's project. He could be persuaded to put some money up for his Theatre of Cruelty. You know how generous he is . . .'

Allendy allowed himself to be convinced.

Antonin Artaud was going to drink from this glass. Antonin Artaud was going to wipe his mouth on this napkin.

Anaïs brought out her finest crystal. She had pencilled in her eyebrows. Dark eyes. Red mouth. Noh mask. Theatre. She wanted to dazzle this more-than-mere-human. The wind rustled in the branches. The iron gate creaked. The smallest noises put her on the alert. She would stand in the doorway when he emerged from the half shadows, just like June. They had the same spectral face, the same distorted lifestyle. They stood at the edge of the same abyss. They had a need to destroy, destroy themselves. Disintegration. Drugs . . . 'Artaud is a person in my literary life, like June. He has dramatic qualities.'

Anaïs still carried June within her, as she walked in the moonlit garden, beside Artaud's wasting body. The gravel crunched under their feet. Artaud examined the shadows. She rubbed leaves between her fingers. She loved his silence. She must not break it. She must forget nothing. Artaud seemed moved. She was even more so. I've entered Artaud's world and I shall follow him. His world is the same as mine.

Anaïs was only seeking her own image in him. 'We're the same sign: Libra,' she marvelled. She was mistaken. She was Pisces, Artaud was Virgo. They did not even share the same ascendant, but no matter. Differences left her indifferent. Only similarities appealed to her. They did exist: they both sought salvation through writing, they both saw creativity as a kind of alchemy; they both had a horror of a 'beautiful' style. *transition*, Eugène Jolas's literary magazine, had opened Anaïs's eyes to the first writings of schizophrenics. Artaud's writing had similarities. She

felt she had to introduce him to hers. She sent him her manuscript of *The House of Incest*, accompanied by a letter: 'Not one of your words in *L'Art et la mort* has fallen into a void. And you can see, perhaps, in these pages how I prepare a world to receive you, by an absence of walls, absorbent lighting, reflecting crystal, drugged nerves, visionary eyes, dreaming fevers.'

Artaud's reply came as a disappointment. He had not had time to read her manuscript. He had been 'literally obsessed, haunted, and uniquely preoccupied by a lecture that I must give on Thursday on the Theatre and the Plague.'

She took herself to the Sorbonne on 6 April 1933, escorted by Hugo. Miller was also there among the curious. The hall was full. At Artaud's request, Allendy had saved her a place in the front row. Artaud had not seen her come in. He was already in full spate, carried away by his own words. He was shouting, thundering, growling. Anaïs became totally absorbed in Artaud's face which 'was contorted in anguish'. 'His eyes dilated, his muscles became cramped, his fingers struggled to retain their flexibility. He made one feel the parched and burning throat, the pains, the fever, the fire in the guts. He was in agony. He was screaming. He was delirious. He was enacting his own death, his own crucifixion.'

At first there was silence, then someone laughed, then someone else. Then ten others joined in. They jeered, catcalled, hissed. They stood up and swore at him. Some just got up and left, slamming the door as they went. The room emptied in confusion. Artaud left the platform in a state of exhaustion. Anaïs went to meet him. 'He walked straight up to me and kissed my hand. He asked me to go to the café with him.'

He was still seeking an audience, but Anaïs was on her guard. He needed her, she thought, her. She must listen, pay attention. No one, not even Artaud, could resist Anaïs's compassion. He relaxed, and regained his confidence. He recited poems to her. He gazed at her. 'You have green, and sometimes violet eyes.'

It needed little else for her to become infatuated and to cry out: 'Everyday life has no interest for me. I seek moments of greatness.'

Did she recognize them when she saw them? Her passion for Miller was wearing thin. Allendy irritated her. Hugo bored her. Artaud alone captivated her. She wanted to captivate him, in spite of – or because of – Allendy's warning: 'Don't play games with Artaud.'

Artaud was going to amuse himself with her. Artaud was always playing. The painter André Masson described his attitude: 'His own suffering did exist, but he enjoyed it . . . Artaud had told himself: "It is I who will play Artaud."'

When he was with Anaïs, he multiplied his roles: he became poet, madman, a man full of jealousy, lover, a man in revolt. She interpreted these roles as delusions. She mistook his witticism – 'The difference between you and other women [is that] you breathe in carbon dioxide and exhale oxygen' – for words of love; his impulsive moves for declarations: 'Artaud put his hand on my knee. I was startled that he should make a physical gesture. I made no gesture. I said, "You don't feel such a spiritual solitude any more. From today onwards you won't suffer any more. You can rely on me."' After he had gone she wrote: 'I can feel no more ardour. I am replete with it, replete with life and love.'

'Why did Artaud take drugs?' she wondered, when she was "drugging" herself with Artaud, with Artaud's words, his irreverence, his intuitions, his potential for ecstasy, when he took her to the Louvre, into the Dutch masters room where there was a painting by Lucas van Leyden: *Lot and his Daughters*, and they both looked at the painting together in a silence that was 'strangely alive, like a trap open upon an abyss from which one might hear the secret murmur of death itself,' as Artaud wrote to her.

That evening she dreamed that he possessed her with a great passion. Like June, Artaud fed her fantasies.

*

Did she ever, as she claimed, kiss that mouth, at the Coupole, that mouth blackened with laudanum? Did Artaud invite her into his room 'as naked as a monk's cell'?

Did he embrace her on the *quais*, crying out to her that he was living the greatest moment of his life?

In April 1964, Paule Thévenin, who was editing Artaud's complete works for Gallimard, received this letter:

Dear Madame Thévenin

My publisher in France [André Bey of Editions Stock] suggested that I write you with regard to Artaud ... I knew him well in 1933. I own some letters from him. He was going to dedicate *Heliogabalus* to me. I did a portrait of him in my journal that I am in the process of publishing. I know that you have had some problems with Artaud's descendants. Do you think that a portrait would encounter similar problems? I would be very grateful if you could let me know the nature of their objections. I hope that you can find the time to reply to me. M. Nadeau knows me slightly. I was born in France, and exiled to America at the age of eleven, and I write in English purely because we happened to move there. Not through choice ... I have done much to make Artaud better known in America.

Paule Thévenin mentioned the letters to the literary magazine, *Tel Quel*, whose editor put forward a proposal to publish them. Anaïs accepted, on condition that Hugo Guiler's name was totally erased, as well as any allusion to physical love. That second demand took Paule Thévenin aback: 'There is nothing compromising in those letters. Artaud spoke of the taste of a woman's mouth, but without saying precisely whose. Anaïs seemed to be ignorant of the fact that it was his custom to write these stream-of-consciousness letters to near strangers and love letters to women who were merely friends. I met Anaïs several months later. I pointed out a passage about her in a piece of writing she

was unfamiliar with. I found literally the same sentence in her *Journal*. Her portrait of Artaud is a tissue of clichés. It is the inmate of Rodez she is describing, not the dandy who, in 1933, was admired by Jean Cocteau and by Jean Paulhan. The mouth blackened by laudanum, the hand-kissing (Artaud detested physical contact), these utterances belong to a false legend. To read her you would think she had never known him.'

Anaïs had sinned through an excess of zeal.

In 1966, the year the first volume of the *Journal* appeared, Jean-Paul Sartre declared in *Un Théâtre de situation* (Gallimard, 1973): 'Artaud never had so many disciples.' In America, his notoriety grew. Anaïs wanted to spread the cult. To give the poet his true stature. She went back to her notes, delved into Artaud's writings, copied some of the passages from them again, which she 'elucidated' in her own fashion, read *Les Cenci* (written in 1935, some two years after their encounter), saw *La Passion de Jeanne d'Arc* by Carl Dreyer which she had not seen at the time, so that she could fulfil the ambition stated in her *Journal*: to separate the myth from the reality.

But Artaud already had a myth. The readers of the *Journal* were awaiting the real man.

JAZZ

Right to the heart. 'The jazz virus has entered my blood.' It has become flesh: hands clamped on thighs of sonorous brass, thighs sticky with sweat, the hots. Fats Waller roused her, and so did Chick Webb, Charlie Parker. Just as love-making gave her a 'heavy sensual Moorish' face, so jazz blackened her soul. 'I want to dope myself with experiences . . . I want to know perverts. . . . Night clubs excite me.' Burnished, perfumed hell. 'Evening dress, champagne buckets, white-coated waiters, smooth jazz. I dissolve in music.' Liquefying intoxication. Bodies swing, conventions slide away. Ready for anything. 'We went into a dance hall. I saw defiance in June's eyes.'

Jazz is June, the sauve sex: 'June led me, she was heavy, I was slim and light. We slid on the last bar of a piece of jazz which was fading, dying.' It was great.

Jazz is a language. 'I shall write the equivalent of jazz.' Anaïs always grew expert in the things that fascinated her. She created her own jazz. In her novels, words slide, are inverted in echoing chambers. Embroideries on a sound, on a theme. Improvisation.

'Only feeling improvises: it can perpetually invent.' (André Suarès)

[20] *Villa Seurat*

Tropic of Cancer would never have seen the light of day without Anaïs.

For two years, Jack Kahane, who owned the Obelisk Press, one of a number of English-language publishing houses established in Paris to avoid censorship, delayed publication of this book which he nonetheless considered a masterpiece. Miller was in despair. Kahane wanted an advance of 5,000 francs. Miller didn't have a sou. Anaïs was going to pay it.

We don't know whether she had Hugo's approval, or whether she indulged in some financial sleight of hand. But she got the required sum together, and obtained a promise from Kahane that he would reimburse her, a promise he never kept. Miller asked her for a preface. He was overwhelmed by the one he received: Anaïs could manipulate *double-entendres* with a discreet perverseness. A subtle eroticism lay beneath the praise. Their passion was sealed.

The book came out in September 1934. the same day that Henry moved to Villa Seurat. Chagall, Lurçat and Dali had all lived in this same private street between Montparnasse and parc Montsouris. 'All the houses are in various colours of stucco. Trees grow in the backyards ... the street is cobblestone and as the sidewalk is so narrow, you have to walk down the middle,' Anaïs wrote. She had got Henry a studio on the first floor of number 18, which consisted of one room with a kitchenette in a cupboard, and a balcony which looked out over pink and green façades. In a cupboard she found a photo of Dreyer's amorous monk. Artaud had rented the studio before Miller. On the ground floor Soutine painted his skinned bullock carcasses. A neighbouring studio, filled with supple, curved sculptures, was where Chana Orloff worked.

She was a Russian emigrée, a former friend of the young Modigliani, and had become a portraitist of some repute. René Allendy had sat for her. And so had Otto Rank, Anaïs's new analyst.

Chana Orloff's account

How can such a tiny woman have such big eyes? That's what I thought, absurdly, when Anaïs came into my studio with Dr Rank. It was sultry that day. I had not closed the glass door on to the passageway, and Rank, as usual, caught me unawares while I was working.

He was interested in what I was trying to do. He found my work as an artist stimulated his own. Like me, he had a passionate nature and was endlessly curious. But each of us in our own way. Rank was a theoretician, while I was creative.

The young woman who was with him seemed at first sight to be rather insignificant, in spite of Rank's tender godfatherly manner, which was as clumsy as ever, like some greenhorn presenting his future bride to his mother. He said she was a student of his. She probably went to the *Cité universitaire* where he was holding his summer seminars: staggering verbal improvisations to dazzle the credulous. There are people who can get intoxicated on words.

From my kitchen, where I was busy preparing tea and cakes and cherry jam, I heard them talking about one of my maquettes, of a woman suckling her baby.

'We don't know much about woman,' Rank said. 'You have to plunge into the unconscious to understand that how a woman feels is close to the three life-forms: the child's, the artist's and the original life-form. All three react to their immediate vision, feelings and instincts. But they can express themselves only in terms of symbols, through dreams and myths . . .'

'Do you believe that women are more knowledgeable about these things?' asked the fluting voice.

'Women who have the courage to see themselves are rare. And when they succeed, they are so disgusted by what they discover . . .'

'Disgusted . . . don't you mean "frightened", rather?'

'No, it really is disgust. These sculptures, for example . . .'

'What about them?'

'Well, perhaps it's their shape – these swollen bellies – or what they imply; I can't look at them without a shiver. Don't say anything. I know what you're thinking. I'm thinking that too. But it's not that. It's deeper, more primal . . .'

I began to understand why they were getting on so well: they were both cerebral, attracted by their own depths, excited by their own neuroses, their deviancy, everything that I had decided to forget about long ago. In order to delight in the richness of the human form instead.

Everything seems clear now: birth, love, life, old age . . . growing old can be marvellous – you become truer to yourself. When I look at this visitor going into ecstasies over my work, with a sort of unsophisticated reserve, I feel that she'll be more beautiful in forty years' time. I've sculpted many pretty women. They are the worst models. They always feel they have to compete.

Then one September morning she came charging into my studio and she seemed so different. She flaunted her happiness like a banner, she was triumphant.

'I've found some lodgings for the writer I told you about, Henry Miller. And guess where? Here, on the first floor. We can come to see you often now. Isn't that fantastic? There are so many things I feel I could learn from you. By the way, d'you know of a good plumber?'

I should have asked her to sit for me for a few minutes then, it would have been long enough to capture the way she holds her hips. But Miller needed her. In record time she had an armada of workmen scurrying about, converting the place into a smart studio, from which I could hear the click-clack of a typewriter.

She was very motherly. She used to shop in the market, order the coal, take shoes to the cobbler's, while the great writer entertained his close friends and sang 'My Old Kentucky Home' or 'Swanee River'. I remember Fraenkel, Trotsky's double, who owned the studio. He was a Mephistophelian character who used to dress like the devil, he was so obsessed with death. Miller was fascinated by him. Anaïs was keeping Miller.

What didn't she do for him — with that superabundance of energy she had which always seemed a bit suspect to me, as if she were trying to expiate some wrong? Miller took her devotion for granted. The more attentive she was, the less gracious he was about it. How could two such opposites understand one another? Miller did not seem to care about anything. Anaïs, on the other hand, acted as if everything were a tragedy. When she came to show me the copy of *Tropic of Cancer* which Miller had just received from the publisher, I thought there was a disaster of some kind: she was in tears. 'Chana, just look at the cover — it's horrible.' I had to agree: it was a clumsy pen and ink drawing of a pustulous crab sitting on the top of a globe with a naked woman between its claws. There was nothing that could be done. The book had already cost a lot to produce. I told her to be brave. Anaïs began the publicity campaign by sending out subscription leaflets, and dozens of copies to influential friends, among them Dr Allendy who had sat for me, and Rank, whom Miller admired.

But success did come. I said 'but', for the praise Miller received ruffled Anaïs's pride. Marcel Duchamp praised the book to the skies. Ezra Pound wrote a letter comparing it to Joyce's *Ulysses*. And T. S. Eliot, a famous English critic, wrote to say that, in his view, *Tropic of Cancer* was superior to *Lady Chatterley's Lover*. Blaise Cendrars heaved his hefty docker's body up to the first floor to offer his friendship.

Strangers were soon pouring in. Miller entertained them all with an amusing condescension. But Anaïs could not conceal her bitterness.

'If Henry had done for me a fraction of what I have done for him, I would have published my novel long ago. But as soon as it's a question of someone else, he doesn't seem to have the same conviction, whereas I make twice the effort. Listen, last April, I even went to London to plead his cause with the novelist Rebecca West, who is an excellent literary critic. She said she thought that my work was better than his. And that an artist should devote her time exclusively to herself.'

'How right she was. You should stop trying to be so high-minded. It doesn't suit you. Forgive me for being frank, but I often get the impression that you're forcing yourself to appear as something you aren't. You can straighten up now . . .'

I had yielded to my vice: I had asked her to sit for me. Rank had let it be understood that he would buy the bust. She had accepted, with a simplicity which sophisticated women rarely show. Was it narcissism? I don't think so. Curiosity more likely. I interested her, both I and my work. Perhaps she admired me for being a recognized artist, which she was not.

I loved talking to my model.

Her talk guided my hands. We discussed so many things then. I learnt that she was married, something I had never suspected, like so many things about her. Here we called her 'Madame Henry'. Her real husband was called Hugh Guiler. Anaïs talked about him as though he were her brother. Affectionately, but without passion. He protected her, he allowed her to live the way she wanted to, he let her write. He had even agreed to rent a garret in the *quartier* for her so that she could write undisturbed. Anaïs spent three days a week away from their home. What man would put up with such behaviour unless he was having adventures of his own? When I said that, Anaïs practically jumped out of her skin.

'Hugo, unfaithful? He's just not capable of it! I've tried to make him lead a life of his own, however.'

'That would be convenient for you.'

She pretended not to hear. She went on, as if in a dream: 'I think of all the things he could have noticed. Like the day I came back from Henry's and washed. He could have noticed the drops of water on the floor; and the stains on my underwear; the lipstick on my handkerchiefs; he could have asked himself why I am always so dead tired, why I have shadows under my eyes . . .You could say that he refuses to register things, to allow them to impinge on his consciousness. He refuses to see. Sometimes it fills me with such pity I feel I'm going out of my mind. I would rather he punished me, hit me even, locked me up. I would feel relieved.'

I wondered why she confided in me when I knew her so little? It took me by surprise that she should want to, and so I put more effort into listening to her: some of the things she told me keep coming back to me.

'I am eaten up with anguish,' she said when I asked her to relax. 'It's only when I'm outside with friends, in a whirl of activity, with my time fully occupied, that I manage to keep my incurable depression in check.'

I wondered what sort of a person she was. Only Rank knew. Brassaï had recently photographed her at Miller's, in a Maja's costume, and was struck by the sickliness of her smile. 'Her face was pale and transparent like alabaster, and her eyes expressed a deep sadness, as though they were accustomed to tears.' I myself could not help thinking that it was the face of someone who was unsatisfied. True melancholy is like the melancholy experienced by Jeanne Hébuterne, that tall pale girl I introduced to Modigliani. She would spend hours never speaking, never moving, as if she were counting the minutes that separated her from death. True melancholy is the feminine form of despair. Anaïs did not suffer from that. Hadn't she always said to me: "It's better to write than to drug myself with June and ruin my health"?'

Another detail: her nose, she felt, was too hooked, so she had

had it straightened. A woman without hope would have neither the desire nor the strength to go through with something like that. On another occasion she said: 'We tend to prefer people who have personalities we don't share or don't wish to share.'

I thought then that she was talking about Miller. But no, it was her father. 'A futile waste of emotions,' she had added, looking for her handkerchief; I changed the subject.

The friendship we both felt for Rank meant that we often talked about him. After hesitating for a while, he had taken the path of exile. Since October, he lived in New York. He invited Anaïs to join him there so that she could work with him. She was tempted. She had it in her head to become a psychoanalyst. I never understood why an artist like her would want to work solely with theory.

'Rank thinks that theorizing stimulates creativity. He always takes his time before coming to any rigid conclusions – any new drama is investigated with the greatest of patience, like a writer with a blank page in front of him. I'm sure the experience will be rewarding for me. Think of entering into all those hundreds of secret lives.'

'Isn't yours enough for you then?'

She gave me a bitter smile.

'The real reason is this: I want to earn my own living so that I can be free to spend money as I wish, on whomsoever I wish. I depend entirely on my husband, who never ceases to remind me of it. I have to beg for every franc I get. If you knew the tricks I've invented to keep Miller . . .' (Feeling that she was on slippery ground, she checked herself, deftly). 'If you earn your own living, you can write without having to make concessions. If I were less dependent, I would have less fear of hurting people close to me. I'm paralysed by that fear. I write my novels without knowing if I'm a true novelist. I often doubt it. I take no pleasure in distorting the truth. Writing about people as if they were fictitious gives me the horrors. But it's the only way of expressing myself without

risk. My journal is a superior piece of work. Miller has convinced me of that. But to publish it would kill my marriage stone dead.'

Anaïs? Paradox incarnate in female form. Some weeks after our talk, she went off to New York to join Rank.

[21] *In Rank's shadow*

He liberated her from her father. He loved her. He believed in her. Anaïs demonstrated her indebtedness in 1973 when a documentary was being made, chronicling the most important encounters in her life in Paris. She gave Rank an equal place with Miller, who had introduced him to her.

One day in 1933, Miller had brought her a copy of Otto Rank's *Art and Artist*. The book shook her. For it revealed her own temptations and obsessive fears: 'Would he be interested in a woman who had experienced all the themes he was writing about? The Double, Illusion and Reality. Incestuous Loves. Creation and Play?'

She wondered whether it would be a good idea to meet him, and hesitated. Her misadventure with Allendy had made her wary. But after she had consulted the register in the Psychoanalytical Library, she discovered that Dr Rank was part of a legend.

'Rank was the favourite official Freudian, more than a pupil, more like an adopted son,' Paul Roazen wrote in *La Saga freudienne* (Presses universitaires de France, 1986). Born in Vienna in 1884, into a family of modest means, he was twenty-two when, through the help of a doctor, he became Freud's secretary, then his disciple and confidant. Like Anaïs, he was self-taught, and had acquired an encyclopaedic knowledge of culture which was exceptionally strong in mythology.

By the time Anaïs went to see him, he had broken with Freud, made his fortune in America, and now led an easy life in Paris, mixing with wealthy patients and artists. He was a short man with a swarthy face. His free-thinking approach delighted Anaïs. 'His curiosity was stronger than his need to put things into categories. He wasn't a mind-surgeon – he improvised.' The

difference between Rank and Allendy was that Rank respected Anaïs's creativity. In his view, her neurosis was not an illness but the symptom of unfulfilled artistic ambition. He understood Anaïs's infatuation. He asked her to spend some time living on her own, in a *pension*, not far from him, in rue des Marronniers. Under his guidance, she finally laid her father to rest in *Winter of Artifice*. After six months' therapy, she told Rank that she wanted to become an analyst, and that same day she gave herself to him.

Seduction, for Anaïs, was a way of freeing herself from the previous lover. Rank – with his artist's charisma, his paternal aura – emancipated her from Miller and from Joaquin Nin.

In November 1934, after convincing Hugo that a short separation would save their marriage, she joined Rank in New York. First he made her his secretary, then, seeing her talent, gave her a few patients.

Anaïs was an analyst! For a short time: five months – time enough to extract some 'meat' for her writing. In April 1935 she wrote to her mother telling her how tired she was: 'I've had enough of playing at being an analyst. An interesting experience. All I have to do now is write it down.'

Rank's account

Every evening I have roses sent to Anaïs's room, next to mine in the Barbizon Hotel. Almost every evening we go out. I never know what to do with all the invitations patients send me: concerts, plays, dinner parties, first nights. Anaïs is always going somewhere. Always gay. I have never laughed so much as with her. I wanted to bring her back to life when really it was I who was dead that autumn day when she introduced herself as a friend of Miller. She told me she was an artist, and asked if she could be treated as such. I asked her what she was writing. She mentioned a novel which had not yet been published.

She took a notebook out of her bag. 'And this?' She blushed. It

was her journal; she was never parted from it, so that she could write down everything fresh.

I grabbed it. 'Leave it with me. I don't want you to start analysing the analyst. Your journal is your last defence.'

She begged me, but I made her understand that she must break her bonds, take a room in Paris, live there alone, write only her novel, totally remove herself from her journal.

She agreed to everything I asked, except this last request.

'I need my journal like a drug. I can't stop scribbling notes. Ideas. Sketches for portraits. I've begun yours . . .'

'I should like to read it.'

'It's only in note form.'

'Copy it out.'

'In my journal?'

I'm good at playing games, but I knew that I had lost the battle.

'Then try to win the battle against my father.'

'So you've seen him again?'

'More times than you might imagine . . .'

I was intrigued by the case. At first sight, it responded to my theory of 'the double'. Joaquin Nin wished to model his daughter in his own image, so that he could love his own unacknowledged femininity in her. Anaïs was forcing herself to resemble this shadowy twin, this Don Juan whom she dreamed of being, while she was loved by men whom he might have wished to have as lovers for himself.

'Do you think he would like you to become androgynous?'

'No, quite the opposite. He loves giving me dresses, perfume. I'm never feminine enough in his eyes. Never sufficiently . . .'

'Desirable?'

I saw her waver. I did not want her to get emotional. She had to talk. I asked her if she would like a Scotch, but she said no.

'Last summer, I spent eight days with him in the Midi. Maruça, his wife, wasn't there . . . Everyone thought I was his mistress. He didn't put them right.'

'And you?'

'Neither did I . . . My father is the most attractive of men. I couldn't take my eyes off him. If he'd looked at another woman . . . He's made me suffer so much.'

'And has he suffered?'

She gestured to me not to interrupt.

'We used to spend the day on the terrace of the hotel. I would write. He'd be scribbling out scores, humming tunes to me. Sometimes we hired a chauffeur to drive us along the coast. "We're like two exiles," he said.

'Every evening, we dined in his room. He had Champagne sent up, wonderful meals. We barely touched them. Our voices seemed too loud. We talked in whispers. I was mesmerized just looking at his hands. Then he raised them towards me. I didn't move. My whole body yearned towards those beautiful hands. Those agile fingers . . . Help me,' she cried out. 'I'm possessed.'

What use was it to question her further?

Which of the two had led the other on? Anaïs was no longer a child. She had broken the last bonds. Seduced her father. Achieved her vengeance by using on him the weapons that he had intended to use on her. I had to make her understand that. In the end I did succeed. In session after session. Anaïs unburdened herself. I was jubilant. We were like a juggling act: she had the words; I knew what they meant. We talked, we understood one another. I, too, was coming out of a dark tunnel. Towards life. I was in love.

One day in May she rang my doorbell. She was wearing a hyacinth-blue dress. I was not expecting her. Even before I could express my surprise, she offered her mouth to be kissed. As I embraced her, I thought: 'Isn't she just using me for vengeance?'

The analysis came to an end. It had lasted seven months. I would not have allowed her to become my mistress if I had not thought her cured. I don't believe in drawn-out therapies. Neurosis is like an abscess. It must be tackled in a dynamic way. It must be examined quickly, looking at the actual symptoms, and nothing else.

The portrait Anaïs painted of her father confirmed my judgement. *Winter of Artifice* was not the work of a woman in peril. The writing lacked control, but the themes were forcefully orchestrated.

Never had the month of June seemed sweeter to me. Anaïs had got it into her head that she wanted to become an analyst. I encouraged her. It was my way of keeping her near me. She followed me to the *Cité universitaire* where I was holding my summer seminars. After the lecture we would go on to the Café Alésia, and, under garlands of artificial geraniums which ran the length of the wall mirrors, I advanced my new theories, argued the concepts, mixed with my students. Anaïs encouraged me.

I spent September in London, but a telephone call from Hugo made me rush back to Paris: Anaïs had given birth to a still-born baby. A little girl. She had asked if I would go and see her.

Hugo was waiting for me at the Gare du Nord to take me to the clinic. On the way he told me in so many words that he was not the baby's father. I made a silent calculation and came to the same conclusion.

The name of Miller was on the tip of our tongues; we suddenly felt very close.

Anaïs was sitting up in bed, in a room filled with flowers. Her hair and face were freshly done, she looked exquisite. She called me to her bedside and slid something into my hand. It was a ring.

'It belonged to my father ... You have it now. Keep it as a thank-you.'

I almost cried out: 'It's I who should be thanking you. You have given me so much. Thank you for your tenderness when we make love. Thank you for such good memories ...

'Your footsteps are hurrying down rue Henri-Rochefort, where I'm waiting for you so that we can celebrate with champagne. The apartment smells of lilacs. I've brought some fine wine. A new suit. I want to please you, for I owe everything to you: I've found my youth again, my *joie de vivre*, my joy of writing, my joy in believing. Without you I would have given up my work,

abandoned my patients, my ambition. As soon as you are well enough, come and join me in New York. I'll teach you the practice. You shall earn your own living. You shall live wherever you like. You will be free. Far from Hugo, far from Miller.'

Free. Anaïs based her decision on that word. She arrived in New York one day in November. I was waiting for her on the quayside. She had only one suitcase – an indication of her old way of life: her fear of possessions. A photo of her by Brassaï as Anita in her Maja's dress. The manuscripts of *The House of Incest* and *Winter of Artifice*. Some dresses. Her journal.

I had reserved two adjoining rooms at the Barbizon Hotel which promised 'Continental breakfasts'. It was not far from the apartment on the East Side where I saw my patients.

Anaïs first worked for me as my secretary. Her verbal dexterity far outstripped mine. She revised my reports, my lecture notes, writing her comments in the margins. They were precious to me. I had the feeling of advancing into 'that dark continent' that Freud had been wary of exploring.

At the end of January, I had seminars to give in California. I left Anaïs in charge of my office. My patients were in her hands: their identity, their neuroses and their dramas. I became a new man: young, and immortal as well, for I had found a disciple.

I telephoned her every day. She seemed to have more than enough to do but was happy: 'scarcely have time for breakfast or dressing before someone rings the bell. Sick people are at the door. Their faces. Do you look at their faces? Their eyes are always lowered, as if they are contemplating some inner drama. The more I explore neurosis, the more I realize that it is a modern form of romanticism. It stems from the same source, a thirst for perfection, the obsession with living out what one has imagined.' It was not as simple as that, but I could hardly get involved in a lesson on psychoanalysis on the telephone.

Anaïs had the gift. I could tell from the reports she gave me on my return. They were lucid, precise, intense. I was struck by the

writing. Anaïs avoided all clinical language. Each report read like a short story. Each patient became a character. I put her on her guard: an analyst is not a writer. She retorted that, like a writer, an analyst manipulates words, and that if Freud had used the language of the sick to cure them, she too wanted to use her own words to cure the patient. I felt somehow that she was trying to show me a new way of looking at things, but I doubted that we would go down this path together. My disciple would be unfaithful to me.

I no longer fear Miller. He is in New York. Anaïs told me. She sometimes goes to see him in the evenings. She meets his friends in Brooklyn. But their passion is dead: 'I can no longer behave naturally with Henry: I play the role of the ideal confidante he needs to be able to write.' Hugo? He's still supposed to be coming in April. She loves him from a distance. She cannot stand him when he is actually there. Sooner or later, they will divorce.

My only rival is Anaïs: Anaïs's ambition, Anaïs's vocation – writing. She never stops writing. While she's waiting for patients, after they've gone, before dinner, after making love, in waiting rooms and on trains . . . on the boat which will soon carry her away from me.

INCEST

Incest, from the Latin *incestus*, impure.

That is what the word originally meant when Antigone nurtured a fanatical passion for her father, when Oedipus married Jocasta, when the daughter of Herodias danced naked for her uncle.

Incest: Anaïs uses the word as far back as the first volume of her Journal.

And becomes:

'Salome.'

In the Salle Iéna, she gave a performance of Spanish dance. She imagined she saw her father in the audience, and stopped in the middle of the dance, petrified. 'You may have wanted to dance for him,' Doctor Allendy suggested ingenuously, reduced to the role of chorus in a Greek tragedy. 'You may, unconsciously, have wanted to charm him, to seduce him.' 'Dancing became synonymous with seducing the father.'

Then there was Beatrice Cenci: the incestuous murderess, in Artaud's play, who shouted out: 'I believe in your absolute impurity.'

Incest, from the Latin *incestus*, impure . . .

'I kept quiet. I did not deny it,' she wrote in her journal.

She must not lie. She must simply say nothing. Or allow the myths of the *Journal* to speak, or the characters of her stories.

'I love my brother,' Jeanne cries in *The House of Incest*.

Can it be incest when life denies ties of blood? When a father, long separated from his daughter, celebrates in her 'the synthesis of all the women I have loved . . .'? 'In June when I go south again you must come with me,' he went on. 'They will take you for my mistress, that will be delightful. I shall say, "This is my daughter" and no one will believe me.'

No one did believe him, not even Anaïs. For a narcissistic person like her, her father was her double.

Joaquin Nin, *animus* of Anaïs: 'his smile had a feminine charm . . . his luminous mouth . . . like an Andalucian garden.' Then in whom did she lose herself?

In a stranger who looked like her father? A father in whom she recognized herself, a female Don Juan, at last victorious?

Joaquin Nin divorced Maruça in 1939, and spent a few months in a *pension* in avenue Mozart, before returning to Cuba where he died in 1949, forgotten.

Anaïs did not attend his funeral.

[22] *Hugo's letter to John*

Paris, 29 July 1936

Dear John

The situation is dramatic but not desperate. About France, I mean, although having written this first sentence, it could equally well apply to my marriage. I'll tell you about it, but please reassure Mother. I've taken the necessary steps for leaving the country in case of emergency. There's a job as director of the City Bank and Farmers Trust waiting for me in London. Anaïs has sent her journals on to her mother who's staying in Italy, so they'll be safe if we have to leave quickly. For the moment Paris is bearable in spite of the shambles Blum's government has plunged us into. Since the beginning of the month, masses of strikes have paralysed the capital – I go to the office by bicycle. If the government gives in to the trade unions' demands, France will be heading for catastrophe. There's something in this country that is being eroded away, I can't say precisely what it is. When I hear the rumours coming from Germany and Spain, I've a horrible feeling that the hatred may cross the frontier . . .

We've had to leave Louveciennes for practical reasons. I'm quite glad to put the place behind me. It became like an old people's home as far as our love was concerned. The house ceased to be mine from the moment Miller set foot in it. You may think it's my fault for not acting like a man. But Anaïs isn't like other women. It's taken me a long time to understand that it's neither clothes nor perfume that she needs, but air, space, solitude. She's a free spirit.

We're living on quai de la Bourdonnais, in an apartment rented to us by a business associate, Henry Leigh Hunt. His wife Louise is a novelist. She is the incarnation of everything I love about

France: full of wit and elegance, qualities her family, the Vilmorins, have epitomized for centuries. She likes Anaïs. They became friends and she visited her at Louveciennes. What they talk about I don't know. Anaïs keeps her secrets for her books.

Leave the rumours about a divorce to those with nasty minds. I'll never leave her. She means everything to me. I'd die without her. I've discovered the courage to be myself again. I've no intention of growing old in a three-piece suit. Once a week now, I go to a course on engraving at Atelier 17. The man behind it is Stanley William Hayter, who's a friend of André Masson, Max Ernst and Yves Tanguy. I watch what they're doing, listen to them. Knowing them, I now feel I can understand my wife better. What I would once have called sheer self-centredness, I now call thoughtfulness. You have to plumb your own inner depths before you can reach others. In the past, I've reproached Anaïs for only writing about herself. Yet I myself am only capable of engraving things like lyre birds, lianas, beetle's wings, curling waves, curving islands: my island – Puerto Rico . . . Anaïs has given me some Japanese brushes. She's encouraging me. Illustrating her work may be my last chance of keeping her.

The House of Incest, on which she's been working for three years, has just been published. In circumstances so bizarre I have to tell you, even though it means mentioning that man Miller who's closely involved in it all. From what I can gather, he must have recommended Anaïs's novel to his agent, Bill Bradley, who was intrigued by the title. He was disappointed however: he found her style too precious and the contents too chaste. He wanted it spiced up. My wife refused.

So how could she get it published without going back on her refusal? Every day she moaned about it, until one day I said to her: Why don't you publish it yourself?

She was taken aback.

'That's just what Miller said. I take his enthusiasms with a pinch of salt, but not yours.'

She didn't ask my opinion again. When the Siana Series saw

the light of day, Anaïs didn't think it worthwhile giving me the publishers' address. But I later discovered where it was: Villa Seurat, where Miller lives.

Siana: it's an anagram of Anaïs. The poor love did not realize then that her first name would be the only acknowledgement its founder would get from her associates. Miller, Perlès and Fraenkel, who had set up the Carrefour Press, had no intention of printing anything except their own work. *The House of Incest* was composed in April while we were in Morocco, so that Anaïs would have no control over the way it was produced. When we got back, she found the copies heaped up in a corner of the workshop. Fraenkel, who'd promised to supervise the launch, had lost interest. We did some mailings. Anaïs went all round Paris placing copies in the best bookshops. She went to Tschami's in boulevard du Montparnasse, which sells English books. Without much success. The novel has sunk without trace. My only comfort is that there've been some enthusiastic comments from Frances Steloff who runs Gotham Book Mart, the most lively bookshop in New York, and she's invited Anaïs to go there if Europe goes up in flames.

Anaïs is fighting depression. She's copying out her journal again, and still working on the manuscript of *Winter of Artifice*. She's clinging to it like a drowning woman.

If I were cynical, I'd bless this setback: it has patched up our marriage. Now that she's been betrayed by her own set, she's come back to me. In Fez, where I had to go on business, she seemed more attentive towards me. More loving. More willing to be cuddled, as if she had been infected by the indolent submissiveness of the harem women with whom she mixed, coming back anointed, washed, polished, her skin soft – like a child. If only her soul could become as pure again, I thought to myself as we lay in bed.

As soon as we got back to Paris, I took her to Maxim's, where she danced and danced, enjoying the fact that everyone was looking at her, and knowing that I was enjoying it so much too.

The client who came with us did everything to charm her. She has had her uses in getting the contract signed. We all laughed a lot about it.

How long will this truce last? I'm quite clear-headed about it. Soon, she will cut herself off from my love – whose transparency she chooses to see as vapid – she'll cast off and sail towards a new mirage. Perhaps it will be a Bolshevik, with whom she can remake the world in less time than it took God to create it. Or a Spaniard will move her to pity about the bloody state of his country and she will follow him: she's always been a sucker for causes, however small.

I'm tired of the pain of it all. But how can I keep on encouraging her to write if I don't allow her to have a taste of life?

Introspection is a monster, she tells me. A writer needs to feed on a mass of material, experiences, people, places, loves, and then introspection ceases to eat you up.

Yes, I've married a cannibal.

FEAR

Fear: just listening to her all-too-mannered voice is enough to squeeze out the splinter which has forced her into a thousand poses, a thousand lies. You can catch that look of fear in the way she carries her head, just a little too erect.

'Fear moulded Anaïs's behaviour. Fear of being abandoned, fear of being badly thought of, fear of not being loved. She wanted everyone to think she was an exemplary person,' was what Miller thought. Despite the healthy debauchery into which he drew her, Miller could never free her from fear's tight hold.

Her first fear — that her father would leave her — had been borne out, and it would engender all the others.

The fear of doing wrong: her neurosis.

The fear of displeasing: her only looking-glass.

The fear of being judged: the force that drove her pen.

Her *Journal* offered this lapsed Catholic the calm haven of a priestless confessional.

When she published her *Journal* in its rewritten, expurgated form, she forged herself an armour for all eternity.

I have always thought that Anaïs published her *Journal* to thwart any plans for a biography. To ensure peace after death. Her safety.

The week before she died, she telephoned all her friends to ask each one for absolution.

[23] *Always on the move*

Each of Anaïs's refuges was attuned to her state of mind. The studio in rue Schoelcher, in the heart of Montparnasse, gave her a foretaste of the Bohemian life she longed for, the decorum of boulevard Suchet revealed her temptation to move in society. At Louveciennes, amidst the wild flowers, she recognized her nostalgic and reclusive self, while in the silence, scarcely broken by the bark of a dog, she found her voice as a writer. 'A fireplace, a book, friendship, the acacia in flower.' It was poetry. 'The magic of this place bewitches me.' In 1936, Louveciennes lost its spell. 'I don't seem to belong here any more, or perhaps I'm so wrapped up in feverish, intense activity, excitement? The new me feels a stranger here now, the new me is an adventurer and a nomad.'

Anaïs had buried so many of her illusions: that she could be the perfect daughter, the only woman, the generous muse. 'I felt strangely free, I felt no limit in me, no barriers, no fears.' She was thirty-three years old.

Having lived for some time in Louise de Vilmorin's apartment, in June she moved out to quai de Passy: 'a psychic need for new surroundings, a background created without any feeling of permanence, but inevitably beautiful. Modern, simple, joyous, light.'

With Hugo's agreement – Hugo was in London where he had a new job at the City Bank and Farmers Trust – she decided to leave Louveciennes. An auction was arranged for 16 November 1936 at 2 bis, rue Montbuisson.

The furniture was set out in the garden. It took four men to get the Moorish bed out of the bedroom. There were two removal men, an electrician and a plumber. They had been drinking, and were sweating. They nudged each other and gave knowing looks,

excited by the intimacy they were invading. Anaïs turned away; they handled her bed as they would a woman.

She had coveted this bed for months before acquiring it from an antique dealer in rue de Seine. Now it drew the curious like a magnet. The shy ran their hands over the mother-of-pearl inlay; others touched the mattress; a few even lay on it.

She wished it would all end. Anaïs begged the auctioneer to start the sale. She felt sick. Full of revulsion for the hands touching, lingering, examining even the smallest trinket. She shuddered.

The sofa retained her body's imprint, the cushions her scent. Drawers harboured a pin cushion, a handkerchief, a crumpled note: her life. At Louveciennes she had been tanned, almost plump, as she bent in her apron over the kitchen stove, sizzling with spices. Energetically chopping wood. Her tiredness had helped her to settle down to write. The hours she spent shut inside the house shivering. Even her shawl, tightly wrapped around her, could not prevent the chill which gripped her and which came from enforced immobility. She wrote page after page, blind to the fact that the day was over. She was inspired. She had never written so much as she wrote at Louveciennes. She felt serene there. Protected. She experienced the same cosy pleasure a child feels snuggling down the bed during a storm.

Louveciennes: the last bastion of her immaturity. Dr Rank had given her a sense of direction: 'Leave the Journal. Leave that house.' At the time she resisted: it seemed cruel. She could not see that Louvëciennes was also like a prison.

The sale began with six cast-iron garden chairs which used to stand in the shade of the acacia, where Henry used to sit after he had woken up, whenever he stayed at Louveciennes, when Hugo was away.

Anaïs pictured him again: his naked torso, in the raw light of morning. Hurry: bread, milk, coffee. Don't forget the jam. He was always hungry for everything: love, words, projects. Living

together. Writing together. Printing together. 'We'll put the printing press in the barn, next to the garage. We'll keep the books in the shed. No more waiting. No more humiliation, we'll publish our own books ourselves.'

He had that gift of turning the illusory into reality. Writing, reading, loving each other, drinking and eating. They used to have lunch in their pyjamas. Wine from Anjou, entrecôte steak, *piperade*, with lots of pepper, butter for the cheese. She would run to the kitchen. Obeying him excited her. Being a woman, a female. The happiness of seeing him swallow in three mouthfuls the meat she had tenderized with her own hands.

His lover's appetite augured the hunger he would have for her.

They owed the best part of their relationship to Louveciennes. They had not only laid bare their bodies – their complicity transcended sex and literature, as on that Christmas night in 1932, when, enclosed in her bedroom, they thought themselves at the very centre of the world, among the manuscripts strewn over the bed so that they could no longer tell whose was whose. They had reached such a height of emotion that it no longer mattered.

'A bedspread of violet satin.' Going for five francs.

She had bought it for June, and was haunted by the memory of her white thighs in their black suspenders against this 'funereal' colour. It was Paulette, Fred's friend, who had used it for the first time, disconcerted at sleeping alone, separated from her lover to whom – rather maliciously – Anaïs had given a room adjoining her own. Poor girl. She had been cruel to her, as she was to women she felt were her inferiors. She gave them a rough time with her obscure wish for revenge, as if these unfortunate women embodied her secret defect. A woman for ever unloved.

'A bed of Moorish influence. Early nineteenth century. A rare piece. Bidding will begin at two hundred francs.'

Two hands went up: the lawyer's wife and a stranger in a grey coat – a dealer perhaps.

'Two hundred and fifty francs,' she heard herself calling out.

A murmur went through the gathering. What was she up to? The stranger went up to three hundred francs. She panicked.

'It's mine! You have no right to take it.'

The stranger gave her a hard, smug look. He obviously thought she was mad, and he was not the only one. Wherever she went, she never fitted in. Here she was too refined. There too eccentric. Too serious for Henry, too uncaring for Hugo. Until Gonzalo, who, despite his admiration, was irritated to find that she had characteristics common to women the world over.

Gonzalo More. Her latest 'love at first sight'. A Peruvian married to a dancer called Helba Huara. Anaïs had gone to the Salle Pleyel at the invitation of Antonin Artaud, who was directing the lighting of Helba's shows. She was instantly fascinated by this insect-woman, who appeared ghostlike under her veils scattered with Aztec jewels, and had not noticed the pianist who accompanied her. However, in Montparnasse, this dark giant with almond eyes and long lashes and a mane of curly black hair streaked with grey could not fail to be noticed. A true *desdichado*, good-for-nothing. His Marxist sympathies completed the portrait.

Anaïs met him in the spring of 1936 at Emile Savitry's, a photographer friend of Brassaï. In introducing them, he warned her: 'Here is a man given to excess – alcohol, women, revolution – it will all prove fatal in the end.' What could be more attractive to a woman who had become exasperated with Miller's *bonhomie*?

Henry, fussy, indifferent to everything, full of humour, tolerance. Gonzalo, fanatical, fatalistic, oriental, was how she compared them some time before laying her head on the 'Inca's' torso.

She guessed him to be a mythomaniac. Which made her even more attracted. Irritated as she was by the real, she could not but follow a man with such hypnotic magnetism. She allowed him to carry her off to the lakes where the firebirds were mating, into vast ranches like villages, into the cathedrals among the Indians, lured by the smell of incense, in processions led by priests in chasubles of gold-embroidered damask. When Gonzalo told her

these stories, he gave her the feeling of a dream already dreamed; of images already imprinted in her blood. He reawakened the memory of Spain in her.

The Civil War had broken out there in July, six months after they had met. Gonzalo, who was on the side of the Republicans, demanded that she follow him there. They were seen together at the Mutualité hall where the leaders had come to plead their cause. André Malraux, Pablo Neruda. La Passionara. Dressed in a grey tailored suit relieved by no other colour at all – not even nail varnish – Anaïs forced herself to applaud them. She did her best to appear convinced. She agreed to type out revolutionary tracts. Gonzalo was jubilant. He thought he had converted a *bourgeoise* to the people's cause. He thought he had given her a class complex, when in fact she had been cured of it by sharing Miller's hard times.

The experience of Clichy had shown her that she was not cut out for the Bohemian life. She loved order and beautiful things. In New York she was ecstatic about the silent elevators, soft carpeting, vases of pristine lilies; in Paris, she liked to walk along rue des Saints-Pères and linger in the antique shops, look into Cartier's windows and covet the Schiaparelli suits that she would never have worn more than once. Her commitment – to read Marx and to go to meetings of the 'cell' – was a response to her secret battle, the one she waged against her father. Joaquin Nin approved of the putschists. It was in defiance of him that she added her name to the list of Marxist sympathizers.

'Nothing to my right. To my left. Monsieur, you give in? Your gallantry does you honour. Going, then, for four hundred francs. Madame, your bed is returned to you,' added the auctioneer, surprised to see neither relief nor triumph on her face.

Anaïs considered her acquisition, biting her lips. Whatever had impelled her to buy back the bed, if not the unhealthy attachment to objects whose brief sense of permanence gave her the illusion

of her own? She had hoped to free herself from the past. She had tied herself to it like a totem.

The sale finished as night fell. They suggested she push her bed into the barn. She refused. The bed was abandoned to the stars, like those shipwrecks which appeared in her dreams.

Messengers of the unconscious, the ships ploughed their furrows through the dark night waves. Some reminded her of the *Monserrat*, the ship which had borne her to America. They cut through the smooth water. She would awaken reconciled to the world.

More often she dreamt of old tubs broken down on the river bank like the carcasses of great predators. In the morning she thought she could detect 'a putrefactious smell of seaweed' on her skin, and had only one wish: to escape.

Her visions had haunted her until she met Conrad Moricand. He was a close friend of Max Jacob, Cocteau, Cendrars and Picasso. He was Swiss and an astrologer and counted among his 'clients' Georges Mandel and Paul Morand. It was they who had persuaded Anaïs to approach him, not through snobbery as some claimed, but through physical necessity: she needed to be in the company of exceptional men.

Anaïs had obtained his telephone number from Dr Allendy, who had admired Moricand's *Mirror of Astrology*, an obscure work which had nonetheless earned the 'magus' his reputation. A monotone voice had made an appointment in rue Notre-Dame-de-Lorette, not far from Pigalle. She had been welcomed into a cupboard-like room, rather like a monk's cell, by a 'white Indian' type, as she wrote in her *Journal*, 'his pallor induced by long research in the Bibliothèque Nationale. His white collar is incredibly starchy, his cuffs dazzlingly white, his buff gloves have never been worn . . . as if he has died already to all the friction and usage of life . . . He has the armature of the aristocrat, which not

only upholds his clothes, but which forbids him to complain, to beg.'

To make a living, Moricand drew up birth charts and these covered the walls of his room. Anaïs felt obliged to order hers from him, in spite of her lack of interest in the discipline. Anaïs, who was 'Pisces ascending Libra', felt an enthusiasm as small as Hugo's was great. Moricand had asked her for a hundred francs. It was not cheap, but Anaïs could not betray her reputation for generosity.

Her prodigality was rewarded by a study several pages long, the acuity of which had stupefied her:

'There is something so soft and smooth and non-resistant about Pisces that it often gives the wrong impression. Pisces does not believe that the truth is the best thing to tell and consequently, since they hate to hurt, they substitute what they believe to be a cosmic truth for lesser truths. The connection of this sign with enchanters and with enchantment is very plain. Unworldliness, self-sacrifice, romantic ideals, inspiration, because of glimpses of larger consciousness. Pisces sometimes are rejected, renegades or prophets.'

No man except Otto Rank had given proof of this clairvoyance. She had immediately written Moricand a letter.

'Never mind the spelling mistakes. I want to write in the simplest way for you, as I am very grateful for the efforts you have made to do my chart in English. I want to tell you about one of the coincidences between the chart you made for me and *House of Incest*. You have summed up: This chart is that of a poet who looks at a ship in flames on the shores of night. On page 41, I wrote: "I was in a ship of sapphire sailing on seas of coral. And standing at the prow singing. My singing swelled the sails and ripped them; where they had been ripped the edge was burnt." I was impressed by the subtlety and acuity of everything you said. You grasped the very essence of individuality. I was particularly struck by it because in general I find the language and astrological maps too concrete, realistic, and insufficient – vulgar

in fact. As to the unusual, pantheistic and mystical form of my life you are the only person who has defined it, grasped it.'

Anaïs recommended Moricand to all her friends, and to Miller, who welcomed him with even more enthusiasm because they were both Capricorn and professed the same admiration for the German philosopher Keyserling. The two men became great friends. She was greatly moved by the thought that she had been the one responsible for this friendship. She needed to feel wanted.

On reflection, her longing to live on a houseboat dated from her acquaintance with the astrologer. Moricand had shown her how much the theme of water had formed her fate. She was born under the sign of Pisces, and Neptune, in the centre of her chart accentuated the impulse to flee which governed her sign. The sea had separated her from her father. She had discovered writing on the boat which took her away from him. Her style was fluid, her eyes aquamarine . . . Hadn't she begun *House of Incest* with the words: 'My first vision of earth was water veiled. I am of the race of men and women who see all things through this curtain of sea, and my eyes are the colour of water.'

She took it into her head to rent one of those barges moored to the *quais* that she could see from her apartment. Those little decked rowing boats with narrow openings made the place where she lived seem even colder. No. 30 quai de Passy was only an empty, superficial expression of herself. Anaïs: society woman. She wanted a refuge where she could expand the secret side of her personality, with curtains, shadows and scents. She dreamed of a bachelor flat as dark as Gonzalo's skin, somewhere where she could remodel the world and love.

She told Hugo that she was looking for a place to write. He treated her with some scepticism when she spoke of a houseboat. The Seine was infested with mosquitoes, he couldn't stand them. He would never put a foot on board her hideaway . . . At the end of the summer, she had seen an advertisement: there was a barge

to let on quai de la Seine, opposite the Tuileries. She hurried there. *Le Boucanier* had for many years been used to transport coal. From its tarred hull there rose an exhilarating, inviting smell of resin. A podgy man with a melancholy face had welcomed her into a mess of scattered manuscripts, sketches and photographs. It was the writer Maurice Sachs. In the middle of their conversation, they had discovered something in common: they had both had therapy with Dr Allendy: and both had equally quickly dropped it. This one coincidence would have been enough to make Anaïs decide to take the boat, if Sachs himself had not advised her against it. The boat had only one stove: it would be too uncomfortable.

Every day she returned to the *quais*. Under the colourful flags of washing hanging in the sun to dry, the barges gleamed like chariots. Was there one to rent? She asked the barge women, the road sweeper, brushing leaves into the river. It was a small boy who at the beginning of September had pointed out to her a blackened barge rocking in the water, its planks squeaking with the slightest fluctuations in the current. How long had it been moored there? Weeds clung to its faded hull. Its chains were thick with rust; it looked like a sleeping whale. And the rent was derisory.

Gonzalo had the privilege of being first on board. Once he had got it into some sort of order, he baptized it *Nanankepichu*, which in Quechua means 'Not at home'. Out of reach. Free.

Anaïs understood why she had been unable to come to terms with selling the bed.

Inlaid with the brass of compasses and nacreous shells from the deep, it had, night after night, instilled in her a desire for wide open spaces, for the great elsewhere.

[24] *Two writers plus one*

In July 1937, the owner of the barge put it up for sale. Anaïs left to look for another refuge. On the quai des Tuileries, she visited *La Belle Aurore*. 'The owner who opened the door was Michel Simon. His face looked battered and distorted, but he had the most beautiful hands I ever saw on a man, slim, white and sensitive.' She liked the boat. She took it, promising to keep on the one-legged 'captain' who acted as caretaker. One of her letters was full of enthusiasm about it: 'I have the boat. For five hundred francs. With heating, bathroom, windows. Everything I wanted – and it floats – and it's marvellous. I am so happy I can scarcely write.'

The man to whom the letter was addressed was Lawrence Durrell, a new star in the Ninian galaxy. Born in Nepal of an Irish family, he was now twenty-five and worked for the British embassy on Corfu. He confessed to a passion: literature. In August 1935, dazzled by *The Tropic of Cancer*, he had written the author an adulatory letter to which Miller had immediately replied. A dialogue grew – emulatory rather than competitive – from which surged two talents, two visions. Durrell sent Miller the only copy of his *Black Book*; Miller sent him books impossible to find in Greece, one of which was *The House of Incest*. 'It is the first book in this mode that I've read which is alive,' Durrell wrote. 'In spite of the method. Dream minus reality etc. It's really alive god help my soul with a queer kind of poignance about it. Like sudden dazzling tears. Who is Anaïs Nin? . . . What else has she written? It's a queer name: has a sort of oriental flavour. But this wasn't written by a sleek soot-black Cleo with a vermilion cigarette-holder I'm sure.' Anaïs too began a correspondence. In September 1937, at Miller's invitation, Durrell embarked for

Paris, accompanied by his wife, the painter Nancy Meyers: 'What struck me first of all,' Anaïs noted in her *Journal*, 'were his eyes of a Mediterranean blue, keen, sparkling, seer, child and old man. In body, he is short and stocky, with soft contours like a Hindu . . . He is a faun, a swimmer . . . Nancy, his wife, is a long-waisted gamin with beautiful long slanting eyes.'

Nancy's account

We were still in Corfu when, one January morning in 1936, Larry handed me a book with a white cover: *The House of Incest* by Anaïs Nin. Miller had sent it to him, mentioning that the author was a close friend of his. 'What a stupid title,' Larry exclaimed. 'It smells rancid, it makes it sound dubious, when in fact the book is fresh, fragrant and suddenly takes on colours and malleable shapes. Tell me what you think.'

Larry rarely asked my literary opinion. Miller's influence had made his misogyny worse.

I waited until evening before I began it. I became completely absorbed in it. I was hooked by the flow of her very first lines, I drowned in a breathlessness of rare words, liana-like sentences, sighs, cries. It was disturbing. Sincere and artificial at the same time. Like the woman who wrote: 'I am the woman with the eyes of a Siamese cat, always smiling, in spite of her gravity, always mocking her own intensity.'

When I'd finished the book, I longed to meet its author.

Larry was sarcastic about my curiosity. Was I naïve enough to want to unmask a writer? Words can be more eloquent than the people writing them, he said. What bad faith. After all, what was he looking for in his correspondence with Miller but a father figure? He couldn't write anything without asking his advice. He had just posted him a Christmas story of which he was very proud. Why not send it to Anaïs. He liked my idea. Three weeks later a letter arrived saying how impressed she had been with his story 'Refuge in the Snow'. She said she wanted him to know that

he had done something amazing, that he had reached a world so subtle, almost evanescent, perceived an atmosphere which was so fleeting ... described the interior of the mystery. Anaïs went further. He had grasped the essence, that elusive something we pursue in our nocturnal dreams ...

I reread her letter with a feeling of unease. It was not Larry's story which she was praising but her own book, her style, her visions: Anaïs could appreciate Larry's writing only insofar as it echoed hers. The letters which followed confirmed that feeling. She wrote she felt she had known him ... From the first she had liked his heraldic world. Behind it she sensed faith ... it was one of her favourite words. It was the only currency that she recognized and used. To be her friend you had to share her convictions.

We arrived in Paris in September 1937, like pilgrims to Lourdes, open to miracles. Writing, publishing, living by one's pen may have seemed idealistic elsewhere, but here it seemed easy, Miller assured us ... He was waiting for us in the station buffet, with his Trilby pulled down over his right eye, a fag-end in his mouth. Anaïs stood beside him, in a suit, turning up her collar against the cold with a manicured hand. Nothing in their attitude betrayed that they had been lovers – even less that they still were. They seemed more like accomplices, adversaries even. A discreet, repressed bitterness. Miller could not hold forth without Anaïs showing her impatience. She interrupted him, showed up his table manners. In our view, the one was no better than the other.

Miller had found us somewhere to stay. A painter friend, Betty Ryan, who lived at Villa Seurat, had lent us her studio while she was away. Anaïs never stopped looking for another apartment for us, as if she were trying to take us away from Miller. Larry got annoyed. But when we were invited to her houseboat, he was quick to calm down when he discovered that she shared his propensity to dream.

'In homage to Larry's eastern roots,' Anaïs greeted us in a sari,

taking us on a tour of the dark hold which was lit only by a Byzantine lamp, swinging like a censer, suffusing everything with coppery reflections. The deep black of the carpet was echoed in a lacquered table, with wooden plates and drinking vessels. A pile of books lay on a Moroccan tray: Swedenborg, Strindberg. Otto Rank's *Art and Artist*. The timber walls were covered with horoscopes and some water-colours by Miller. A cask on a shelf caught my attention. It seemed to contain red wine. 'I bought it for my Peruvian friend, Gonzalo. I hate having to see him in bars . . . He's so impulsive . . . This is him with his wife Helba, on the boat coming to Europe.' Anaïs showed me a photo of an ox-like man with thick lips.

Miller took us to one side: 'He's her lover. And her son. It comes to the same thing with Anaïs. I don't know what she sees in him. He has every fault imaginable. Except perhaps . . .' he made an obscene remark at which Larry felt obliged to laugh. Anaïs had heard none of this. She was busy round her table, tailed by an ageless creature, her maid, whom she nicknamed 'The Mouse', and by 'Pépé le Moko', her Siamese cat. Hugh Guiler, her husband, had given it to her to keep her company. 'The Husband had christened it thus for its instincts of an apache,' she wrote in a letter. To a friend who said that Siamese are cats who are inclined to extremes, the Husband replied: 'I have a wife who is inclined to extremes.'

'The Husband!'

What feelings did she have towards 'Hugo', whom Miller found an honest sort of man, for her to speak rudely of him in this way? I made his acquaintance in London. A man rigid in body and soul – with that English shyness which Latins mistake for mistrust. Hugh Guiler was not at all an old fogey. He was jolly. He could joke, but not without a certain stiffness; as if he were playing a role.

The *Belle Aurore* became an island where our nocturnal wanderings ended. We ate well there. We smoked a bit. We talked endlessly, lying on cushions. Nothing excited Henry and

Larry more than teasing Anaïs. They took pleasure in contradicting her. But she held her own and often emerged victorious in their verbal jousts. I remember one argument about creativity which kept us awake till dawn. Larry reproached her for being so wrapped up in herself.

'You have to make the leap from the womb, and cut the cord.'

'So that I can be like you! So that I can be objective like you! I'm looking for a new way of writing. As a woman. For women. For Nancy, who can't say three words without you hinting that she shut up. Woman's creativity must come from her blood, be nourished with her milk. You may mock, Henry. Play at being the great writer. Your art and mine are not the same. You destroy. You shock. You delude yourself. I want to celebrate, unite, elevate the mysteries of life.'

She argued, she pleaded, she remonstrated. In her mouth the word 'man' took on the meaning of 'demon'. I discerned a suffragette under the geisha mask.

Against all odds, Larry was beaten. He yielded to that charm, that mixture of eccentricity and common sense, flirtatiousness and compassion. Anaïs knew how to listen, to give advice with a patience of which Miller was incapable. She understood Larry's agonizing conflicts. Better still, she revealed him as a visionary. There was a voice that emerged from him, from deep within, from his cosmic self. With his wide-ranging mind he terrified the boy, the little imp, the child in himself, she had said to him. There was a conflict in him between the old Tibetan and the Peter Pan. It was true Larry was taken aback by what she said. Compared with an established writer – Miller's second book, *Black Spring*, dedicated to Anaïs, had been published by Jack Kahane in spring 1936 – with an artist recognized by his peers – Raymond Queneau had translated Miller's books in his magazine *Volontés* – Larry and Anaïs were sibling apprentices, sharing the same hopes and the same impatience. According to Miller, Jack Kahane had read both the *Black Book* and *The House of Incest* and seemed ready to publish them. 'Don't worry, I'll work on your

behalf,' Miller repeated. By the following day, he had forgotten his promises, dissipating his energies between articles he had to finish, friends he had to see, the innumerable projects with which he filled his notebooks. Anaïs reminded him of his commitments. Very briefly and very gently (with her greatest subtlety and charm) she reminded Henry of their publishing business, as she had promised she would, she wrote. She could have persuaded God in person ... Without success. Larry and Anaïs continued to wait.

The *Booster* venture happened at a fortuitous moment. It was a folly, a gift from heaven: the American Golf and Country Club in Paris had just asked Alfred Perlès to edit their magazine. 'A sort of white elephant ... my friend is just being given,' Miller wrote to us. They had plenty of advertising to cover all the expenses. Fred was obliged to keep the title and to devote two pages to the Club's activities, as the price of the deal. But gradually he was going to turn it into a literary magazine. Villa Seurat would have its own official mouthpiece. Except for the painter Hilaire Hiler and the writer William Saroyan, all those who collaborated on *Booster* lived there. They gave me the section on art and the job of designing the cover of the first issue. Larry, using the pseudonym of Charles Norden, shared the section on literature with Henry, and Anaïs was Society editor. She was hurt. 'Once more, I'm being denigrated,' she sighed. 'They won't acknowledge my talent. Why? Because I'm a woman?' I expect so. But also because she would disturb things, in that elusive manner of hers, in her other-worldliness, as well as in the risks she took.

What can one say about *Booster* except that it was a sort of Grand Guignol in which Larry and Henry permitted themselves every excess. Sometimes it was the best of Dada. Sometimes bad slapstick, as the issue entitled: 'The Air-Conditioned Womb'. Anaïs had written a review of *Black Spring* for it and was beside herself. 'It's vulgar and farcical. Strident. Henry is wasting all his talent on this childish bit of nonsense.' God, how we wished she

could have a sense of humour. You could not be angry with her. She suffered. It was stronger than she was. She took everything seriously, because no one took her seriously.

Life in Paris was beginning to weigh on us. I was growing pale away from the sun. Larry despaired at not being able to find a publisher. Anaïs drowned her bitterness by copying out her journals into a black book that she locked away in an Arabian marriage chest. She had given copies to a literary agent. He returned them: too long, too dense, too obscure. Larry cast an eye over them. He thought they were superior to *The House of Incest*. But like Henry he's torn between admiration and distrust. They're full of shortcomings: boasting, their accounts of men's pettiness. The journal frightens them like some unknown thing at the bottom of a lake.

Kahane has still not made up his mind. The manuscripts deserve to be published, but the threat of war is hardly an inducement to take them on. In December 1937, Larry and Anaïs pushed Henry into creating their own literary collection: 'The Villa Seurat Series'. To avoid the opprobrium of 'author's royalties', Anaïs underwrote the costs of printing the *Black Book*, and I, those of *Winter of Artifice* and *Max and the White Phagocytes*, Miller's last work – Miller's only contribution was his reputation.

Kahane undertook to distribute the three novels at a commission of twenty per cent of the sale price. He almost recanted when he discovered the subscription leaflet edited by Miller: 'The Series,' he explained, 'has been established to cater for the exigencies of writers, not of readers. Its aim is to publish unpublishable books.' It took all of Anaïs's diplomacy to get the contract signed. He promised publication of the three books in the course of the following year.

In April 1938 we left for Greece, with Henry's promise to come and see us in Corfu. And to stay there if the situation grew worse . . .

[25] 1939: *The last year before exile*

JANUARY. With the threat of France going to war, Anaïs left the *Belle Aurore*. As a precautionary measure all the barges were towed out of Paris. A two-roomed apartment at 12 rue Cassini, not far from the Luxembourg gardens, became her new refuge: 'The bathroom and kitchen are combined . . . so I can watch my cooking while I am taking a bath.'

It was there she discovered her first grey hairs . . .

Miller was preparing to flee Paris. Her mother and brother Joaquin had already returned to the States. Hugo organized their exile in London. An epoch was drawing to a close.

FEBRUARY. France and England had just recognized Franco's government. Anaïs celebrated her thirty-sixth birthday with Hugo, who gave her a Parker fountain pen – something she had long wanted – before returning to London. She filled her lonely hours copying out her journals, so that she could deposit a second set in the vaults of the City Bank, in case she had to leave Europe.

MARCH. 'Paris is atrociously empty' she wrote to her mother. 'The [Spanish] refugees are flooding in, all have contagious diseases, like virulent dysentery . . . The French are letting them die like flies.' This did not prevent her either from caring for her beauty by having two widely-spaced front teeth seen to, or preparing for an Easter holiday. For forty francs a month, Hugo rented a villa overlooking the Mediterranean at Villefranche near Nice. He went fishing while Anaïs, in her Mexican hat, lounged around the Café de la Jetée. 'I'm thrilled with my new smile. I can now smile much more than I used to.'

MAY. Germany and Italy signed the 'Pact of Steel'. Anaïs was still believing in the carefree life. She went to London to see Lawrence Durrell before he went back to Corfu. There were outings and picnics: they bought a new kitten for Hugo, Durrell composed this limerick for Anaïs.

> The world famous diarist Anaïs
> Went hunting the planet for peace
> She combed every ocean
> Till sans aucune émotion
> She finally settled in Nice.

Terrified by the imminence of war, Miller decided to join Durrell in Greece. 'Glad to get out of Villa Seurat,' he declared to Anaïs, 'I'm not even getting visa for Greece yet. Will do that in Marseilles. Well, all this sounds hectic and is just the way I feel. We'll meet again surely somewhere in the South before going to Corfu.' He had just lost his last chance of winning her back.

Anaïs felt doubly betrayed: in her love for him – Miller had sacrificed her for his own safety; in her admiration for him as an artist: 'Henry is weak. Telegraphing in all directions to ask for money so that he can go back to America . . . Henry's views on wisdom have never stood up to the test of reality.'

JUNE. She met Miller in Aix-en-Provence, before he sailed from Marseilles on the *Théophile Gautier*, and told him that she would never leave her husband for him.

And so the misused muse was avenged. And Anaïs, the prudent wife, wrote to her mother: 'In these moments of crisis, I can see that [Hugo] is the most intelligent choice of my life. There's no one else like him.'

A short burst of common sense. Hugo had scarcely left for London when Gonzalo disembarked. They met in Saint-Tropez at Sennequier's. She wore a cotton dress with flounces to please him and lay on the beach under a Tahitian parasol.

AUGUST. Anaïs received copies of *Winter of Artifice* which Jack Kahane had at last published. She asked her mother not to read it: 'It's similar to *The House of Incest* and I know that you prefer the journal ... My novel is to do with psychoanalysis and all the confessions that I have collected, you see; I haven't finished sowing my wild oats yet, but I am still your little girl of years gone by.'

3 SEPTEMBER. France and England declared war on Germany. Anaïs hurriedly took a train from the south of France, travelling third class. Paris was on the verge of collapse. They had started a curfew. Her hairdresser had shut up shop. 'I would like to go to America, but I don't want to leave Hugo. He has never needed me so much as he does now.'

OCTOBER. When she learned of Kahane's death, Anaïs believed that fate was conspiring against her: 'It's all over for our books. The publishing house is going to close. Why have I had such bad luck with my publishers? My first, [Edward] Titus, went bankrupt. Fraenkel, who was my second, went bankrupt, and now Kahane has died before my book is scarcely born. Happily Rebecca West thinks that I have genius.' The last tie which attached her to France had been broken. Gonzalo promised to join her in America. Together with him, she took the necessary steps to obtain her visa.

Never did the month of NOVEMBER appear so gloomy to her as in rue Cassini where she watched the rain falling and her dreams crumbling. Conrad Moricand had enlisted in the Foreign Legion. Gonzalo delayed his departure. Miller was blooming in Greece. She went to see *La Grande Illusion*. Renoir could not have expressed it better ...

Only the nights retained their tatters of magic. 'The café fronts are painted blue, the shop windows covered in green cellophane and taxis have violet, green and red night lights – it looks like the

windows of the Sainte-Chapelle. Very poetic, but bloody annoying.'

She had only one wish: to run away. The air-raid sirens turned her into an insomniac. Sometimes she played with fear by staying in bed, while the sirens moaned. She would lie gripping the sheet and listening to her quickening heartbeat.

In DECEMBER, clutching a complete copy of her journals and a visa for Portugal, she caught the train for Lisbon with Hugo, repeating, twenty-five years on, the gestures of that little exile on the *Montserrat* who had held on her lap the willow basket containing her journal. This time it was in a blue canvas bag. More precious than the most precious of jewels. Her true treasure. Some of it was mislaid in the upheaval. Some months of her life, lost for ever. She tried to write them down again from memory. But her sentences were stilted, corpse-like in their stiffness.

Life and nothing else. It was because she wanted to live that she was leaving.

The closer they got to Portugal, the more her throat tightened. At the frontier the searches were systematic. Her hands were tensed on the blue canvas bag. Should she have hidden her notebooks in a trunk with a false bottom? Have left them in France, in the vault of the City Bank as Hugo had advised her? What did she risk if they were discovered?

Her fears were unfounded. The customs officers had too much to do to bother those going into exile who were travelling first class and staying in the best hotels of a capital which in just a few days had become a symbol of hope. 'Lisbon is a mad house full of refugees from all over Europe,' wrote the photographer Man Ray who had found a place on one of the last liners leaving for the free world. France let its artists escape: Marcel Duchamp, André Breton, Max Ernst, even Salvador Dali, for whom fear of war had overcome his legendary sea sickness. Doubtless he would have envied Anaïs: she was on board a sea plane which was

taking them to the Azores, from where she was to take a plane to New York.

At the moment of take-off she was flooded with a kind of peace. 'Strange that, when we finally fly, the separation from the past seems easier to achieve. The face of Europe grows smaller.'

Farewell to France. Farewell to Paris.

Farewell to the chestnut trees on the Champs-Elysées. To the street lamps of Villa Seurat. To the tired steps of the Hôtel Central, rue du Maine. To the red banquettes of Café de la Coupole ... To the zinc table tops of Café Viking. To the polished brass of the Zener. Farewell to the usherettes of the Gaumont-Palace. To the violet seller in place Clichy. To the *patronne* of rue Blondel. Farewell to our nocturnal skirmishes, to our literary talk.

Farewell to my youth.

Her face pressed against the window, fixed on the dark masses of cloud, Anaïs drew up her balance sheet.

Thirty-six years old. A husband. Some lovers. A great many friends. And more than anything else: three books published.

Thanks to France, she could claim: 'I am a writer.'

DJUNA

A beautiful woman with an arrogant mouth promenades along the café terraces of Montparnasse; elegant, almost dandyish, but how solitary she looks, her gaze as icy as *The Blue of the Sky* (Georges Bataille). She is a cynic and therefore without hope, a puritan haunted by sin, offering her body to both sexes, to remain mistress of her soul. She is Djuna Barnes, an American in Paris — the most difficult of all to categorize.

Journalist, poet, designer, novelist, at twenty-five a disciple of Baudelaire in her *Book of Repulsive Women*, published in New York; her acerbic *Ladies' Almanack* was a satire on the lesbian circle of Nathalie Clifford Barney. Her novel *Nightwood* was a scandalous and inspired staging of perverted desire.

In 1937, a reader wrote to her about *Nightwood*: '[It was] the most beautiful thing I have read about women ... It was intolerable. It was unforgettable. I am very much afraid to write you. You will know why. I would like you to know what your book has touched, illumined, awakened.' The reader was called Anaïs.

Barnes did not reply. She never would reply.

Anaïs kept on trying.

For in Djuna, there was June: Djuna was the emblematic first name Anaïs used in her novels; Djuna represented an Eve who was not submissive.

Djuna, the dark twin. Barnes who wrote down what Nin did not dare say herself.

Barnes was so brusque; Nin was so naked.

There was a disturbing game of hide-and-seek in New York where the two writers lived in the Forties.

Nin tracked Barnes through the streets of Greenwich Village to

Patchin Place, the recluse's hideout, begging a look, a word from her.

Barnes avoided her.

Nin persevered, relentlessly, as if it were a part of herself she were pursuing: the part she suppressed?

For Anaïs never ceased to question her mirror. Very soon, Djuna veiled hers.

The two works are different and yet they reflect each other, like a photographic negative in which the lights and shades of a portrait are reversed.

[26] *Publishing to exist*

'I have lost a universe.'

It was almost like a curse: Anaïs was condemned to everlasting exile. 'I am homesick to death and a part of me is taking breakfast in a bistro in Paris,' she wrote in her room in the Washington Hotel, where she was temporarily in residence with Hugo. However, they were all there: painters, sculptors, musicians, filmmakers. The first to settle, like Yves Tanguy, had encouraged their friends to follow. Europe's famous were gathered in New York: Zadkine, Mondrian, Chagall, Man Ray, Léger, Schoenberg, Fritz Lang, Breton, Duchamp, Matta, Max Ernst. The Museum of Modern Art had just opened, and New York became the 'capital of Europe'. Marcel Duchamp, Matta and Dali showed their work at Julian Levy's. In 1942, the magazine *View* devoted a special issue to Max Ernst. His friend, Peggy Guggenheim, one of the richest heiresses in America, opened The 'Art of this Century' Gallery, devoted to Surrealist painting, to support him. Money attracted art.

The rich opened their salons. Painters rubbed shoulders with businessmen, sculptors and starlets. Hugo was working in finance again (he would take charge of the administration of Peggy Guggenheim's sister's fortune) and so was able to ease Anaïs's settling-in period in New York, as she took care to show in her *Journal*. The third volume abounds in society gossip: 'Danced with Pierre Matisse, son of the painter, who owns a gallery in New York ... Luis Buñuel was there, with his thyroid eyes, and moles on his chin ... Beautiful apartment on Central Park, full of modern paintings and sculptures. André Breton, Yves Tanguy and his wife, Kay Sage ... People who work in museums, art critics ...' Anaïs, driven by ambition as much as by distress,

sought introductions, pleaded with them. She had never felt so alone. 'Their faces betray no interest, no sensitivity.'

There was one exception, a tiny woman with pale eyes, lost behind piles of books: at the Gotham Book Mart Frances Steloff had created for herself a role not unlike Sylvia Beach's in Paris. She sold avant-garde magazines, rare books. The James Joyce association held their parties in her bookshop, which was open in the evenings. Anaïs met the photographer Alfred Stieglitz there. 'Make me love New York,' she challenged him.

What she really needed was for New York to love her. New York ignored her. No one there had read her books. The publishers whom she contacted took cover. Interesting, they said, but unpublishable.

For Anaïs, not to be published was not to exist. She therefore decided to be her own publisher. In December 1941 Frances Steloff helped her buy a second-hand printing press. For thirty-five dollars a month she rented a workshop in Greenwich Village and installed the 'Gemor Press', a contraction of the name of her lover, Gonzalo More, whom she had made her assistant. Hugo participated in the venture as an illustrator. The first book to emerge from Gemor Press was the illustrated edition of *Winter of Artifice* which came out in May 1942, after five months' work.

The closest witness to these years of apprenticeship was Caresse Crosby. She had squandered her fortune and youth in Paris, created the Black Sun Press on the Left Bank, published James Joyce, D. H. Lawrence, the first translations of René Crevel, supported Miller when he was entirely unknown, entertained Dali at her mill at Ermenonville. When Harry, her husband, committed suicide in 1929, she remarried, divorced, and returned to her country of origin, where she pursued the life of a woman of the world.

Anaïs met her at a reception given by Yves Tanguy and his wife: 'Caresse Crosby enters with the buoyancy of a powder puff. The word on her lips is always YES and all her being says YES

YES YES to all that is happening . . .' Caresse Crosby was 'a pollen carrier'. Their friendship lasted until Caresse died in 1970.

Caresse's account

I went to the Tanguys' in the hope of meeting Max Ernst and asking him to illustrate the translation of Paul Eluard's *Malheurs des immortels*. I had published the collection in French in Paris at the Black Sun Press.

While I was looking for his archangel face among the guests, another equally angelic face, but rounder and paler – rather moonlike – had intrigued me: it belonged to a slight woman who was beautifully dressed and moved from one guest to another with the smile of an impish child.

Of all the people there she seemed the pleasantest to be with. So I went up to her and asked her her name. She put her fingers to her lips, grabbed my arm and drew me to one side so that we were hidden by a curtain, and whispered. 'I'm Anaïs Nin. You doubtless know my husband, Hugo Guiler. Don't tell him you've seen me here this evening. Or he'll know I've been lying.'

Her husband's name was familiar. He managed the fortune of a friend of mine. The name of Nin stirred misty images. Paris, rue Cardinale. The printing works of Roger Lescaret where I had installed my own press. The chubby face of René Crevel. Miller's old felt hats. Miller. Nin. Now it all became clear. Anaïs Nin: Miller had mentioned her as an admirer. She didn't take kindly to the description.

'Do you still see him?' I asked.

She gave a little moue.

'From time to time, when he needs me. He always needs something. At the moment he's looking for an apartment. Would you know of one?'

'Well, it so happens I've just the thing. My own house is much too large for me. I could let him have the top floor.'

Anaïs sighed. Fortune always favoured fools.

'Sometimes,' she said, 'I just want to go back to Europe. In Paris, I was on first-name terms with poets, painters and psychoanalysts, and Rebecca West thought I had genius. I would walk for hours. Street life stimulated me. Every walk was an adventure. In New York I'm Mrs Guiler, a banker's wife, who nearly kills herself writing unpublishable books. I was hoping to see André Breton again – Miller introduced us once. I had hoped he might be able to help me. But he told me that he could do nothing for me, even less since I didn't belong to the movement. I'm proud that I don't. I've the feeling that a large part of what the Surrealists write is produced artificially in the mind and not in the unconscious. If you put an umbrella on an operating table, it's incongruous, but the feeling of absurdity is an intellectual reaction to events, it's not poetry. Henry is the only authentic Surrealist, the others are just theoreticians . . . New York has ruined their talent; mine as well perhaps.'

She let herself fall into a chair, her head in her hands.

'Going back to Europe would be suicide. But I no longer know what keeps me holding on to life.'

Did she really mean that? Or was she playing games with me? I followed my instincts. I had to help this woman. I took her hand.

'Come to Virginia with me, to Bowling Green. I have a Georgian mansion there in the middle of parkland planted with weeping willows. You would think you were in Europe. You can write there, enjoy the sun, the tranquillity. You can rest, find yourself again.'

I had already invited Dali and his wife Gala. I decided to add Miller. I love cocktails.

Miller accepted. He had finished his book on Greece. He couldn't think of a more wonderful solitary retreat than Bowling Green. Anaïs was more hesitant, torn as she was between Hugo, Gonzalo and Henry. She would have to lie to the first two, and reassure the third. It seemed to me that Miller was still smitten with her. They arrived together, in the Ford Model A driven by one of my friends, John Dudley. He claimed descent from the Earl

of Dudley, one of Elizabeth I's favourites. Anaïs, who couldn't resist people with aristocratic connections, even if they were spurious, became quite besotted with him. There were stolen kisses, furtive embraces, bedroom doors opening and closing in the middle of the night; I found myself slipping through Miller's door just as Anaïs reached John's . . .

The Dalis arrived a week later, loaded down like royalty in exile. They were exhausting, demanding, appalling.

Within forty-eight hours they had made Bowling Green their domain; my servants became their personal slaves and my guests their subjects. Gala reigned like a queen. Nothing counted except Dali's well-being and hers. Access to the library was reserved exclusively for her husband. She demanded mutton at every meal – it was the master's favourite meat – fresh shrimps, wolf-hair paintbrushes. Anaïs was commanded to translate an article about Dali, who could not read English. One evening, to try to relax the feeling of tension, Anaïs cooked a paella. Gala detested Spanish cooking, but Dali was moved by her gesture and developed a covert passion for this cordon bleu writer with whom he could converse in his native tongue. Gala fumed, Anaïs was jubilant. Dali would take her into his studio – she tried her best to understand his painting. It was all quite touching. 'Come and see, Caresse. He's painted a soft guitar like a body that has no muscles.' She could not see his genius. Nor could Miller, who treated Dali as if he were an imbecile; while the latter tried to convince me that Miller was a con man. It reminded me of two prostitutes squabbling over their pimp. In Dali's view, I should devote all my fortune to painting. Whereas my real passion was books. I was hoping I could relaunch the Black Sun Press. Miller and Anaïs were encouraging me in this and I had promised to publish their books. In the end, the project folded.

Some months later, I bumped into Anaïs on 57th Street: she looked splendid. Her dream had come true: she was now her own publisher.

'Come and see me tomorrow at 144 MacDougal Street. My name plate's by the entrance: 'Gemor Press, 3rd Floor'. Don't be surprised if a swarthy giant opens the door to you. It's Gonzalo, my assistant. Without him, I wouldn't have the strength to work the pedal for the press.'

Anaïs recalled the time when Harry and I had asked Picasso to do a portrait of Joyce. We could move mountains then. In spite of her frail appearance, Anaïs still seemed capable of such things.

The following day, I climbed the stairs to the third floor of this old building which was opposite the Provincetown Theatre. Anaïs welcomed me with an air of distress, which later was to become familiar.

'Gonzalo hasn't come in today. He must have drunk more than was good for him. I bought this press to try to keep him off the drink and give him something to do. I've failed. And so I drown my sorrows in work. I've been composing type for the last three hours. I must have ink all over me, even my nose. Take care your coat doesn't get marked,' she said as she led me between boxes and cartons. 'This place reminds me of the houseboat. It's all higgledy-piggledy. There are gaps in the windows, the floorboards creak, like in Paris. Look over there. The rows of zinc roofs. You would think you were in Montmartre. I love the Village. The little Italian shops selling their homemade spaghetti and *fromage frais*, the night clubs where they play subtle, restrained, rather plaintive jazz . . .'

They had put the press itself under the skylight so that they could benefit from maximum light, and painted the walls yellow. On the left wall they had pinned drawings: animals, with elongated, tapered wavy bodies, as if one were looking at them through water. I asked Anaïs who had done them.

'My husband Hugo, Hugh Guiler in the world of finance. Ian Hugo in the artistic one. He's a pupil of the engraver William Hayter, you know, Tanguy's friend and also Ernst's. In Paris, Hugo used to go to Atelier 17. He did the illustrations for *Winter of Artifice*. Look how fine the engraving is. We are the only ones

to use William Blake's technique. You put the copper plate on a support, raise the chassis, pass ink over the plate, pull the engraving, clean the plate, start again.'

'It must take you hours.'

'Days. Nights. Not to mention the text. You know what that's like. Take the letter o, place it next to the letter n, then a comma, then a space. I manage to compose thirty lines a day, about a page. If all writers had to be compositors of their own books, we would only have masterpieces. Come and look.'

She led me over to the stone.

'It takes me one minute to write this sentence. I spend two hours composing it, examining each letter, looking for any superfluous word or redundant adjective. My style has become more concise as a result. I wonder what Miller will make of it.'

I was amazed. The typography, the quality of the paper, the rhythm of spacing and letters, the choice of inks left nothing to the professionals, although Anaïs possessed neither their equipment nor their capital. An idea crossed my mind. I had still found no solution to publishing Eluard's collection. The war had cut off any links with Europe. I asked Anaïs if she would do it.

The Gemor Press had had no orders as yet. My offer came just at the right moment. Anaïs could have kissed me. We concluded an agreement: she would undertake my work once *Winter of Artifice* was completed. The paper, printing expenses and promotion would be my responsibility. I undertook to underwrite *Winter of Artifice*.

I knew everyone in New York.

[27] *Erotic in spite of herself*

Anaïs owed her reputation as a writer of erotic stories to a book which she was never to see published, commissioned by a collector for someone who did not exist.

Delta of Venus was published in June 1977, five months after her death – with great success: it remained on the bestseller lists for a number of weeks, when thirty-seven years earlier she had written it for a dollar a page.

In April 1940, Anaïs reported in her journal that a book collector had asked Miller if he would write some erotic stories for a rich client. The payment was to be a dollar a page. Miller immediately set to work: 'He invented stories, wild stories which we laughed over. Henry entered into it as an experiment and it seemed easy at first. But after a while it palled. He didn't want to touch upon any of the material he planned to write about for his real work, so he was condemned to force his inventions and his mood.'

Who then was this rich man from whom he received no encouragement, Miller began to wonder. Could he meet him? The collector replied that his client wished to remain anonymous. His doubts grew: were the rich client and the collector one and the same person? Pornography was a lucrative field at that time. Smelling a rat, Miller asked Anaïs to take over.

She hesitated. Writing to order was not something she enjoyed. She had her reputation to think of. Miller reassured her. The text would remain anonymous. The collector had not laid down any rules. She was free to write what she wanted. For a dollar a page. Anaïs could not do it without justifying herself. Every time she behaved in a risqué manner, there had to be a cautionary moral: 'Gonzalo needed money for the dentist. Helba a mirror for her dancing and Henry money for his trip.'

Every morning, after breakfast, Anaïs 'eroticized'. Her method was inspired by the exquisite corpses drawn by the Surrealists: from a sentence uttered at random, a story was constructed. She excelled at it.

She did not know what the anguish of the blank page meant. The virgin page drew her, she said, 'like a ski slope'. She threw herself into it with unbridled enthusiasm. What restraints were there for her? Wasn't every page worth a dollar?

The story called 'Elena' was already 393 pages long. A troubling prolixity. Anaïs defended herself from the accusation that she had drawn on her own experiences: 'I spent days in the library studying the Kama Sutra, listened to friends' most extreme adventures.' However the themes articulated in her stories were those which haunted her in real life: incest, frigidity, lesbianism; and 'Majorca', 'Artists and Models' and 'Marcel', written in the first person, seem more inspired by her journal than by her dreams. This is what the story 'Marianne' suggests: the plot revolves around a collector of erotic books, a woman and her intimate diary. Would Anaïs have shown the collector her diary before embarking on the commission? The Preface to *Delta of Venus* gives the official version:

'I gathered poets around me and we all wrote beautiful erotica . . . Robert Duncan, Caresse Crosby . . . all of us concentrating our skills in a tour de force, supplying the old man with such an abundance of perverted felicities that now he begged for more . . . [I was] the madam of this snobbish literary house of prostitution, from which vulgarity was excluded'; in its place was preciousness which Anaïs mistook for poetry.

She over-wrote, as Truman Capote commented, using ten adjectives where one would have sufficed, carried away by the example of her master, D. H. Lawrence, whom she wished to outdo as a lyrical writer. *Delta of Venus* abounds in an excess of style, sensations, positions. John Ferrone puts forward the view that she could never have reread it; for 'sometimes she lost

track of the bodies. I was surprised when I counted the arms and legs.'

When the book finally appeared, Djuna Barnes would slaughter it: 'Frightful style. Mediocre pornography.' The opinion of a biased expert.

Anaïs was the first to admit that *Delta of Venus* was not her masterpiece. In 1975, the year John Ferrone made a proposal to publish it, the manuscript was tucked away in a metal cupboard. Anaïs wanted it to stay there. Already weakened by cancer, she felt her reputation as a 'universal diarist' was too important to be compromised just at the moment when she was about to achieve lasting fame.

The publisher was obstinate. The manuscript, he said, belonged to a European literary tradition, in the footsteps of Diderot, Apollinaire and Aragon, to cite only the most famous. It was time that a woman joined the galaxy. Anaïs capitulated.

'I long felt that I had compromised my feminine self. I put the erotica aside. Rereading it, these many years later, I see that my own voice was not completely suppressed. In numerous passages, I was intuitively using a woman's language, seeing sexual experience from a woman's point of view. I finally decided to release the erotica for publication because it shows the beginning efforts of a woman in a world that had been the domain of men,' she declared in her Preface.

Thanks to the publisher's advance, Anaïs was able to pay her hospital bills.

After her death, the copyright was partly shared by Hugo, the only person of independent means to live off his wife's audacity.

Fate has its cruel ironies.

VOYEURISM

As the daughter of a voyeur who photographed her naked in the bath, she repressed her inherited tendencies until the exhibitionist, June, reawakened them.

'June Mansfield. I was a slave to her beauty. She saw only the reflection of herself in other people's eyes. Sitting opposite her, I feel that I would commit any folly for her. I do not make sense of her words ... I am fascinated by her eyes and mouth, her discoloured mouth, badly rouged ... Perfidious, infinitely desirable, drawing me to her as towards death.'

Before Miller could liberate her sensuality, June freed her fantasies.

She was able to see the woman she did not dare to be: a prostitute.

'One evening, I suggest to Hugo that we go to an "exhibition" together, just to see. I enjoy looking at the women's naked walk ... It is all unreal until I ask for the lesbian poses.'

She wanted to watch what she did not dare become: a slave of her sex.

In a hammam in Fez, she watched, hallucinated, 'breasts like sea anemones, the stomachs of perpetually pregnant women.'

At seventy-one, she half-opened the bathroom door where a young student, to whom she had lent one of her size 7 bikinis, was undressing: to see how she herself had once looked.

[28] *Summer of '42*

Physically I have not changed. My body is still that of a young girl's. I weigh just over eight stone. My breasts are beautifully shaped, with pink nipples. Only my hands reveal my age: and I have some wrinkles around the eyes, a few grey hairs. When I am tired, my chin sags. But the beautician at Elizabeth Arden has told me that, except around the eyes, I'm perfect. My muscles are firm. I take everybody in, even my doctor. They think I'm thirty. The surface is intact, but the feelings are those of an older woman. America has aged me.

1942: Anaïs was almost forty. That year, she pasted into her journal the announcement of Stefan Zweig's suicide. The Austrian writer who had been in exile in Brazil since Hitler's rise to power had made his choice. Rather death than *ersatz* life. Anaïs envied him his courage, counting her disillusions at the same time as counting her wrinkles in the mirrors of cafeterias. Gonzalo/Rango drank. Hugo was becoming embittered. Her book was not selling. Caresse Crosby had not kept her promise. Her influential friends had not helped her. But the newspapers were silent: not even those who marvelled at her tenacity, seeing her tear her fingernails on her press, spoke up. Kay Boyle had not written a line, nor Henry Bull of *Harper's Bazaar*, or Mark Slonim of the *New York Times*. The editor of the *New Republic* had censored an article of hers. *New Directions* magazine had allotted a page to her asking her to choose her own reviewer. She had suggested William Carlos Williams, whose critical work she admired. He took the book to be a confession and extracted scabrous remarks from her explanation of insomnia, frigidity, neurosis, the quest for the ideal father. He attacked her life: there was not a word about her style.

*

Frances Steloff had organized a publication cocktail party at the Gotham Book Mart in May. She had piled books in the window and near the table where drinks were being served. The guests clustered around the bar. Anaïs saw them drinking and laughing. And her book? A few came up to her. 'The cover is superb. Hugo is very talented.' And what about me? she silently screamed. 'The typography is exquisite. And the contrast of inking. Rango is gifted.' And what about me? They grabbed the book, turned it over, skimmed through the pages distractedly; their eyes slid over the words. Stop. Savour the rhythms. That alliteration. She looked back to her hours on the houseboat, or in the furnished room to which Rank had exiled her, to her cell in the Barbizon Hotel, when she was face to face with these pages, agonizing over every word. It was unjust. If she could, she would have told them all to leave. She was suffering. This struggle. These efforts to write, to print. The pain in her thigh from working the pedal. The press was too old. Rango got on her nerves. He drank and swore, and became aggressive. Keep going. These were the only words on her lips. The salons on the East Side smelled of morgues. The faces advertised their indifference. Dorothy Norman, who had published her story 'Birth' in the magazine *Twice a Year* could do nothing for her book, in spite of her interest in it. So sorry.

They all said that. André Breton claimed never to have received his copy. Max Ernst did not have time to read it. Gipsy Rose Lee, queen of New York striptease, had asked her for her portrait. The Surrealists were no more than cheats. Instead of creating, they tore one another to pieces. A sad bunch. Marcel Duchamp had begun to look like his abstract staircases. Breton, for all his scorn of accepted values, was seen pompously kissing a girl-friend's hand on the top of a bus on Fifth Avenue. Eleanora Carrington, a former mistress of Max Ernst, stroked her fine plumage, hoping that her inspiration would not dry up. To see her canvases, Anaïs feared that it had already happened.

They shared the same doctor: Max Jacobson, a German emigré: 'Miracle Max'. All New York society swore by him. Among his

clients were Marlene Dietrich, Truman Capote, Winston Churchill and Cecil B. de Mille. Anaïs went to see him when she had bronchitis. He cured her with an injection. His case was full of syringes. Whatever was wrong, he had an injection for it. He made up his own prescriptions and kept them a secret. It was said he used amphetamines, steroids, hormones. He had been struck off the New York State medical register. Anaïs did not listen to rumours. The injections were a success. She could no longer manage without them. She had one once a week before going to see her analyst, Martha Jaeger.

The first time she went to see Martha, a woman with a rather too serious face, she got off at the wrong subway station. She had to walk through the snow, battling against the wind. Against a desire. Perhaps her own. She could not say what it was that drew her to those simply furnished rooms – just a desk, a chair, a couch turned towards the wall. A desire to be understood. A need to confess. The relief of crying, like a child. Martha Jaeger told her that she made too much of everything. That the nurse-maid in her had supplanted the artist. That she confused love and devotion. Love and self-denial. That, to punish herself for identifying with her father, she was now imitating her mother. The female martyr. Anaïs sobbed. The tears made runnels down her powdered face. Martha Jaeger gave her a handkerchief: 'Don't hesitate to telephone me if you have an anxiety attack.' Anaïs called her and talked. Martha Jaeger listened, then absolved her. Anaïs put down the receiver. She was dogged by depression again. Some mornings Hugo had to force her to get up. She would not open her eyes. She thought of Zweig, of Virginia Woolf. She saw her walking into the water. Until it was around her neck. Her own hurt her. After that she lost the desire to go on breathing.

Miller suggested she take ginger or honey. The Californians were mad about them. Since June that year he had been living in Hollywood, in a house given to him by a couple of painters, a flowery villa in Beverly Glen. He would rather lose a friend than

his comfort. 'Everybody very hospitable . . . I'm well taken care of here. The only thing I lack is space and privacy. I have been going out — swimming, riding, etc. Am getting tan already and feel wonderful. Tho' I stopped the vitamins for a while I notice no difference and my eyes are much stronger than last year.'

Anaïs had sent him a copy of *Winter of Artifice* so that he could show it to bookshops on the West Coast. According to his last letter, he had not kept his promise: 'Haven't begun to show your book around yet. Now I am some distance from Hollywood and will go to town only when someone is driving in.'

Can one still be hurt by a man one has ceased to love? Every letter Miller wrote wounded her. Like the one where he gloated that he now possessed a bank account: 'God, I feel like a capitalist. And there are royalties soon due — from England . . . Almost every letter I pick up contains more good news. I wrote my last "business" letter last night. I have been at it steadily — like a monomaniac.' Then there was the one he closed with: 'Well, I must stop. Dinner is ready. Feel sober and inwardly calm, content.' Or the one which stated: 'You must learn to be detached.'

Was it for this man that she had ruined her marriage, sold her dresses, given up her friends?

She had to be detached, accept the break. Stop replying to his letters. It was impossible. A hope that was all too alive prevented her from doing so. Drunken images. The pink walls of Villa Seurat. The chrome yellow and oranges of the zinc roofs. Music everywhere. Children's laughter. Writing to Miller was a way of still believing in Europe.

The previous June, Dorothy Norman had invited her to her summer house at Woods Hole, not far from the Atlantic. They had gone there in a convertible. The wind had whipped their cheeks. 'On the other side of the ocean is Europe!' they had shouted into the waves. Europe. The word was lost in the roar of the waves. Europe. The air went to their heads like wine. 'We are the White Russians of America.' They had taken off their shoes.

The water turned their ankles blue and they held on to one another to keep their balance. On their lips was the taste of salt, a flavour of oysters, a dazzle of pearls, nails touching shells: a restaurant on the Seine.

Paris was anchored inside her, in her thoughts, in her writing. She began stories, all with the same setting: the Tuileries, the *quais*, the Seine, the Left Bank. She used the same words in each of them: water, boat, music, mirrors, sails, dreams, voyages, clairvoyance, birth and death. It was as though the past would never finish dying. As though these people from the past would never cease to haunt her: Artaud, Moricand, the one-legged captain and 'The Mouse' who had looked after her on the houseboat. Were the people here so empty that she should prefer the company of ghosts dwindling away with time, with the past, with regrets, like images seen through layer upon layer of glass?

This was the title of her collection: *Under a Glass Bell*. Hugo did not understand it.

'It's really very simple. Any living being enclosed under a glass bell is doomed to suffocate.'

'Are you talking about yourself?'

'Who else?'

'Why don't you stop all this self-examination, and write about other people, the people you see around you?'

'I do that in my journal.'

'Well, select some portraits, develop them, turn them into a novel.'

'A novel is the opposite of life. It segments time, freezes the emotions. Are we so insecure that we cannot bear the idea of truth being ephemeral? Answer me, Hugo.'

Hugo became more distant. He had lost his former patience, and had gained in confidence. His talent as an engraver had been recognized. Anaïs's talent impressed him less. He had matured, she had aged: that was the difference. He had never been so seductive as he was now, whereas for her it was a constant

battle. Young people worried her. They smiled at her. She caught herself hoping. She liked them smooth-faced, shy, embarrassed by their too-clear voices, their too-thin arms, their too-fine skin, their blushing. She rediscovered her old impulses in them: wanting to know, understand, desire, dance, create. Their youth imbued hers with eternity. Robert Duncan was one such. He was born on 7 June, the same day as June. He was a poet. He looked seventeen: narrow shoulders, slim waist, chiselled features – as though he had stepped out of an Egyptian frieze. He moved noiselessly. He seemed to express himself as though hypnotized: 'You are much kinder and sweeter than I imagined from *House of Incest*.' When he spoke of his abnegation, of his quest for his father, of his need for love, it was as though she heard herself speaking. Like her, he kept a diary. She discovered her own portrait in it. 'She is a very delicate woman, you know, sharp. She has such tiny fragile bones and eyes, I am sure, and she moves sideways through glass.'

Were homosexuals the only people to understand her? He had told her of his homosexuality, although he wished he were virile with her. When he visited her at the press, while Rango was away, he took Rango's place. 'This is no work for a woman.' He straightened his back, firmed his step. But face to face with men, he wavered.

He reminded her of Eduardo in his thirties, tormented by his own good looks, terrified by his leanings. She was sorely tempted to counter them. To awaken him to other pleasures, to revitalize her own.

He had asked her to put him up while he was looking for a studio in the Village. Later, he would ask for a little money. She would let him persuade her. Then she would agree, thinking herself noble. What an idiot.

We tell small children how the young of the albatross feed from their mother's entrails.

Anaïs began a story: *Children of the Albatross*:

'When will I stop loving these airy young men who move in a realm like the realm of the birds, always a little above or beyond humanity, always in flight, out of some great fear of human beings, always seeking the open space.'

[29] *Rupert*

'My young man from the West', the shadowy lover, 'my phantom lover', she called the man who was going to share the last thirty years of her life.

Half her life: travelling between Hugo and Rupert, New York and the West Coast, reconciling opposites. Rupert was the antithesis of her husband. He was luminous, like those young men whose youth she envied, now that she began to be vague about her age. He was as free as one can be at twenty; handsome enough to envisage a career as an actor. A bit like Gary Cooper, with intense blue eyes, a determined chin and large frame: a neat American boy, but also a graduate of Harvard and brought up in the 'best of worlds'. His father Reginald Pole had been educated at Cambridge, was a friend of Rupert Brooke, had played in Ibsen and Shakespeare in New York. His mother, Helen, had the good taste, after her divorce, to marry the son of the most innovative architect of the century: Frank Lloyd Wright, who designed the Guggenheim Museum in New York. Rupert had the candour of the West, the culture of the East: he personified the best of America.

Anaïs still felt herself to be an outsider there, despite the success of *Under a Glass Bell*. The first edition had sold out in three weeks. She had had to buy another printing press to keep up with demand. *The New Yorker* had honoured it with a review by a leading literary critic. Edmund Wilson had praised the talent of this 'secret creature. Half woman, half childlike spirit [who] is likely at any moment to be volatized into a superterrestrial being who feels things that we cannot feel . . . A very good artist, as perhaps none of the literary Surrealists is.'

Thanks to Gore Vidal, at that time a young novelist and literary

adviser to a publisher, with whom she had an elusive sort of relationship, she signed a contract with Dutton. Her third novel, *Ladders to Fire*, was at last published by a big publisher. So was she now what one might call an integrated person? Did she still suffer from a feeling of isolation? 'Three formidable barriers stand between me and American writers: one is drinking, which I do only moderately; another is I do not have the rough, straightforward, tough, plainspoken manners of masculine women, which inspire them with confidence; the third is, I suppose, my not being a native.'

'Only with the heart do you see well,' Saint-Exupéry said. Rupert would offer her his country, as he offered her his love, with an ingenuity revealed by cryptic clues in Volume IV of the *Journal*. 'I went to a cocktail party and was talking about all this with a young American from the West. He said "New York? You mean that is all you know of America? You must see it all, especially the South and the West." Henry's book [*The·Air-Conditioned Nightmare*] had not given me a desire to see all this, but the young man from the West, and his love of the country, did.'

The day following their encounter in March 1947, Anaïs decided not to put any more dates in her journal. She was past the age when she felt like revealing hers: she was forty-four.

The elevator gate was about to close when Rupert heard hurried steps. He pressed the stop button. A woman with her hair in a chignon and wearing a long red dress appeared and rushed in. He asked her which floor she wanted. It was the same as his. She was obviously going to Azel Guggenheim's, Peggy's sister.

He was right.

'We can go in together. It's not often that I go anywhere unaccompanied.'

Having reached the floor, they walked towards the mahogany double doors. A butler led them into the large salon. She took leave of Rupert and was lost in a crush of evening dresses.

Rupert greeted a few faces, wandered on to the terrace, for a breath of cool air which rose from Central Park, returned to the salon and found her, on a corner couch. She was looking for somewhere to put down her empty glass. Rupert had time to look her over. Her blonde hair seemed too brassy to be natural. She had an elegant neck, a full bosom, but her hands ... Rupert frowned. Her fingers were black. He took a few steps forward. Had he drunk so much that he was mistaking the hands of a really sophisticated woman for those of a miner? She looked as though she had been digging coal.

'It's ink,' she said.

She had surprised him looking at her.

'Printer's ink. I write and I print as well. In New York it's the only way to get read. I've just finished a ravishing booklet: my preface to Henry Miller's *Tropic of Cancer*. It has never been published in the States. Doesn't the name Miller mean anything to you? And my name? I'm Anaïs Nin.'

Rupert avowed his ignorance. It wasn't held against him. He didn't look like a typical reader of this rather stiff siren's work.

'My novels would bewilder you, unless you're an admirer of Martha Graham. I write the way she dances. Mixing dreams and symbols together. Her choreography is stunning. I can see a real relationship there with my work. I've tried to meet her. I've sent her my books, but she's never replied. Adults are a disappointment. So what is a young man like you doing among such conventional people?'

'My mother is hoping I shall find a fiancée.'

'Are you hoping that too?'

'My god no. I'd like to be an actor. I'm not really sure what my vocation is. While I wait, I'm working for a printer . . .'

'You as well . . .'

'Greetings cards. A student job, it could be worse, nothing comparable with yours though.'

She made a tired gesture.

'The passion is wearing thin,' she sighed. 'I've lost my initial

enthusiasm. If you knew the energy I've spent, wasted away, to the detriment of my books . . . I'm thinking of giving up the press. Or I might go back to Europe. In Paris, small publishing houses can survive. I lived there for more than ten years.'

'Do you think about it?'

'Every day. Especially now that peace has been declared. I can't stand America.'

'New York is not America. Have you ever been to Louisiana?'

'No.'

'Georgia? South Carolina?'

'No. No.'

'Colorado? New Mexico? Taos? El Paso?'

'No.'

She laughed.

As he took his leave, he promised to get in touch with her.

'Don't play with me. I'm as fragile as crystal . . . A mere nothing and I break.'

Rupert usually dined at the Bilaene, a Spanish restaurant with pink walls adorned with huge mirrors. There was wine and music, dark women. It was almost Europe. He invited Anaïs to go with him.

'You're divine. It's my favourite restaurant. I don't believe in chance. Only fate. We'll talk about it this evening.'

She arrived, dressed in a striped shawl and carrying an embroidered bag. She seemed smaller than in her red dress; her perfume gentler. A flowerseller passed between the tables. He bought her a rose. She broke the stem, turned towards the mirror and fixed it in her hair.

'Are you showing me your real face?'

'Why do you ask?'

'I've seen the publicity photo on your last book, *Ladders to Fire* . . . the three Anaïses: Anaïs veiled, submissive; Anaïs in furs and lamé, the vamp; and the one who smokes, dresses like a man . . .'

'You . . . you've got it wrong as well. Hedja, Stella and Lilian are the three main characters in my novel. The photos should have been captioned with the characters' names. It wasn't done. They missed it out on the paste-up; there should have been a fourth photo as well, one of me, Anaïs, the real me, the writer in a purple suit. It was fun posing for my characters. But my publisher only used the three women. Hence the misunderstanding. People think I'm schizophrenic, and lesbian because of the man's suit and bow tie . . .'

Anaïs looked away. Rupert beckoned the guitarists. They came up to the table. Strumming the strings of their instruments, and making eyes at her. Anaïs started humming the tune. One of them asked her if she was Cuban.

'How did you guess? Because I'm beautiful. *Muchas gracias*. Rupert, how wonderful.'

The siren had become animated at last, her face relaxed into a joyful smile, her hands twirled. She laughed at everything.

'Only young people make me feel at ease. They understand me. They don't make fun of my idealism. They share my rebellion. They expect a lot too. To please them, one has to . . .'

Rupert told her to stop.

'You please them. You please me.'

They sat *tête-à-tête*, in front of the *bananes flambées* which she had cooked in her apartment on 13th Street. Her name appeared everywhere. Her books were placed on coffee tables as evidence. Pieces of brown wrapping paper covered the windows. They were dining on the floor, seated on cushions, the sound of the *quena* in the background.

Rupert no longer knew where he was.

'What's the matter? You're not eating.'

He made some excuse. He was not going to tell her that bananas cooked in butter made him feel sick. She was cooking for him. In her language that meant that she loved him.

It was not a time for outpourings but for discoveries. They

were pierced by the same desire: the longing to go away somewhere.

'When I'm in other landscapes, speaking other languages, seeing other colours, I feel like a new person,' Anaïs sighed.

Rupert owned a Ford Model A convertible. They could go down to Louisiana, then over to Texas, New Mexico, and on to California.

One day in July 1947, they drove through the Holland Tunnel which separates New York from the rest of America.

Was leaving so simple after all? Had Anaïs reached a point where she had freed herself from Hugo, of whose existence Rupert knew nothing? What pretext had she invented for disappearing for two months? Did Hugo spend hours on the telephone trying to convince her to stay with him?

Forty years on, Rupert recalls another image: a woman in an astrakhan coat loading a canvas bag into the back of a Ford Model A. He also remembers the beret he bought, her laughter when she saw him: 'Why do you want to look like a Frenchman? I'm in love with an American.'

In Virginia, they put the hood down. Anaïs protected her face from the sun with a purple scarf. They drove through cotton fields and Anaïs waved to the cotton-pickers. She enjoyed everything. They had to stop in New Orleans. Her maternal grandmother had lived there: Rosa's mother, the scandalous woman who had sacrificed her children for love. 'I must take after her,' Anaïs said when they reached Alabama, under a changing sky which the storm washed and painted blue again.

But they could find no trace of her. What did it matter? Anaïs guessed that the indolent woman had known happiness, lounging on a balcony overgrown with lemon-scented geraniums whose smell mingled with the spicy smells of cooking from the stalls below. Here you lived just for pleasure. Like at Saint-Tropez. The

same heat. The same forest fires among the pines, the same *insouciance*. And jazz, childlike, flamboyant, in all the bistros.

'It was jazz that made New York bearable for me. I felt myself coming to life in Harlem. Do you know the Savoy Hotel? I've spent whole nights there. Gin fizz. Charlie Parker. Embraces. Saxophones. Sugary sweat. Smells of musk and tobacco. The body relaxing. I feel close to coloured people. I come from the same race. I miss the sun. Love brings out my Cuban soul . . . I had a Haitian lover once. Dancing was all he could do. If you could have seen him with his gyrating hips, he made women blush. Don't be jealous. It was only a physical attraction, nothing more. He liked to be provocative. I enjoyed his infidelities.'

'You've saved me from impossible loves,' she told him. They were approaching a colonial house, painted white, whose veranda overlooked parkland planted with hibiscus.

It was Gore Vidal's home.

The *enfant terrible* was the nickname Truman Capote gave to his rival, a man who was handsomer and richer than he, the grandson of a senator educated in the best school in New Hampshire. Like Capote, Vidal had published a novel at an age when boys are usually only thinking about girls. But both preferred the company of their own sex. Truman scarcely hid it. Gore, on the other hand, forced himself to please women. Putting people off the scent served his ambition, which was to live, by writing, on the Riviera.

When I met him at a conference on love in literature, he was happy enough being a literary adviser to Dutton, the New York publisher. He was in uniform, finishing his national service. In my black long-sleeved dress, with a pearl-trimmed hat I must have looked like Mary Queen of Scots. He introduced himself as Chief Warrant Officer Vidal, descended from the troubadour Vidal. I think he had recognized me. He had read *Under a Glass Bell*.

'You deserve to have a real publisher. I'll introduce you to Dutton's. I work there.'

'And you're so young.'

'I'm twenty, Madam. Quality has nothing to do with age. I've already published my first novel, *Williwaw*. It's dedicated to my mother Nina, who had the good taste to abandon me when I was ten.'

'You as well . . .'

You as well: this is what was important to her. The attraction of the similar. Ambiguous reflections, in which she was only seeking an image of herself in the other person. An unloved child like herself. A lonely adolescence, like her own. Precociousness. Vanity. Gore seemed so close to her that she checked his birth sign. Their affinities were precise. They were both ruled by Neptune. But Gore was a rebel. He responded to gentleness with aggression. The horoscope had said that someone born under Pisces would bring out the best in him. Anaïs listened to oracles.

'We saw each other every Sunday. We listened to records, exchanged manuscripts. I'd give him the pages of my stories, with my heart thumping, like a little schoolgirl. He'd promised to introduce me to his publisher.'

'Did he?' Rupert asked as he stopped the car. They parked under a barn where tobacco leaves were drying, giving off a smell of bark and honey. She wanted to turn tail. What point was there in seeing Gore again, now that she had Rupert? So that she could thumb her nose at him on the arm of a man whom he might desire himself? Had she still no common sense?

'Yes, it was thanks to him that I was published. He boasted enough about it.'

'So why this hysteria? Who're you seeing again? A friend or a lover?'

'A man I loved.'

Does loving consist only of pasting his photo on the opening page of her journal? Is loving only waiting by the telephone? Is loving feeling too ugly in the morning to go out that evening with

a boy who only kisses or embraces you if pressed? Is loving undressing in front of a man who does not even look at you?

'Let's go. I don't want to inflict my wounds on you.'

'If you want them to heal, you ought to see him. Your past hardly scares me. I'm ready to face him with you. If you want, we'll go to see Miller as well.'

'In California?'

'My mother and stepfather Lloyd Wright live in Los Angeles. We'll spend a night or two with them, before going on to see the "great writer".'

Miller was now living at Big Sur, on the edge of the Pacific, in a country of canyons planted with oaks and sequoias. In clear weather, you could see eagles and buzzard hawks. Thanks to his author's royalties which had been looked after in France by Jack Kahane's son, he had bought a house built on a crag, nine hundred feet above sea level. He had married Lepska, a young Polish woman, a philosophy student, and they had a daughter.

Anaïs was expecting to meet a disquieting Slav, June's double. They were greeted by a blonde, massive in the way some Teutonic women are. She scarcely spoke. Her attention seemed fixed on where their feet had stepped on the floor. Rupert had never seen such a clean house. Order reigned, as far as the library. It was clean, bare, lifeless. How could Miller adjust to this setting?

In appearance, Miller had hardly changed. He was tanned, contented. His books were still banned in the States. But he managed. His water-colours were selling well.

'Always merry and bright,' he said to Rupert.

'Ten years ago he would have slapped you on the shoulder,' Anaïs whispered.

His manners had mellowed. He walked gently past Lepska. He seemed embarrassed by their visit. He took Anaïs to one side. Did she need money? He could lend her some, after all she'd done for him. An angel passed. Anaïs looked at Lepska's legs. She already had varicose veins. Miller had problems with his sight. Anaïs

asked him if he had read *Ladders to Fire*. Not yet. The extract which had been published in *Circle* magazine had left him perplexed. He was not sure he understood her 'emotional algebra'. She would benefit from writing more clearly, more concisely. He looked at his watch. It would soon be lunchtime. Lepska announced that there was not enough meat to go round. And bread?

Anaïs signalled to Rupert. It was time to go. A piece of the past crumbled away.

LSD

In 1943, when he had succeeded in synthesizing lysergic acid diethylamide, Albert Hofmann, a research chemist with the Sandoz company, was overcome by a slight dizziness. He interrupted his researches, went home and, falling into a twilit state, was plagued by hallucinations of incredible plasticity: LSD had just been discovered — it was the most effective of all the hallucinogens, ten thousand times more powerful than mescalin.

Very quickly it began to be used in psychiatry under the name of Delysid, for cases of anxiety or obsessional neurosis, and it was recommended to doctors who were willing to undergo self-experimentation in order to glimpse the mental patient's world of ideas, and thereby be able to study the pathogenesis of psychotic types using a normal subject for a short time.

During the Fifties, and always under medical control, LSD was tested on theologians, churchmen and artists. Among the guinea pigs was Anaïs Nin. It may have been Oscar Janiger, a professor of psychiatry at Irwine University, Los Angeles, and a friend of Albert Hofmann, who suggested she try a trip, as she recounts in Volume V of the *Journal*, or she may have put herself forward.

Anaïs had a limited experience of drugs. June had been addicted to cocaine without dragging the all-too-impressionable Anaïs down with her. Miller professed to only one addiction: wine. What about opium? Once or twice as a reckless tourist in Morocco.

Her attraction to drugs remains literary. She had read Baudelaire, de Quincey, Cocteau. Henri Michaux and Aldous Huxley had whetted her curiosity.

Would it enable her to reach a higher state of consciousness? Would it open, as Huxley had written, paraphrasing William

Blake, 'new doors to perception'? Would her work benefit from it?

'LSD is a short cut to the unconscious,' she wrote after a trip of several hours in which she saw herself turned to gold. 'The most pleasurable sensation I had ever known, like an orgasm . . . But through my writing, I had visited all those landscapes . . . this world opened by LSD was accessible to the artist by way of art.'

According to a friend's account, she was to try several other trips. In 1963 she encountered Timothy Leary, an apostle of the Hippie movement, whose crusade in favour of LSD she supported for some time, for she commented later: 'America, with its pragmatic culture, had no access to this inner world: blocked by Puritanism and materialism' and she hoped that LSD might prove to be the key which would open up her work to them.

In 1974, six years after LSD had been declared illegal, she made her confession, stating: 'People who have misused it to get high have given it a bad reputation.'

There was no question of risking hers.

[30] *Star of the underground*

Anaïs is still living, on 16-millimetre film. The magician of words also revealed herself through the medium of pictures. Like Artaud.

Anaïs lent her voice and her body to three underground filmmakers in the Fifties, who like her were fired by Surrealism and psychoanalysis and opposed to Hollywood. They were convinced that the cinema could express consciousness as much through the play of images as through something more imponderable, which would free them from the laws of reality. They were Maya Deren, Ian Hugo and Kenneth Anger. A fraternity?

Such had always been Anaïs's ideal: creating together, helping each other, inspiring one another. A fertile brotherhood, an exchange of visions, a transfusion of talents.

Was it an ideal or was it fantasy?

A woman washed by waves in an intertwining of seaweed and hair, on the beach at Amagansett, near New York, one day in August 1945. A man is filming the scene.

Anaïs had been walking on the seashore and had silently observed the couple. The filming finished. She wandered over to meet them. The young woman's beauty took her breath away. Her mass of red hair accentuated her pallor. She introduced herself: she was Maya Deren. The cameraman was Alexander Hammid, 'Sacha'.

'One of the leading figures in the Czech avant-garde movement of the Thirties,' she said with some seriousness, with the suggestion of a Slav accent. 'Usually I'm the one who's holding the camera.'

Maya had been born in Kiev, where her father was a psychiatrist. She had studied poetry and dance before making her

first film with Sacha, and quickly catching up with her teacher. She filmed the way other people might caress or juggle symbols, ordering the body into strange choreographies, manipulating actors like pieces in a chess game in which she was queen. Her face appeared in all her films.

What could have been more attractive to Anaïs?

In the Village Maya lived among snakeskin drums, masks and votive statuary. Voodoo art fascinated her. She studied the occult. She traced the unsaid, the unseen. She films what I write, Anaïs thought. She works instinctively, with few resources, using her friends as actors.

Her new short film, *Ritual in Transfigured Time*, needed thirty extras. 'I'm trying to find out about movement, appearances, the instantaneous. Would you like to take part?'

Anaïs did not know how to say no, especially to a creative woman. Women like her. She was linked to them. She had to help them. She had had so little herself . . . she had to support them even if no one else was supporting them, in spite of the gnawing bitterness she felt. She was born too soon. A day would come when women would no longer have to fight to hold a camera or publish a book. When that day came, Anaïs would have the right to say no.

The shooting took place at Maya's. They turned on the projectors. Maya climbed on a stool, loaded the camera on to her shoulder. Action.

'Move. Be sinuous. Be sensual, sensual.' Anaïs, her eyes closed, imagined that she was in Paris, her naked thighs on the red banquettes at Zeyer's, stretched out, awaiting a caress. But bodies were avoided. Hands hesitated. Anaïs approached Maya. Shouldn't she be giving some stage directions, like a choreographer? The young Haitian woman for example . . . Maya ordered her to shut up, or leave.

Anaïs went back to her place. Tiredness creased their faces. Maya raged. Did women have to shout like this to make

themselves understood? Must their voices drown out the men's? Did you have to surrender gentleness? Grace? Did Maya herald a race of female warriors? What good would it have done to send her my books? We didn't speak the same language. Happily, there was Sacha. A true Slav. Generous, passionate. If he would teach Hugo how to make films, I won't have wasted my time with this woman. Hugo must be taken in hand. Since he had left the bank, he'd felt a little lost. He'd never needed her so much as he did now. She had never pressed him so hard in his life . . .

Anaïs had triumphed. When Hugo had given in his notice, his colleagues had thought he was mad. He had to be, to give up the comfortable retirement which twenty-nine years' loyal service would have earned him. His wife had convinced him. Creativity was incompatible with finance.

In 1949 he changed his three-piece suit for Hawaian shirts. He also changed his name to Ian Hugo. Anaïs was delighted. At last she had a husband who was creative. But engraving was no longer enough, he was looking for fresh fields. The cinema? Hadn't Artaud let it be known that everything there was still to be invented, that it was much more exciting than a box of matches,* more captivating than love. Fortified by lessons from Sacha Hammid and furnished with a second-hand 16-millimetre camera, he flew to his childhood Eden: Puerto Rico. And made *Ai-Yé* there.

This short film, which was first shown in 1950, received a prize from the Cinémathèque de Paris. He was launched. So quickly. 'What injustice!' Here she had been battling away for twenty years to achieve recognition. For twenty years she had plumbed the depths beyond reality. In what way was the daring form of *Ai-Yé* any different from her work?

Could it be that Hugo guessed her vexation and so adapted

* This is a reference to Artaud's staging of burnings at the stake.

The House of Incest the following year? Of all his wife's stories, that was his favourite. He had done his most beautiful engravings for it. Now he was going to make his most accomplished film from it: *Bells of Atlantis*. The 'first successful cinematographic poem', Abel Gance would call it.

They had to choose a location and Anaïs suggested Acapulco. Everything was hotter there: flowers, blood, embraces, looks. It was a land of pleasure. She had discovered it with Rupert. She took Hugo there. Was he aware that he was retracing the steps of his rival? Probably. The time for jealousy was past. It was an era of compromise. Hugo closed his eyes. Anaïs kept her secrets to herself. They shared the same apartment in New York, but Anaïs kept the key to the room where she stored her journals. When she flew to the West Coast where Rupert was living, Hugo did not question her. He merely waited for her return.

Anaïs had taken the project to heart. She swore *Bells of Atlantis* was going to be a masterpiece. This was a film from her own writing. She didn't want to be disappointed, betrayed. She accompanied Hugo to the locations, and guided his vision. It was touch and go whether she tore the camera from his hands. She believed in his talent, but doubted his genius. Without her, he would have accomplished nothing extraordinary. Not even the superimpositions of *Ai-Yé*; those fade-in fade-outs which the critics had called 'sublime' had been her idea. Hugo was happy to apply his technique to it.

One morning on the beach, she noticed a huge boat, rotting away, half buried in the sand, bleached by the sun, as if it had run aground at the dawn of the world. Anaïs shouted to Hugo to load the camera. The film would open here. Hugo edged his way between two planks. A watery cathedral. An upturned hull festooned with seaweed. Entrails of kelp. Belly, uterus.

Anaïs whispered: 'My first vision on earth was water veiled.' The opening sentence of the film.

Voice of Anaïs, fragile threnody mingled with electronic percus-

sions. Then her shadow, swaying on the pale waterline dear to Rimbaud, in a hammock stained with spray. Then her body outlined, gently touched by the flow of the waves, eternally young.

Voice of Anaïs. Breasts of Anaïs. Curls of Anaïs. Arms of Anaïs. Anaïs crucified. Anaïs sublimated. Anaïs celebrated. *Bells of Atlantis*: a hymn of desperate love. Anaïs fleeing, captured here. In colour, for ten minutes ...

Another filmmaker. Another generation. Other visions. Kenneth Anger, rising star of the underground. An actor at the age of five in one of Max Reinhardt's stage extravaganzas, a filmmaker at eleven, at seventeen Kenneth Anger had become a legend with *Fireworks*, eponymous film of the underground. First 'gay' manifesto in the history of the cinema. 'Coming from that night, whence all true works of art emerge. He touched the quick of the soul,' wrote Cocteau. Kenneth Anger denied himself nothing: eroticism, magic, Surrealism, comic stories and abominations. What was essential was to confuse the senses. He tried this, with the refinement of Chinese torture, in 1954 in his first version of *The Inauguration of the Pleasure Dome*, a cult film, lauded by Fellini and later by Andy Warhol.

It started with a party, in a villa in Malibu perched high above the Pacific. Its owner, Renate Drucks, a red-head from Vienna, had two passions: Surrealism and fancy-dress balls, to which she invited the local eccentrics. This one had as its theme: 'Come as your Madness'.

She had invited Anaïs Nin who lived not far away, at Sierra Madre among the orange trees and eucalyptus.

Renate would have loved to know more about the novelist. People said she had a lover – a forest warden called Rupert – a husband who made films, a famous friend, Henry Miller, and a white poodle.

Come as your Madness.

My madness: writing.

When Anaïs appeared at Renate's, words died on people's lips. They elbowed forward. She was more naked than naked. Stripped even of a skin-tight leotard. 'How old is she?' Laughter. Stupefaction. Her body was still firm, her buttocks had not sagged. Narrow waist, encircled by a synthetic leopardskin belt. Fur earrings glued to the tips of her breasts, which were held up by a transparent half-cup bra.

Her eyelids were painted gold and on her head was a cage. A parrot cage. Parakeets. Diamond mandarin ducks. A cage for talking birds. Anaïs said not a word. The gate of the cage was open. She plunged her hand in. From her mouth she drew a roll of paper which she offered in lieu of conversation. On it were sentences from her novels: 'Come as your madness' ... Accept mine. My words. My madness in writing it all down, in keeping everything like a captive bird. Each breath of life becomes a fragment of eternity.

Rupert had drawn genitalia on his underpants. Renate, an iridescent scarf around her waist and wearing a black hood, advanced under a death mask. A guest had immersed himself in a bath of black ink. Then a spectre arose, his nails covered with feathers, draped in lace and widow's veils: it was Kenneth Anger. He had waited for all the guests to arrive before making his entrance, holding a candle before his veiled face.

He observed; the visions became fixed in his mind. Anaïs in her cage. Renate as a Kurt Weill heroine. Her son, Peter, a miniature maharajah. Rupert innocently obscene ... So similar to his fantasies that he decided to make a film of it.

'We were to come in the costumes we wore,' wrote Anaïs. '[Kenneth] said to me "I want you as Astarté, the goddess of light. I want to capture that luminosity which startled everybody at the party."'

He would capture something quite other, in making her appear draped in yards of blue muslin, a celestial mummy with the

hobbling step of a Chinese girl, a begonia mouth, platinum eyelashes, charming the camera like a professional, playing Anaïs much more than Astarté, caged behind bars of gold. Already a prisoner of her myth.

[31] *Paris lost?*

'The Journal almost expired from too much travelling, too much moving about, too many changes. I felt pulled outward into activity . . . I have installed myself in the present.'

In Rupert's grey Ford Thunderbird, Anaïs grew more daring, escaping from New York to Los Angeles via Acapulco. She confided in her new analyst, Dr Bogner: 'For a neurosis such as mine, to take root means to be rooted to a situation of pain.' She evaded, fled, escaped from herself. Her journal during the Fifties becomes less a depiction of herself than of other people, and is less revealing. It was no longer a matter of tactlessly recording her escapades, as she sat up in bed beside her sleeping husband. But nor did she set out to hurt Rupert. At her age, she could not afford to fool around with love, when the man in question was only thirty.

Her reputation as a writer crystallized. In just over ten years, from 1947 to 1958, she had published a critical essay, *On Writing*, and four novels: *Children of the Albatross*, *The Four-Chambered Heart*, *A Spy in the House of Love*, and *Solar Barque*, brought together in 1959 into a single volume, *Cities of the Interior*, by the publisher Alan Swallow. One might have thought that this would have suppressed her urge to write her diary. But no, this continued under the guise of novel-writing, for her four books were tailored from one and the same material: the journal.

The original journals lay in the vaults of a bank in Brooklyn. But there was not a day when she did not reread the typed copies: 'to refresh my memory', she said. And to feed her fiction. Her journal was like a preliminary sketchbook. And her novels revealed what she had remained silent about in the journals. Paris, Los Angeles and New York were blurred into a single

town; people she knew were renamed – Hugo/Allan, Miller/Jay, Gonzalo/Rango – but the masks under which they appeared exposed rather than concealed her. In Djuna she confided her lesbian tendencies; in Sabina, 'a spy in the house of love', her infidelities. She wrote movingly, sensitive to the sound of words. According to her, her books were now selling at the rate of two or three thousand copies a year – and in the absence of any publicity, reviews or external help. The New York magazines produced some good reviews for her stories. For the paperback edition of *A Spy in the House of Love* she received an advance of 1,200 dollars. She was asked to lecture. In spring 1958, the American Cultural Center in Brussels invited her to Belgium for the Universal Exhibition. Hugo went with her. He gave a showing of *Melodic Inversion*, his third film in ten years. It had become impossible for him to make any more for he had returned to the world of finance, and set up on his own, offering currency exchange services and tax advice. It was for this reason that, after Brussels, Hugo had to go on to Paris for a few days. Anaïs was beside herself with impatience. She had waited twenty years for this return.

The Caravelle began its descent towards Le Bourget. Anaïs buckled her seat-belt and nudged Hugo. He was asleep. In Brussels he had taken a nap in their hotel room every afternoon while she had jumped into a taxi and visited the town, to try to expiate the painful feelings the memory of the city still evoked in her. It was here that she had almost died from undiagnosed peritonitis when she was nine years old. It might have made her sterile. That at least was the opinion of the surgeon who had operated on her five years earlier for an ovarian tumour. She had feared the worst. But the biopsy revealed not a trace of cancer. Dr Jacobson's injections had speeded her convalescence and she had quickly recovered all her youthful energy.

In Brussels, when she had gone on her visits in the evenings, she had not bothered with the embassy cars so that she could be

alone. She was astonished by the narrow streets, the slowness of the buses, the small stature of the people, and astonished at her own astonishment. Had she become American? The bathrooms in the hotel seemed antiquated, the wardrobe inconvenient. She had not had anywhere to put her clothes: skirts, handbags, high heels, stoles and, matching her orange nail varnish, the apricot muslin scarves that hid the wrinkles on her neck.

'Has America won me over without my even realizing it?'

Hugo stroked her thigh.

The weight of his hand. A husband's rights. Never had a convict experienced heavier shackles. Hugo considered her his chattel. His object. A charming plaything for whom he had put on his double-breasted suit. 'You like luxury, my little pet.' Contracts, negotiations, social gossip, between two concerts of electro-acoustic music.

How boring it all was. But how could she leave her husband now? It had become impossible. She belonged to him by virtue of a ceremony thirty-five years old. To a journalist who asked her about marriage, she had replied: 'We shall shortly abolish it. Conjugal life should be free of legal ties. And it should become more flexible. Men have always been allowed to have a parallel love life; why not women too?'

She and Rupert were going to meet in Paris. A discreet, cheap hotel had to be found. In Saint-Germain perhaps. Far enough away from theirs to avoid a scene. Would Hugo's business meetings give them enough freedom? Were there public telephones in the streets? She never telephoned from the hotel. When husbands are rich, receptionists are always on their side.

It was an exhausting double life: making up alibis, juggling with meeting-places, keeping a cool head if your lover telephoned you when your husband was there; treasuring your friends who were in the know, the ones who would post a letter in New York which you had written in Los Angeles; lying.

She had no choice. Hugo protected her, Rupert gave her back her youth. For him, she took care of her looks, made herself

beautiful. She did not belong to one any more than to the other. She needed them both in order to be herself. They made her real. Hugo loved the Anaïs he had always known; Rupert the eternal Anaïs.

She would leave one to join the other, moving from the apartment in Washington Square with its Japanese flower arrangements and abstract engravings, to a quiet bungalow on the West Coast in the shade of umbrella pines, where she would write until overcome by a desire to sparkle, socialize, go back to New York, attend private views, premières where she could dress extravagantly, like a siren, and be with Hugo, drowning his bitterness in Scotch.

What she wanted was an artist's life: just a few possessions, a simple home, a little money and very few compromises. But it would have required courage to flout rules, laws, taboos. Why hadn't she left Hugo when she first met Rupert? Because Rupert was looking after his retired mother in San Francisco? Or because Hugo's lifestyle suited her?

Without Hugo, she would never have seen Paris again. He had to do his business deals there, contact the Cinémathèque about his films. Then he would take her to Maxim's, when what she really dreamed of was a ham sandwich in a small café in Clichy.

Was the washing still hung out on the barges? Anaïs wondered, lounging on the brocade bedspread, blinded by the light from the chandelier. Hugo had wanted to stay at the Crillon. When you're travelling on expenses, why deprive yourself of the pleasure of savouring the best Paris has to offer?

For her, pleasure lay elsewhere, along the cobblestone streets round Villa Seurat, where she had broken her high heels in her haste to meet Miller. She wondered who was living at No. 14 now. Did Soutine still live on the ground floor, and what had happened to Chana Orloff? She still had all their addresses in her black leather notebook: Moricand, rue Notre-Dame-de-Lorette, Jean Carteret, rue de la Tour-d'Auvergne, Louise de Vilmorin,

quai de la Bourdonnais. She closed her eyes; the places appeared. She should be content with roaming; pilgrimages frightened her. But Paris beckoned, its sky, its opaline beauty, its parks filled with children and statues. She wanted to walk around Paris, to see, be seen. In America, passers-by don't look at you. Here people stare at you openly, desire you. She had a reversible cape which she could wear black or white depending on her mood. For Paris, it would be white, white like a shining armour to defy the past. The white of a débutante. If only you could relive the past . . .

Hugo went off to his appointment. She was free the whole day. The receptionist offered her a street plan. She thanked him. 'I know Paris perhaps even better than you, monsieur.' His smile in reply hovered midway between surprise and irony.

She had worked out her route that morning, while Hugo was shaving: the *quais*, the Luxembourg, rue Cassini, the Dôme, Villa Seurat; from there a taxi to Montmartre, so that she could gaze with wonder at the city at her feet.

She ran across place de la Concorde. In Paris, she had always been running, either to meet Henry or leave Hugo or find Gonzalo on the houseboat. It had been moored just here.

'Can you remember the *Belle Aurore*, a creaking old barge?'

They shrugged their shoulders and stared at her. A funny accent. Peculiar coat. A foreigner.

Why did they turn away?

'You an American?' the waiter in Zeyer's asked her when she ordered a coffee.

What should she say? She had tears in her eyes. She was from nowhere. Here and there, bobbing like a cork on the waves. Alone.

The Dôme had changed ownership. There was no longer a concierge at 14 rue Cassini. She twisted her ankle on the cobbles of Villa Seurat, only to learn that Soutine had been dead for fifteen years and Chana Orloff lived in Israel. Moricand had left without leaving a forwarding address.

In the taxi that took her back to the hotel, she leafed through her black book. Tomorrow she would telephone Marguerite, a young interpreter she had met in New York, her only contact in Paris, the only one she could turn to, the only one here who believed in her talent. Marguerite tried hard to get the bookshops to take her books. Without success. The French read French. Novels had to be translated. All her efforts to be so were in vain. The publishers, Plon, were interested in *Ladders to Fire*, on condition that they could censor the references to lesbianism. Had puritanism conquered this homeland of Genet and Colette?

When she was an unknown, Paris had published her. Now she was treated with suspicion here, while Stockholm, Amsterdam and Milan welcomed her work. Why couldn't she be translated into the language closest to her heart? Because she didn't know the right people? Whom could she contact? Breton was still as secretive as ever. Pierre-Jean Jouve, whom she admired, had no power. Malraux would not budge an inch. Someone suggested Jean Paulhan, Gaston Gallimard's closest colleague whom she had met when she knew Artaud. Not a single book was published at Gallimard without his approval. He saw people without appointments on Wednesday afternoons. She could not fathom what it was that held her back from going to Gallimard's office. Was it deference? Timidity? Fear of being misunderstood? A novelist: this bleached blonde in an Indian dress?

Her only hope was a young publisher or a young writer. Lawrence Durrell had given her the address of a medical student, originally from Mauritius, a sometime poet, who enlivened the literary pages of a magazine for medical students. He was nursing a more ambitious project called *Two Cities*, a bilingual magazine in which both French and English writers could express their opinions.

'You've nothing to lose and everything to gain,' Larry had said to her. 'This boy has talent. He'll try to do for you what Jolas did for Joyce, even if he doesn't have the means. He may ask you for

a little money to get his magazine off the ground. Give it to him. If the magazine appears, it'll serve as a European platform for you. Jean Fanchette spoke to me about your books with great sensitivity. He could write an appreciation of your work.'

She said she would meet him at the Deux Magots, where the cream of Parisian intelligentsia met, if you were to believe what you read in the papers. Wasn't that Simone de Beauvoir coming in? Why on earth was she wearing that disgusting turban? Why was she hiding her hair? So she would not appear too feminine? So she would be respected, taken seriously? That was her problem. *The Mandarins* was didactic. Her writing was sexless. How could she work on behalf of women when she did not speak their language? If she had had the nerve, she would have introduced herself: 'I'm Anaïs Nin, the writer. I've read your books in French. I'm bilingual. I've been asked to write articles about you, but I've refused. You bore me deeply, but I'm prepared to revise my opinion.'

Wouldn't it have been clever to say: My dear Mme de Beauvoir, since you supported Violette Leduc, I wondered if you might be interested in another bastard, me: not quite French, not quite American; between two cultures, between submission and revolt, between two ages. Can you bear yours? The fifties are a nightmare: not old and certainly not young. If I'd been young, I wouldn't have allowed a young man to keep me waiting. Jean Fanchette is half an hour late. I'll be patient. I'll have a look through a copy of *La Nouvelle Revue française*, powder my nose again, order another cup of tea. I stare at Simone de Beauvoir. I sketch just the trace of a smile. I look at my watch. Time's precious, and I'm wasting it. However, I wait. This young man will come. My journals will be published. I will be recognized. All I need is patience. I shall die of it. I've already been waiting for fifty years.

ANNA KAVAN

An English novelist who was born in 1901 on the Côte d'Azur; deflowered in Burma, locked up in Switzerland in a sanatorium; given electric shock treatment in a clinic in Sussex; twice divorced, orphan of an only son. A lonely accomplice for this dyed blonde: the white lady. 'Fine white powder is not repugnant; it seems pure,' said this frigid mystic, haunted by the gaping void her novels exposed even in their titles: *Asylum Piece*, *Change the Name*, *I'm Lazarus*, *House of Sleep*, *A Scarcity of Love*, *Let me Alone*, *Who are you?*

Who are you, Helen Woods Ferguson Edmonds, known as Anna Kavan? Kafka's sister?

Anaïs asked her that in a letter of 9 March 1959. 'I hesitated to write to you . . . I had carried a letter in my head so long that I felt as if I had written it . . . You entered the realm which was inevitable and necessary to explore . . . I move in and out of conscious and unconscious and was reviled and ignored for twenty years. Have you read mine? I am sending you my *House of Incest* which has parallels to your *House of Sleep*.'

In spite of other letters, in spite of the preface she wrote in 1967 for *Ice* (published by Peter Owen who published the British edition of the *Journal*), Anaïs was never to meet this maniac of despair in whom, confusedly, she recognized herself.

On 8 December 1968, at the moment when the party to celebrate the publication of the first volume of the *Journals of Anaïs Nin* was at its height, Anna Kavan, who had been invited to the party, was found dead on her bed, wearing her cocktail dress, a syringe by her side.

[32] *In the labyrinth of the journal*

On her sixtieth birthday Anaïs telephoned a friend in Los Angeles and said in a broken voice: 'I don't deserve to be alive. I'm an old woman.' Her friend reassured her: the face-lift she had just had was a success. She groaned: 'I seem to be trapped in a false youth. Strangled. I'm suffocating under this mask.'

She was to add yet another mask, the definitive one: her journal. She had decided to publish it. But before doing so, she was going to remove all the scoria, all the scandals, and turn it into a monument as perfect as her face.

The moment had come. Her literary reputation was now firmly established in America, in Europe, even in France.

The young Jean Fanchette had not let her down. In the first issue of his new magazine *Two Cities*, devoted in part to Lawrence Durrell, was an article several pages long on her work. The title is sober: '*Pour une Préface*' (By way of a Preface) but it is a vibrant homage: 'I write Anaïs, and I think of a word which is untranslatable in French: "awareness". Anaïs Nin has such insight . . . she can name and explain this chemistry of body and soul, can arouse from one's innermost core so many distinct anxieties, biological anxieties.' It was a wonderful review and, what is more, it was written in French. Anaïs hastily got it translated and had five hundred copies distributed with a feeling of self-satisfaction that would grow as success came. Rare would be letters to friends without press cuttings or photos . . . waiting had blunted her modesty.

Fanchette's article drew the attention of the French publisher, Editions Stock. In 1962, *Ladders to Fire* was translated into French, to be followed two years later by *A Spy in the House of Love*.

Anaïs was invited to Paris for the occasion. At her request, they reserved a suite in the Hôtel d'Angleterre in rue Jacob, at the elegant heart of Saint-Germain, the hotel where Rupert had stayed, and where they had held their secret rendez-vous, the last time she had visited Paris. This time there was no lover waiting in the shadows. She was being chaperoned by Hugo. She had at first refused. She found his presence oppressive. Her husband was ageing, his wrinkles reminded her of her own which lay concealed under make-up. But at the thought of having to cope with airports, formalities, the arrogance of taxi-drivers, she tolerated his company, while making him promise never to show his face in front of the press. France must not know about Hugo Guiler. Anaïs, alone, existed.

On her bedside table was a bouquet of red roses. That was France for you. A French publisher sent you flowers. She opened the accompanying envelope. It contained her timetable. A diva! Monday, photo session. Tuesday, three interviews. Wednesday, recording for Radio Canada. A journalist from *L'Express* in Lausanne was going to telephone her at around eleven o'clock. In the afternoon, she had an interview with a journalist from *Le Figaro*.

He was waiting for her in a café not far from the *quais*. She had dressed for a confrontation, in red, like a flamboyant suit of armour. She was determined to establish herself, defend herself, convinced the critics were going to attack her. Journalists were like beasts of prey. This one was smoking a pipe. She screwed up her nose. He puffed even more strongly. The tape-recorder failed to start. She hoped it would stay like that. She hated them, and smoke, and interviews. However, she had decided to be delightful, patient, and very tactful by speaking French. As always.

'How is it that in anthologies of American literature, you barely get a mention?' he asked between two evil-smelling gusts of smoke.

'I'm not American. As far as Americans are concerned, I'm a foreigner. For a long time they've thought in the States that my novels were translations from French. I'm a sort of displaced person. But in France I feel at home.'

She waited for a smile. None was forthcoming. The journalist was checking the sound level, gesturing to her to continue.

'My style disturbs people. I'm absolutely not a realist. When I'm interviewed on television, they ask me why my characters don't smoke or drink whisky. As if that were all there was to life.'

The journalist looked up, surprised by the vehemence of this melodic, almost childlike voice. Her green eyes flashed. Could it be there was a real writer hidden in this doll with the wrinkled neck?

'People say you've been keeping a diary for almost fifty years?'

'Yes, it's true. I've always refused to publish it till now. But it's possible that fragments of it will be published. My journal has been written like a sketchbook. I want to give it the intensity of a novel. I want to complete passages that are too summary, eliminate repetition, enrich the portraits, tone them down. But how can you extract the essence of life without causing hurt, without wounding? That's a major preoccupation with me. I shall give pseudonyms to the people who're still living. I hate scandal . . .'

'Miller compared your journal to . . . wait while I find the exact quotation . . .'

The journalist leafed through his notebook. Anaïs could barely restrain herself from tearing it from his hands.

How could people say she was a gentle person? Within her seethed revolt. Miller. Still Miller. Always Miller. The French swore by him, as if he were the only American writer in existence. Miller. What a buffoon! Presiding in his new villa with its swimming-pool at Pacific Palisades, like a Buddha in a temple. Famous throughout the entire world. *Tropic of Cancer* had even been translated into Finnish and Hebrew. Dollars rained down on him. What was he doing to help her? Nothing. Or very little:

a gesture, a single gesture: he had offered her the rights of his letters to her: *Letters to Anaïs Nin*. Generous, no: magnanimous, for the initiative to publish them rested with him.

Their correspondence was the good seed of their passion ... The letters were unique documents ... They had written to each other madly for ten years. There were letters in their hundreds. Strife, desire, fever, ecstasy, hatred. She had kept every one that he had written. The most beautiful book by Miller lay in the vaults of a Brooklyn bank, inviolate. And hers? Miller had deposited them in the department of manuscripts at California University at Los Angeles for safekeeping ... She had taken fright. One day or other he could sell them to the highest bidder. A shady publisher attracted by a box of matches ... Anaïs unmasked, as a voluptuous, deceitful woman. She had to get her property back as soon as she could. She had gone to see him to propose an exchange: you give me my letters back, I'll give you yours. You will gain in the exchange. Famous as you are, you will get a fortune if you publish them ... on two conditions: that I choose them, and that any allusion to our relationship is removed; and that my name appears in the book's title.

Miller had not only accepted on the spot, he'd relinquished his royalties as well. People were ecstatic. What class, what generosity! Anaïs gave an embarrassed laugh. Generous. That would be the first time in thirty years. Please, monsieur, don't mention his name again. Nor Durrell's. They understand nothing about my work. For him, I'm but 'a child of the palace', my work has the delicacy of soap bubbles. He said as much in a preface which I was thoughtless enough to ask him to write. I believed in his friendship, in his taste. He betrayed me with a tissue of lies, sarcasm. I couldn't help venting my disappointment in a final letter, breaking off our friendship. Since then he's made honourable amends, but I can't bring myself to forgive him. The wound is lasting.

*

On her return to America, Anaïs found a photocopy of the interview in the mail. It was headed: 'Anaïs Nin: muse of Durrell and Miller'. She was furious and on the point of tearing it up, when Rupert stopped her.

'Let me read it to you . . . "Anaïs Nin is here in Paris on a brief visit. When I met her, a sentence from her new work sprang to mind. 'All dressed in red and silver she evoked the tearing red and silver siren cutting a pathway through the flesh.' In fact, she was wearing a simple long red dress, a little red hat, and red cape. She has the fragility of a flame struggling to rise in Paris. But this fragility conceals a considerable energy . . ." You see, it isn't bad.'

'And how does it end?'

Rupert skimmed through in silence. His face darkened.

'Oh, well,' he murmured.

'Well, what?'

'It ends with a quotation about your still unpublished journal – from Miller: "A monumental confession which when the world receives it, will take its place beside the revelations of St Augustine, Petronius, Abelard and Proust." He adds: "Isn't it time you discovered Anaïs Nin?"'

Yes, it was time. At the risk of dying misunderstood, of being overshadowed by false friends, and wearing the showy rags of a 'pure intellect who haunts fashion boutiques'.

She thought about death often now. Without imagining anything except the image of an empty vault, similar to the one which housed the fifteen thousand pages of her journals, keeping them cool and alive. If she published her Journal it would keep her alive for eternity. The vastness of the work frightened her: fifteen thousand pages to revise, to retype. Hundreds of portraits to be put together. She needed time, and calm.

She had a place, in Los Angeles. A house built of wood and stone clinging to a hillside above Silver Lake, in a picture-postcard landscape, facing the setting sun like a Muslim at prayer.

You had to walk to reach it, hidden among pines and eucalyptus. It was born of the rock from which the trees grew, appearing fragile, defenceless, almost air-borne, and yet so earthy in its brown harmonies, which echoed the natural world around it, both modest and regal in its mirror image in the lava-coloured swimming-pool.

Rupert called it 'The Hamburger House'. He had used each dollar with care, battling for loans from bankers who were reticent about lending money, disconcerted by the reddish-brown building merging into the landscape, in the style of Frank Lloyd Wright. His grandson Eric, Rupert's half-brother, had designed it. Anaïs had offered directions.

She had wanted a fireplace of volcanic rock, a kitchen of wood and Venetian mosaic, next to the huge room which served both as drawing room and bedroom. No walls. No shade. Only in her office: a narrow room, facing north, facing the hill. It contained a table and chair and a metal cupboard, nothing else. The shelves were bulging with books: some French novels, some by Romain Gary whom she had known and who had been consul in Los Angeles. Marguerite Duras. Andrée Chedid. In the window was a geisha doll she had brought back from Japan. Pinned to a cork board was a sun, the star of her Paris friendships, with names radiating from the centre: Artaud, Breton, Brassaï, Duchamp, Bernard Steele . . . Ghosts which would be brought to life again through her.

What filled her thoughts each morning, from nine o'clock onwards, after she had swum a few lengths in the swimming-pool, eaten a yogurt under the watchful gaze of her white poodle, and sat down in the narrow room with her notebooks, removed from their protective wrappings of plastic?

Did she think back to the times when she used to carry them from one bed to the next? When her tears smudged the pages? When her legs were steady? Did she remember Miller saying: '[They] should be preserved like the first copies of the Gutenberg Bible, under a glass case. Not even the air that people breathe,

that they foul with their dirty lungs, should be allowed to contaminate [them]'. Did she remember the letter Miller had sent to William Bradley, his literary agent, trying to persuade him to get the Journal published without cuts? 'How can you be certain that what you find uninteresting won't interest thousands of others . . . I'm thinking of the Japanese reader, the Indian reader, the Spanish reader, the Scandinavian . . . I'm thinking of the reader in the year 2000.' Bradley didn't want to know. The journal was unpublishable. How many times had she heard those words? In Paris, London, New York. All the publishers had the same language. But for her, as she told Bradley, quoting Oscar Wilde, becoming a work of art mattered more than creating one. Her point was made. On Rupert's advice she had decided to get an agent: a solid German, a fighter, who put publishers in their place. Every day she telephoned him to tell him of her progress.

Together they planned the first volume: no more than 300 pages – no publisher would want more. It was to begin in 1931, the year of her true birth, when she had met Miller and begun to write in earnest. It was to finish in 1934, which marked the end of her analysis with Rank, and her departure for New York: the dawning of a free woman.

Free. The adjective was critical. Women will be your principal readers, they will identify with you, it was explained to her. You will offer a model to the younger reader, and a salve for their bitterness to the more mature. The barge, Villa Seurat, the kitchen at Clichy will be focal points for their dreams. Don't mention your husband. What could be less romantic than a banker? Exit Hugo. 'I did it only to obey his wish for discretion,' Anaïs would claim later; and, out of fair play, Hugo kept his silence and went along with it.

Miller was to be the leading male protagonist. On her agent's advice, she sent him all the relevant passages, and asked for corrections. It would be the same for all the people mentioned in the journal who were still alive.

Legal action had to be avoided.

Miller returned the manuscript covered in cuts. The Guru of the West Coast wished to be shown in his best light — inspired, passionate, rakish, but not excessively so. And, above all, not in love with her. 'No Anaïs, no sliding into sentimentality.'

She took all his demands into account. He was still the winner. And June? . . . a faltering flame. In 1961, Miller had seen her again in her New York hideaway on 95th Street on Riverside Drive. At fifty-eight, she looked twenty years older. She was thin, and had developed a compulsive tic. She talked non-stop, as if she hadn't opened her mouth for years. She was incoherent.

Anaïs made no attempt to visit her. She was content with seeing June's psychiatrist instead. Together they refined her portrait.

To be fair was what was most important. Not to betray, not to wound. But it was impossible: she had betrayed so many people. Wounded so many. To be truthful, to expose herself to the malevolence of the world was frightening. There was a defiance in it all: she was offering herself, immolating herself in literature. 'Take my life: it is my work.'

One night, she awoke with a start. She was frozen and trembling, still in the midst of a nightmare. She was walking down an endless corridor. Every two yards, a closed door. She had to open one. No, she must not obey on pain of . . . Open it. An unseen force compelled her. Open it then. She gave in and stretched out her hand to the doorknob. She was pierced by a ray, right through to her heart, a violent, mortally wounding ray. Could it have been the truth?

At the beginning of 1966, Anaïs was rushed into hospital, in New York, and diagnosed as having a tumour of the ovary. They operated on her immediately, and when she awoke, she learnt that her journal had found a publisher.

UCLA

Since 1975, the University of California at Los Angeles has been the keeper of the journals. They are contained in three iron trunks labelled 'Miller', which are double-locked and held in a strong-room maintained at a constant temperature. There are sixty-nine notebooks as thick as bibles, wrapped in cellophane. Their covers vary from hogskin, pink paper and black leather to a coloured drawing (by Miller perhaps?), an engraving by Hugo, and another from a Modern Astrology manual, to dark canvas and purple cloth.

Sixty-nine notebooks, hand-numbered by Anaïs and bearing titles like future novels: her dramatized life.

'Journal of a Possessed', 1932
'La Folle Lucide. Equilibre', 1932
'Flagellation', 1933
'Incest', 1933
'Definite Appearance of the Demon', 1934
'Révolte', 1935
'Vive la Dynamite', 1936
'Les Mots Flottants', 1938
'Intermezzo: Book of Climacterics', 1940

As you leaf through them, the writing gallops across the page in sharp arabesques, leaping from English to French, French to Spanish, here a photo of Miller in Greece, Gonzalo in bathing costume on a beach, Dali and Gala perched up an oak tree at Bowling Green, Gore Vidal in a tie, sitting in a coffee shop reading an article called 'Be your own psychologist', a concert programme, a visiting card, the address of an Italian restaurant –

Eddie's, in the Village — and letters, letters everywhere, always kept in the original envelope.

Like a child, she pasted in scraps of reality, as though writing things down was not enough to remember by, as though real fragments of life were needed to ward off the stasis of words: Death.

What fear, what temptation was it that haunted Anaïs, that she should keep in her journal the announcements of Virginia Woolf's and Stefan Zweig's suicides, and the first photographs of concentration camps?

[33] *Success*

'Did you know she has become a champion of women's freedom, and acquired a vast reputation? People ask her for her autograph, like Liz Taylor. Do you remember that timid, shy creature? Well now she enjoys addressing crowds and does it with authority, she gives lectures, participates in meetings and is applauded.

Miller quoted by Brassaï in *Henry Miller: The Happy Rock*

Letters poured in at the rate of two to three hundred a week. The post office at Silver Lake District had to employ a postman just for Miss Nin's mail, for the author of the *Journal*. The letter she had begun writing as a lonely child now generated thousands more, like the Wedding Feast at Cana, like a soul spreading manna. She was free, and her voice spoke out radiantly to those who still spoke in whispers. Now that the first feminist groups were being organized in the States, Anaïs spoke to women seeking their freedom. While Betty Friedan was talking about the 'inexplicable malaise' of the *Feminine Mystique*, Anaïs revealed the mystique of the accomplished woman. The *Journal* was being read by thousands.

Every morning brought a harvest of confidence: 'I am a night nurse . . . reading the *Journal* has helped me to endure ward duty . . . I am sixty years old. I was letting myself die. Your journal has given me a new life . . . I am a farmer's wife, mother of eight children. I also have a journal. When the house is asleep and I at last have time to myself . . . I am sixteen . . . at college. Your *Journal* revealed to me who I am and who I want to be . . .'

Anaïs savoured each message like a gulp of water in the desert: here at last was the recognition she had awaited so long. She

replied to all the letters. She was still wounded by Djuna Barnes's indifference: Djuna, her model, the author of *Nightwood*, a recluse in Patchen Place in the Village. Anaïs had made attempts to see her. She had written to her but Djuna Barnes had never deigned to reply.

Why be a novelist and cut yourself off from the rest of the world? Why write if you are so suspicious of your readers? Anaïs liked hers without even knowing who they were. The *Journal* was their bond: they had made her life theirs. All the letters said the same thing: 'I'm like you,' or 'I long to be like you.'

It cost her a fortune in writing paper, which she chose with care, since it offered a message even before they read the words on it. On one set she had a portrait of a geisha at her toilette, seated in front of a mirror . . . On another two fishes biting each other's tails: her star sign. On a third, LOVE in capital letters. She would use this last for teenagers. Japanese paper was suitable for the older woman. Her mail became slavery: it ate into her siesta time. Piccolino her poodle was most annoyed: their walks were shorter. When she flew anywhere, she no longer read, she answered letters. Several hours every day were devoted to it. She sacrificed her work. Now that her *Journal* had been born, it was dying. She scarcely opened it.

The seventh volume, published after her death, contains letters, descriptions of her travels, extracts from lectures. Her ego had dried up. Narcissus had veiled the mirror. Anaïs confessed she no longer listened to herself.

Rupert told her she must look after herself properly: she was losing her eyesight, her strength. She would shrug her shoulders and demand a Martini, for which she had developed a taste. Like a magic potion, a glass would cheer her up. She felt so weak after her operation and it was taking a long time to convalesce. Anguish had left its traces round her eyes, for she had spent whole nights crying. When they had removed the tumour, they had also

removed all her female organs. She had a mask for a face, and an empty body. It was enough to make her scream.

But she no longer had the right to do that: she was the incarnation of happiness, accomplishment, success. Her publisher was gleeful; he had discovered the goose that laid the golden egg. The first printing had sold out in a week.

Frances Steloff, who, in spite of her great age, still ran the Gotham Book Mart, no longer knew what to do. The hundred copies she had ordered had gone in two days. As a mark of their long friendship, she had held the first signing session in her shop. There was a queue along the pavement, and readers were impatiently asking when the next volume was coming. Anaïs was working on it, between two articles. Publishers who previously had had no faith in her were now begging her for prefaces. Magazines squabbled over who should have her. Universities fought for her.

Anaïs wondered why they wanted to see her. Wasn't the *Journal* enough? But no, readers wanted to meet her, touch her cape like a holy relic. Lecture rooms filled two hours before she arrived, in a long black dress with a white collar, like a modern nun's habit. She would mount the podium with tiny steps. 'The students applaud me like the Beatles,' she wrote to a friend.

She needed a ritual to conquer her shyness: she would adjust the microphone and then ask in an inaudible voice: 'Can you hear me?' Naturally they couldn't. So she would raise the tone an octave, then another. And gradually her self-confidence would come. She looked out into the auditorium through clouds of smoke from joints. Girls with violet lips, hair plaited with pearls and feathers. Dreaming boys with tattooed foreheads. For simplicity's sake they were called Hippies. Anaïs found them more intelligent and more sensitive than their elders. They were suspicious of the 'American monster', and turned instead towards the East. When, in the course of a lecture, she mentioned the symbolism of teak oil that the Thais pour over the minature

houses in which they keep their gods, they immediately seized the sense of her words. They were on the same wavelength.

Like them, she loathed businessmen, lawyers, men of power and the atomic bomb.

'Call me Anaïs. My first name is pronounced: Ana-ees, Ana-ees.'

They clapped and threw flowers. She picked up one, gracefully, and put it on the desk in place of her spectacle case. Yesterday her glasses had been indispensible; today she didn't need them.

In the beginning she had read all her lectures, her nose buried in her paper. 'We no longer see your face,' Rupert said. 'You're losing impact. Students look at you, as much as listen to you. You must make do with notes.'

Could she improvise? She tried, cautiously at first. It worked well: she could speak fluently and animatedly, use fluid gestures, with hands outstretched like a Balinese dancer. And she smiled. Her voice filled the room, steady and pure, guided by inspiration, growing quieter as she was drying up, murmuring more and more quietly, until there was a final silence. End of lecture. 'Finishing with a fanfare, like Tchaikovsky, meant little to me.'

Then came the questions. She made them repeat them to avoid talking at cross-purposes, as she wanted her view to be understood. 'Do you understand what I'm trying to say?' If 'Yes' was late in coming, she would explain things a second time. She seemed tireless to those watching her, as she spoke for two hours at a stretch, or sat in front of a queue of students waiting for her to sign their books, and following her pilgrimage from campus to campus.

She visited some hundred of them in 1969. Her friends became anxious. Or else they thought she was a little mad, somewhat fanatical, powered by a Messianic will. 'Anaïs is spreading the good word.' Even to the deaf. The feminists. The hard cases. The ones who, with Kate Millet, declared war against the 'male chauvinist pigs', of whom Miller was one. Anaïs defended him. They booed her. As a pioneer, she made a plea for a loving

dialogue based on emotion. She wrote an essay entitled 'In favor of the sensitive man'. 'I was asked one day what I thought of men who cried, and I replied that I liked them, because that way they showed their sensitivity.'

She believed in marriage, in the complementary nature of a relationship, in gentleness. She considered *The Second Sex* passé. Simone de Beauvoir lived in Sartre's shadow. She had sacrificed her female emotions. The heroines of her novels had no realism. The hall was in uproar. At one meeting she came across a bathtub filled with Tampax. She withdrew.

In December 1969, she had a setback: a new tumour, in the same place. She was overcome with neurosis: feeling she had been born a sacrificial victim. She was not made for fame. She was being made to pay, through cancer. Her analyst, Dr Bogner, shook her. She had so much to offer: she had to fight.

She went to New York, to the Presbyterian Hospital on 168th Street, where she had had her first operation. The surgeon refused to attempt a second. In his opinion radiotherapy seemed preferable.

'You have a seventy-five per cent chance of recovery.'

'Only seventy-five per cent? Wouldn't an operation be more likely to get to the root of it?'

He looked daggers at her. What business was it of hers? Seventy-five per cent was good . . . at her age.

Anaïs bowed to his verdict. Every morning a taxi took her to the hospital. The X-ray room had yellow walls. She closed her eyes, so that she would not have to look, so that she would not have to think about the ravages of the X-ray. Images went through her mind: eucalyptus, crown imperials. A teahouse in Kyoto. A white beach. She was swimming. She was making love.

If only she could be cured. Everything else was going right. She looked so pale in her plum-coloured velvet dress, but a little bird made her believe in the good days to come . . .

In spring 1970 she announced she was well. Editions Stock had

just published the second volume of her *Journal*. She was going to Paris. 'It's madness,' cried Rupert.

'I must,' she replied.

Anaïs was as conscientious as ever. While Hugo stayed at the Madison in Saint-Germain, she remained shut up in her suite at the Hôtel du Pont-Royal drinking China tea, waiting for journalists. Among them was Jean Chalon. He had never met her before, but had guessed her to be an enchantress, like certain others in the past who had moved and excited him: Nathalie Clifford Barney, Florence J. Gould, Louise de Vilmorin. When he mentioned this last, Anaïs exclaimed:

'She was my friend. We met in the Thirties, through our husbands. Hugo was Leigh Hunt's banker. I would so love to see her again. Could you arrange a meeting?'

'She died last year.'

Anaïs was heartbroken. She and Louise had parted on a misunderstanding. Hating each other, almost ... Louise had recognized herself in one of Anaïs's novels — although under another name — and felt she had been betrayed. Anaïs had promised her that she would keep her confidences to herself, and felt that she had respected that promise by changing her name. Who except her most intimate friends would have been able to identify her? And in any case, had her story been unfair?

Jean Chalon reassured her. Anaïs unburdened her heart to him. She was so alone. She wandered through Paris as though she were walking through a stage set. She no longer had any friends, only admirers. Salons on the Left Bank, cocktails at the Closerie des Lilas. It was all so boring.

'Do you know what I should really like to do: sit somewhere quiet and have some bread and butter. I can't bear anything else. My cancer. I'm in remission. You wouldn't think I had cancer, would you? I look wonderful, don't I. It's my Cuban skin. Cubans don't get wrinkles until they are quite old. Dine at your house? Why not? Then we can talk about Louise ...'

She appeared in a white Mexican dress, her shoulders covered

in a soft wool shawl. At the end of the evening, she asked him if he would drive her to Clichy, where she used to meet Miller. They found the street. Anaïs was out of breath. She had no recollection of it being so far away. In the past, it had taken her no time at all. They looked in vain for the house of love. It had been demolished. Anaïs dried her tears. The following morning, fully made up by eight o'clock, dressed in a purple mini-skirt and white stockings, she posed for photographers, offering her: 'Renaissance madonna face. A pure intellect clothed by Courrèges. From this harmonious combination emerges a gentle voice, and, often, laughter which at the turn of the century would have been described as "pearl-like". Anaïs laughs a lot, but quickly grows sad when she learns that she cannot meet Violette Leduc who is out of town at the moment. She asks the photographer to take off his glasses, takes them and plays around, acting briefly like a warm human being, instead of the distant goddess which has become her image.' (*Figaro Littéraire*, 27 October 1969, Jean Peloux)

Docile goddess perhaps. A German TV company took her to Louveciennes to play the game of historical reconstruction. No. 2 bis, rue Montbuisson was falling in ruins. The new owner lived close by and they persuaded Anaïs to pay her a visit. The woman took her for an intruder. Anaïs Nin? Never heard of her. The producer insisted: 'A famous novelist. A filmstar.' The woman was furious and threatened to call the mayor. All Anaïs wanted to do was make a quick exit; the comedy had gone on long enough. But they made her stay. They had to have a picture. She was asked to push the gate open as though she were going into the house. Her cape was stained with rust. What a farce. On her return to Paris she posed with Michel Simon in front of a barge. But not hers. The Germans had riddled that one with bullets until it sank. What did it matter? It was a successful take. They drove her to the Dôme and made her sit at a table. She protested: she never wrote in cafés. Miller used to, but she never did. What did

it matter? It was a pleasant backdrop. What was she grumbling about? Hadn't she got what she wanted, fame?

'Anaïs was malign, she obtained exactly what she wanted — for example, becoming a legend. "Legend" was a word Anaïs uttered with respect.' If Gore Vidal's judgement must be used with care — one must bear in mind that Gore never forgave her for describing him in her *Journal* as a talentless gigolo — it is also not far off the mark. From childhood onwards, Anaïs saw herself as 'chosen'. For sixty years she fought for glory, and was jealous of Miller and Durrell for their more precocious fame.

She forged her legend exclusively and tenaciously by herself. Muse. Artist. Analyst. Enchantress. She moved the players in her game with such artistry that she became a prisoner of it.

In 1973, the film director Robert Snyder decided to make a twenty-minute documentary about her, in the same style as the one he had made about Henry Miller in which Anaïs had taken part, despite her sourness at once more having to play second fiddle.

'Don't treat her as you treated me,' Miller advised. 'Stage-manage her. Mythify her.'

The shooting took place at Silver Lake. It was the first time she had unveiled her retreat in front of the camera. She was afraid they might find it a bit too sober, too austere. It was so far removed from her former exuberant décor. There was no Moorish bed incrusted with mother of pearl, no Byzantine lamps. Instead crude, almost masculine furniture.

Had the fantasist become an aesthete? Well, not to the point of giving up her coquetry. She was no longer an *ingénue*. The technicians were told that there must be no harsh lighting; they must use filters, shadowy effects. Then there was the question of where to do the filming: the office was too sombre, the drawing room too bare. The best place was the swimming-pool, criss-crossed with shadows of weeping willow. Water gave her a feeling

of calm, reassured her, diluted her fears. Every morning she was able to forget her body in it.

Taking care not to crumple her long batik dress, she sat down at its edge, her bare feet in sandals, hugging her thighs like a little girl. Action. She spoke in a graceful, fragile voice. But with no fire. A seasoned performance while images passed across the background. Fragments of legend: the *Montserrat*, Joaquin Nin dressed for a gala concert, Antonin Artaud in Carl Dreyer's *The Passion of Joan of Arc*, Miller photographed by Brassaï, Rank in his office, Martha Graham, Maya Deren. She made pertinent comments. She scarcely moved, except sometimes when she raised her beautiful hands. She could still show them. They had not betrayed her. Not yet. Piccolino wagged his tail. The camera caught a smile. Anaïs gently stroked her dog, then took up her recital again, already far away, her chin resting on her hand.

FEMINISM

In 1966, if you wanted freedom, it was better not to be a woman.

1966 was the year when the first Women's Lib groups were organized in California, the year when the male came to epitomize evil, when woman reclaimed her body and her language as hers ... 'Life has a language which begins with my own body. I am already part of that language' (Hélène Cixous); her own law, her own mystique: 'They have invented everything about sexuality while our own sexuality kept silent' (Annie Leclerc); the year that Sappho, Nathalie Clifford Barney, Lou Andreas-Salomé and Djuna Barnes became the new prophets. It was also the year that Anaïs published the first volume of her *Journal*.

Better than a language was a consciousness, a life, a voice. The new cult was looking for its priestesses.

Anaïs was chosen by the militants by an overwhelming majority. When she appeared in public, they were shocked. They had expected a Passionara, instead of a powdered vestal virgin who recognized Miller's genius.

'I regret nothing I have done for him ... I believe in the couple. I do not believe in separatism or in violence, or in abolishing differences.'

They became aggressive towards her, insulted her. 'The feminists have proved the inhumanity of revolutionaries,' she said. 'They are the sort of people who would guillotine anyone who had clean nails.'

Hers were varnished.

She referred to feminist meetings as 'Kotex Congresses'.

[34] *Lady with bowed head*

Go and rest, Rupert, you're even paler than I am. Just put that cushion behind my head, and take the plate away: I'm not hungry any more. You can bring me a Martini this evening if I can't sleep. What time is it? The setting sun turns everything mauve. It's the colour of my dress, and the branches of the weeping willow sketch the same lacy patterns. I never tire of looking at it. Do you know that it breathes? Nature unveils herself to me as if she knows that soon I shall dissolve into her. In the hospital I asked them to push my bed under the window. I could see the cedar in the park . . . You could have left me there. It wasn't so bad. The nurses read to me. They swore by the *Journal*. Please, find me something else: Karen Blixen, Proust or Marguerite Young. No, nothing was as good as my *Journal*. They've all got their copies, I've written a dedication in each of them. It's easy to give pleasure when you're famous. They deserve it. They anticipated my every want. When I was filled with *angst*, I would ask them to play me that cassette of birdsong – the one we recorded together, in the garden. The chirruping filled the room. I fed on it, like a newborn child on its mother's murmurings. I became a lark, a red-throat, a nightingale. I could fly away. I could fly to the cloth sun, in the sky over my bed. Do you know what the decorations in my room made me think of? That coloured paper I stuck on my windows in Paris in 1939, to brighten the darkness.

I have always sought the light, and now I have attained my goal. It envelops me, so tenderly that the pores of my skin dilate under its touch. Tell me, Rupert, are they going to leave me alone now that they've scorched me for fourteen days without any result? Don't protest. Would I have suffered any the more if they had removed the tumour? You can do nothing about it. You've

tried everything. Me too. Like you I thought the Japanese vaccine would cure me. You couldn't import it, but you fought for me to get it, and I took it like an offering, persuading myself that it contained Japanese serenity. I am so much in need of that. Dr Stone believed he was giving me that when he gave me a copy of *Positive Thinking*. To fight cancer! Imagine it. Capture it in your mind. Act. Attack it in your thoughts. In the beginning, I withheld my laughter. I could see nothing. Stone inveighed: If you want to cure yourself, you've got to imagine it. I did my best. I saw my cancer like a sulphurous crater in Hawaii. Two young Fates approached with pitchers of water. I recognized them as students. They bent over the crater and flooded it. How long did I believe in Stone? A month or two. And that Frenchman who gave me injections between the toes. You were pretty sceptical about him. You dared to question the word of a Frenchman – I was annoyed with you. I was expected to do what you told me. After him came Dr Joy. Joy. I read a lot into his name, at his ranch, lost among the juniper trees, like the grotto at Lourdes. My hands grew numb with praying. He passed his hands over my navel. I resented the tickling. Warm waves, then burning ones invaded my body, numbed me till I fell asleep. But once I was back at the house the pain began again. Vengeful. Pulsating. Stabbing. Tearing . . .

I won't die of cancer, Rupert, I shall die of pain. The pain will slowly kill me. In the hospital, they thought it was a good idea to talk about it. I asked for morphine. They put two sleeping pills on my bedside table. Two sleeping pills when my screams could be heard through the wall. Stop this torture. Do anything, but do something. Give me whatever you want. Gin. Cocaine. LSD. But just make it stop, I beg you.

I have forgotten what it is like to be calm. I can hear the pain preparing to attack, getting ready for the fray.

Every day, my strength is seeping away without my being able to do anything about it. I have struggled for so long; now, I shall die powerless.

Hand me the mirror. My hair must be all untidy. In hospital I

was always losing my comb. I could never find my lipstick. They used to cajole me. Still a flirt. While they smiled, made jokes. As if I were past the age of looking attractive. Attractive, no, merely surviving. My nose is glistening with sweat. It seems shorter. Narrower. And my eyes – fever gives them their old, deep, intense look. Will that look make death retreat when we come face to face?

Do you remember that portrait of Helba when she was sick in *A Spy in the House of Love*, the one with the woman sitting up in bed, doing her hair and tying a blue ribbon in it? Her face was frighteningly ravaged, yet she was powdering it and putting on her lipstick, and she smiled like a woman who was going to die, but who wished to die beautiful.

It is the ethic of an aesthete: at heart I had only one religion and that was beauty. When I close my eyes, you can do my hair in a chignon. Curling it makes it look thicker. You won't forget. And put kohl on my eyelids, and I want to be wearing my Balinese dress. I would have liked to die in Java, among the silk and the waterlilies . . . Write that in my notebook. I no longer have the strength to hold a pen . . . my hand is trembling. Don't insist. Read the lines that go before. No, let me listen to the Debussy quartet. Turn the sound right up.

My veins are gorged with music. Like a drug. Peaceful. When my father was at the piano he came within a hair's breadth of holiness. When my mother sang, she could not cry at the same time. Listen to that melting of notes. Breaths. Isn't that proof of a better world? A world from which we have been exiled and to which we shall return, pure or impure.

Could I be called pure? Perhaps. But a corrosive purity, like the purity of a glacier or a flame.

What image will people keep of me? A lover? A deceitful woman? Fear dictated my faithlessness. Rather than risk betrayal, I betrayed first. A *femme fatale*? A scandalous woman? Should I have refused to allow my erotic stories to be published? They're not my best work. I wrote them for fun, for amusement, thought-

lessly. What perversity will I be accused of when I am no longer there to defend myself? What lies will you hear? One day the entire Journal must be published. You must not cut out a single sentence. You must not change a single name. You must deliver up my life, like a Christian to the lions. I shall be absolved.

Yesterday I telephoned Dr Bogner, then Joaquin. I asked them to forgive me, to exonerate me, to grant me their indulgence. 'Address your prayer to God,' my brother said.

I have nothing more to do with God. Nothing but music, your presence, the rose at my bedside, and those lilies on the table. My students swamp me with flowers. I miss them, their questions, their waiting on every word, their eagerness. I see myself in them. What I used to be ... I so much wanted to go on with my seminars ... All those young people around me, blind, in the presence of death. They restored my confidence ... I am living: I am giving a lecture and I will be giving one next week. Living ... they are smiling at me, asking me questions. They admire me. At last. Tiredness seals my lips. Too tired, to win, to fight, tired, too tired to hope ...

Anaïs died on 14 January 1977, shortly before midnight. 'The Ocean will spread my ashes on to all the shores of the world.'

Braving the threatening storm, Rupert climbed aboard a helicopter which would take him out over the Pacific. By his side was a tightly knotted pink silk scarf, on his knees a map of the sea. His fingers wandered from one intersection to another looking for a place, hoping for a sign. Guide me, Anaïs. In the middle of the bay of Santa Monica, his finger stopped at the intersection known as the Siren. That was the place.

The helicopter was buffeted in the gusts of wind. Rupert leant out over the void. A sudden flash of light tore the clouds and a patch of iridescent light slid on the waves, drunk with the sun. He released the scarf.

Caught in the light, Anaïs became as one with the sea.

MUSIC

'There was never a smile on his face except when there was music.' (*Winter of Artifice*)

The father is playing the piano, the mother singing, the child is calm. 'The music would transform a human battle into beauty.' (*Journal 1966–1974*)

If music could move a father, it was art that could change life. Anaïs forged her belief from this hope. From that first memory – 'I fell asleep listening to music' – she fashioned her manifesto: as soon as she arrived in New York, she grabbed her brother's violin.

Her father's library had both books and scores. Words would be her notes.

'I have often wanted to write the equivalent of a sonata.' Her stories were variations on the same theme. Her sentences pulsations more than constructions.

A music close to 'the Peruvian flute, the conch shell of the Tahitians, Satie and Debussy'. She was going to fade out, as she had lived: in music.

They fixed speakers to the ceiling of the room where she was dying.

'Music indicates another place, a better place. This was the place from which we were exiled . . . if it follows death, it is a lovely thing to look forward to . . . So I shall die in music, into music, with music.' So ends the last volume of the *Journal*.

Acknowledgements

A portrait thrives on encounters. Those I made were in Anaïs's image: attentive and serious, poetic, passionate.

I must thank Rupert Pole, who welcomed me into his light-filled house in Los Angeles and opened the doors of the department of manuscripts at UCLA for me, so that I could see the original journals; Joaquin Nin-Culmell, 'Joaquinito', whose regular letters and astonishing memory have helped my work so much; André Bay, Anaïs Nin's first French publisher; Jean-Yves Boulic, who is working to make the house at Louveciennes a shrine to Anaïs's memory; Jean Chalon, who gave me a sparkling picture of an enchantress; Béatrice Commengé, translator of *Delta of Venus*, *Henry and June* and *A Literate Passion*; Jean Fanchette for his very sensitive recollections; Marguerite Rebois, a discreet and constant friend of Anaïs; Paule Thévenin, who helped me towards a greater understanding of Antonin Artaud; Marie-Claire Van der Elst, translator of the first volumes of *Journals*, for the help she gave me.

I must also pay tribute to Marie-Josèphe Guers who edits the '*Elle était une fois*' collection. For her attentiveness and her warmth, and those many small kindnesses which seal a friendship.

WORKS BY ANAÏS NIN

JOURNALS

Journal d'enfance, volume 1
 Preface by Joaquin Nin-Culmell
 Edited by Marie-Claire Van der Elst
Journal d'enfance, volume 2
 Edited by Marie-Claire Van der Elst
Journal d'une fiancée (1920–1923), volume 3
 Preface by Joaquin Nin-Culmell

(Published by Editions Stock, Paris, and translated as *Linotte: The Early Diary of Anaïs Nin*, published by Harcourt Brace Jovanovich, New York)

Journal of a Wife (1923–1927)
 Edited by Gunther Stuhlmann
Journal (1931–1933) [volume 1]
 Edited by Gunther Stuhlmann
Journal (1934–1939) volume 2
 Edited by Gunther Stuhlmann
Journal (1939–1944) volume 3
 Edited by Gunther Stuhlmann
Journal (1944–1947) volume 4
 Edited by Gunther Stuhlmann
Journal (1947–1955) volume 5
 Edited by Gunther Stuhlmann
Journal (1955–1966) volume 6
 Edited by Gunther Stuhlmann
Journal (1966–1974) volume 7
 Edited by Gunther Stuhlmann

(All published by Peter Owen Ltd, London)

Henry and June, from the unexpurgated diary of Anaïs Nin
 Edited by Rupert Pole
(Published by W. H. Allen, London, and Harcourt Brace Jovanovich, New York)

FICTION

House of Incest, Siana Editions, Paris, 1936
Winter of Artifice, Obelisk Press, Paris, 1939
Ladders to Fire, Dutton, New York, 1946
Children of the Albatross, 1947
Under a Glass Bell, Editions Poetry London, 1947
The Four-Chambered Heart, Duell, Sloan and Pearce, New York, 1950
A Spy in the House of Love, British Book Centre, Paris, New York, Amsterdam, 1959
Seduction of the Minotaur, 1961
Collages, Alan Swallow, 1964
(All published by Peter Owen, London)

Solar Barque (excerpt from *Seduction of the Minotaur*, privately printed, 1958)
Cities of the Interior (2 volumes of collected novels) 1959
(Not published in the UK)

EROTICA

Delta of Venus, 1978
Little Birds, 1979
(Published by W. H. Allen, London and Harcourt Brace Jovanovich, New York)

NON-FICTION

D. H. Lawrence: An unprofessional study, W. Titus, Paris, 1932; Neville Spearman, London, 1961, Alan Swallow, Denver, 1964
The Novel of the Future, Peter Owen, London, 1969
A Woman Speaks: The Lectures, Seminars and Interviews of Anaïs Nin Edited by Evelyn J. Hinz. The Swallow Press, Chicago, 1975, and W. H. Allen, London

BIBLIOGRAPHY

K. C. D. Alberts, *Henry Miller: Colossus of One*, Sittard, 1976

Paul Bowles, *Mémoires d'un nomade*, Quai Voltaire, 1989

Brassaï, Gyula Halasz, *Henry Miller, grandeur nature*, Gallimard, 1975

—, contribution in *Henry Miller, The Happy Rock*, Bern Porter, 1947

—, *Le Paris Secret des Années 30*, Gallimard, 1976

Jean-Paul Crespelle, *La Vie quotidienne à Montparnasse à la grande époque, 1905–1930*, Hachette, 1976

The Durrell–Miller Letters, Faber and Faber, 1988

Hugh Ford, *Published in Paris. American and British Writers, Printers and Publishers in Paris, 1920–1939*, Macmillan, 1975

Maurice Girodias, *Une journée sur la terre*, La Différence, 1990

Peggy Guggenheim, *Ma Vie et mes folies*, Plon, 1987

André Kaspi, *La Vie quotidienne aux Etats-Unis au temps de la prospérité, 1919–1929*, Hachette, 1980

Jay Martin, *'Always merry and bright', a life of Henry Miller*, Capra Press, 1978

Henry Miller, *Letters to Anaïs Nin*, Peter Owen, 1965

—, *A Literate Passion: The letters of Anaïs Nin and Henry Miller, 1932–1953*, Allison and Busby, 1987

—, *Complete Book of Friends*, Allison and Busby, 1987

—, *Recollection*, Capra Press, 1981

—, *Tropic of Cancer*, Obelisk Press, Paris, 1934

—, *Tropic of Capricorn*, Obelisk Press, Paris, 1939

Anaïs Nin Foundation, 'Anaïs: an International Journal'

Alfred Perlès, *My Friend Henry Miller*, Neville Spearman, 1955

Maurice Sachs, *La Décade de l'illusion*, Gallimard, 1950

Sharon Spencer, *Collage of Dreams, The Writings of Anaïs Nin*, Swallow Press, 1977

Frédéric-Jacques Temple, *Henry Miller. Qui suis-je?*, La Manufacture, 1986

Two Cities (ed.), *Letters to Jean Fanchette, 1958–1963*, ETC

Robert Zaller (editor), *A Casebook on Anaïs Nin*, Meridian

Further Biographies Available from Minerva

While every effort is made to keep prices low, it is sometimes necessary to increase prices at short notice. Mandarin Paperbacks reserves the right to show new retail prices on covers which may differ from those previously advertised in the text or elsewhere.

The prices shown below were correct at the time of going to press.

☐	7493 0647 5	**Dickens**	Peter Ackroyd	£7.99
☐	7493 9177 4	**My Left Foot**	Christy Brown	£4.99
☐	7493 9091 3	**Pietro Citati**	Kafka	£6.99
☐	7493 9019 0	**In Search of J. D. Salinger**	Ian Hamilton	£5.99
☐	7493 9152 9	**Writers in Hollywood**	Ian Hamilton	£5.99
☐	7493 9086 7	**Sylvia Townsend Warner**	Claire Harman	£6.99
☐	7493 9070 0	**Lost in Translation**	Eva Hoffmann	£5.99
☐	7493 9005 0	**The Orton Diaries**	John Lahr	£6.99
☐	7493 9803 5	**Colette: A Life**	Herbert Lottman	£7.99
☐	7493 9014 X	**Nora**	Brenda Maddox	£6.99
☐	7493 9156 1	**What Fresh Hell is This?**	Marion Meade	£7.99
☐	7493 9082 4	**Timebends**	Arthur Miller	£7.99
☐	7493 9901 5	**Sartre**	Annie Cohen-Salal	£9.99
☐	7493 9047 6	**Friends of Promise**	Michael Sheldon	£6.99
☐	7493 9924 4	**Ake**	Wole Soyinka	£5.99
☐	7493 9170 7	**Isara**	Wole Soyinka	£5.99
☐	7493 9133 2	**Lawrence of Arabia**	Jeremy Wilson	£9.99

All these books are available at your bookshop or newsagent, or can be ordered direct from the publisher. Just tick the titles you want and fill in the form below.

Mandarin Paperbacks, Cash Sales Department, PO Box 11, Falmouth, Cornwall TR10 9EN.

Please send cheque or postal order, no currency, for purchase price quoted and allow the following for postage and packing:

UK including BFPO — £1.00 for the first book, 50p for the second and 30p for each additional book ordered to a maximum charge of £3.00.

Overseas including Eire — £2 for the first book, £1.00 for the second and 50p for each additional book thereafter.

NAME (Block letters) ..

ADDRESS ..

..

☐ I enclose my remittance for

☐ I wish to pay by Access/Visa Card Number

Expiry Date